D1388018

ARTISTS AND AUTHORS
AT WAR

ARTISTS AND AUTHORS AT WAR

by
HENRY BUCKTON

with a foreword by
DAVID SHEPHERD OBE

LEO COOPER

First published in Great Britain in 1999 by
Leo Cooper
an imprint of
Pen & Sword Books Ltd
47 Church Street
Barnsley
South Yorkshire
S70 2AS

ISBN 0 85052 676 0

A catalogue record for this book
is available from the British Library

Typeset in Sabon by
Phoenix Typesetting, Ilkley, West Yorkshire

Printed by Redwood Books Ltd,
Trowbridge, Wilts.

CONTENTS

CONTRIBUTORS

Bruce Allsopp
Sir Martyn Beckett
Edward Hollamby
Claude Harrison
Arthur Hackney
Anthony Eyton
A. Stewart Mackay
Richard Seddon
John Napper
Leonard Rosoman
Eric Taylor
William Gear
Laurence Whistler (Rex Whistler)
Kenneth Armitage
Franta Belsky
William Maving Gardner
Sir Hardy Amies
Andrew Grima
Bill Ward
David Langdon
James Bostock
John Hawkesworth
Shaun Sutton
George Macdonald Fraser
Michael Gilbert
Ralph Hammond Innes
Richard Hough
John Prebble
Nigel Tranter
George Lloyd

Paul Griffin
John Press
Gavin Ewart
Randle Manwaring
Robert A. Strand

FOREWORD
by
DAVID SHEPHERD OBE

I was only too pleased to accept the invitation from Henry Buckton to write a foreword to this book which can do so much to bring to the attention of the general public the great contribution that many artists, authors, poets, composers and film designers made during the Second World War, both in serving in one of the armed forces and in the field of art, portraying the glory and the horror.

As an artist myself, I have in my own way had the honour to portray some idea of the momentous events of World War II. However, I was only ten years old during the Battle of Britain, so I suppose I was the archetypal little 'spotty-nosed schoolboy with a cloth cap and a gas mask', who, totally unaware of the horror of what was going on, watched with excitement at the events unfolding over my head on my way to school. Nevertheless, that period influenced me so much that when I became a professional painter I was able to record some of the events between 1940 and 1945.

During my career I have visited many military establishments throughout the world and seen many huge oil paintings recording events in military history, most of them, seemingly, of the last century. I think it is sad when one thinks that relatively few paintings exist of more recent times. It is indeed ironic that many young painters, who were not even born at the time, are now redressing the balance.

There are, of course, countless photographic images of World War II which are now part of history, but cameramen, in spite of their incredible bravery shown in so many cases, were nevertheless hampered by the very limitations of their equipment, because, after all, a camera can only record the facts.

Artists have so much more freedom of expression. My admiration is therefore all the greater for those who served with the armed forces, yet who, in their own way, were able to record the war as it was happening. This book and the illustrations and photographs in it contribute greatly in bringing to the eyes of the general public the great service that was done by painters and other artists, to whom we owe such a debt.

INTRODUCTION

The subject of a book entitled *Artists and Authors at War* could follow one of several courses. It could be about official war artists, and war correspondents, employed to record events during the Second World War, as and when they happened. It could be about art and literature inspired by the Second World War, some of which has been created by people who weren't even born at the time. Both of these particular avenues have been explored in several authoritative books and, although an element of both can be found in this book, its principal theme takes the title much more literally.

During the Second World War almost an entire generation of young men, and many young ladies, served in one of the Armed Forces. It's little wonder, therefore, that many of the great artistic talents that shaped the post-war art scene had experienced some form of military service. It's little wonder, too, that much of their work was influenced by images observed during some of the cruellest years in modern history. This book looks at the historical background of these great talents to discover how they were employed during the war, and how – if at all – their artistic talents were utilized by the war effort.

Each artist featured in the book is introduced by a short biography, listing their main artistic achievements and any relevant historical background to the events covered in their story. This introduction is followed by an article written by the artist himself, describing his military service and, where possible, the art he was able to produce under such difficult circumstances.

Before we begin it is essential to define the meaning of the word Artist, as represented in the book. The Oxford Dictionary describes art as, 'the various branches of creative activity concerned with the

production of imaginative designs, sounds, or ideas, e.g. painting, music, writing, considered collectively'. The key words here are creativity and imagination and the artists featured in this book are those who have used their gifts to create original works of art, such as sculptors, painters, engravers, jewellers, dress designers, poets, authors, composers, script writers, producers and designers for film and television. Exponents of the performing arts are not included unless they are also represented in one of these other mediums.

One of the most fascinating things the reader will discover is the high rank and responsibility that many of these artists achieved, as well as the practical application of their talents. For instance, the sculptor Kenneth Armitage found himself running courses in the identification of tank and aircraft shapes with the Royal Artillery; designer William Maving Gardner used his design talents in charge of an Army Camouflage School; painter William Gear served with the Monuments, Fine Art and Archives Section of the Control Commission; poet Randle Manwaring commanded the RAF Regiment in Burma; dressmaker Sir Hardy Amies ran the Belgian Section of Special Operations Executive; poet Paul Griffin worked on Orde Wingate's operations staff in Burma; jeweller Andrew Grima commanded the REME divisional workshop of the 7th Indian Division on the Arakan Peninsula; and authors like Ralph Hammond Innes and John Prebble used their emerging literary talents as journalists for service newspapers. Then, of course, there were official war artists like John Napper, Leonard Rosoman and Richard Seddon, who studied Allied troops and other associated themes around the world, and unofficial war artists like Eric Taylor, who painted the war itself from the Normandy beaches to the horrors of the Belsen Concentration Camp.

Perhaps the most interesting thing of all is the tenacity and dedication of artists who sketched, painted and penned verse, while civilization collapsed around them. For it was men such as these who returned colour and light to the world once the madness was finally over.

<div align="right">Henry Buckton</div>

ACKNOWLEDGEMENTS

All articles published in this book are original works, written specifically for this publication, with the exception of the following extracts, for which acknowledgement is duly given:

Thanks to Ralph Hammond Innes for letting me reproduce an article, written for *The Royal British Legion Golden Book of Remembrance* by Henry Buckton, published by Ashford Buchan and Enright: copyright Ralph Hammond Innes.

Thanks to David Langdon for his permission to reproduce his article from *High Flyers* published by Lionel Leventhal Limited for Greenhill Books: copyright David Langdon.

Thanks also to John Prebble for his letter 'Along the Maas', taken from *Landscapes and Memories: An intermittent Autobiography*, published by Harper Collins: copyright John Prebble.

Thanks to Richard Seddon who used extracts from his autobiography in his article, *A Hand Uplifted*, published by Frederick Muller Ltd: copyright Richard Seddon.

Thanks to Laurence Whistler whose article about his brother Rex Whistler uses extracts from his biography *The Laughter and the Urn*, published by Weidenfeld and Nicolson: copyright Laurence Whistler.

Thanks to David Gear for his help in preparing the article about his late father William Gear RA.

Thanks also to Robert A. Strand whose article was originally written for the Queen's regimental journal: copyright Robert A. Strand.

Thanks to Margo Ewart for allowing the reproduction of the following poems, written by her late husband Gavin Ewart: 'Only The Long Bones' from *Poems from Putney*; 'War Death in a Low Key,'

'A Murder and a Suicide in Wartime,' and 'A Piece of Cake,' from *Collected Poems 1980–1990*; and 'War-Time' from *Selected Poems 1933–1993*: all poems copyright Margo Ewart and reproduced with her kind permission.

Finally, a special thanks to David Shepherd for writing the Foreword.

Chapter One

ARCHITECTS OF VICTORY

In this chapter you will be reading the stories of some of the best-known architects and town planners who served in uniform during the Second World War.

Understandably, the majority of practising architects and students of architecture found their way into the ranks of the Royal Engineers, and since the end of the war many of these ex-sappers have been involved with important architectural programmes.

Sappers were responsible for all types of field construction, from pontoon bridges to sophisticated field defences. Officers and other ranks were, where possible, experienced engineers or skilled artisans, with architects being a coveted bonus for the regiment, who afforded such individuals a certain amount of professional satisfaction. In fact students of architecture were often able to design and oversee the construction of significant projects at an age when, in civilian life, they would normally be an insignificant junior. There was also scope in the regiment for surveying, map intelligence and aerial photography.

Among our better known architects who served with the Royal Engineers were Alexander Campbell, Edwin Maxwell Fry, Sir Alex Gordon, Sir Stirrat Johnson-Marshall, Archibald Jury, Sir Denys Lasdun, Robin Seifert and Reginald Uren. Cyril Lemmon served with the Royal Indian Engineers and eventually became Director of Civil Camouflage in India. Architect sapper Dennis Lennon was mentioned in despatches and won the Military Cross in 1942. A high percentage of other architects, such as Peter Bartlett, Robert Goodden, Alan Irvine, John Kitchin and Leonard Manasseh found

suitable employment in branches of the Royal Air Force or the Royal Navy.

One of the most respected figures in British architecture, Sir Hugh Casson, had a varied war, although in a more civilian capacity than the contributors to this book. However, his architectural skills were still utilized by the war effort and therefore worthy of note. Sir Hugh says of his wartime experience, 'My National Service did not involve weapons. At wartime I joined the National Fire Service River Division in London – the only time I saw action was when the roof of the fire station caught fire. I served until 1940 and was then extracted by the Air Ministry to join a small camouflage unit until 1943 and was in charge of all AM properties – aerodromes, bomb dumps and camps in the Midlands. I was then extracted to the Ministry of Housing to assist in the design and placing of post-war temporary housing. I then returned to private practise in architecture in London. No dramas or heroism, I fear.'

The three architects who recount their stories in this chapter, Bruce Allsopp, Martyn Beckett and Edward Hollamby, followed very different military careers. Edward Hollamby, who became chief architect for the London Docklands Development Scheme, adhered to the above principle, employed by the Royal Marines Engineers, and was therefore able to use some of his architectural training and skills. Bruce Allsopp, on the other hand, although serving with the Royal Engineers for much of the war, had initially served with the Royal Artillery, hoping to use his knowledge and experience with their Survey organization.

The reader will soon discover that a high percentage of the contributors to this book, whether they are painters, sculptors, designers, writers or architects, also served in the Royal Artillery. There was nothing unusual about this, as by 1945 one out of every four soldiers in the British Army was employed by one of the various artillery regiments, and the RA had grown to roughly the same size as the Royal Navy. In fact it became a policy later in the war to strengthen infantry units which had been decimated through combat with surplus gunners. However, having said that, most of our contributors were able to use their relevant artistic skills in a range of different activities with the Royal Artillery.

The motto of the Royal Artillery, 'Ubique', means 'everywhere', and the artists and writers who recount their experiences in this book

certainly lived up to it. The 800,000 men and women who served as gunners worked with three distinct types of unit: Field Army Artillery, Anti-Aircraft and Coastal Artillery.

The different branches of the Royal Artillery demanded different qualities from their personnel, and creativity was often recognized and put to relevant use.

Sir Martyn Beckett, unlike Bruce Allsopp and Edward Hollamby, served as a front-line soldier with the Welsh Guards. It was unusual for young men with an artistic eye to join a regiment of Foot Guards, yet the Welsh Guards could not only boast the likes of Martyn Beckett, but the accomplished painters Simon Elwes and Rex Whistler. Other artists who became guardsmen include the painter Algernon Asprey and the stained glass window designer Patrick Reyntiens, both of whom served in the Scots Guards; photographer Iain Maxwell Erskine in the Grenadier Guards; and architect Donald Insall in the Coldstream Guards.

Film producer, designer and dramatist John Hawkesworth, who also served in the Grenadier Guards, recounts some of his own experiences later in the book.

BRUCE ALLSOPP FSA
(Painter, Author and Architectural Historian)

Bruce Allsopp's military career is a particularly good place to start our investigations for a couple of reasons. First, because his artistic career was varied and difficult to categorize, and, secondly, because he served in both the Royal Artillery and the Royal Engineers. After serving as a Gunner for a short time, working with their survey units, he was transferred to the Royal Engineers, who had their own survey organization. With one such unit, Bruce Allsopp had intended to follow the war, which took him through North Africa and Italy with the 8th Army – but, as it turned out, not as a surveyor.

Better known as an artist and author, Bruce Allsopp began his career in architecture in 1933, after graduating from the Liverpool School of Architecture with First Class Honours. He went on to lecture in the subject at the Leeds College of Art, the University of Durham and the University of Newcastle-upon-Tyne, where he was director of Architectural Studies between 1965–1969, and senior lecturer, then reader in the History of Architecture, until 1973.

He has also been the chairman of various bodies including the Society of Architectural Historians of Great Britain and the Independent Publishers Guild. He has been a Master of the Art Workers' Guild and president of the Federation of Northern Art Societies. Until 1987 he was chairman of the Oriel Press.

Bruce Allsopp has presented a number of television films and published numerous books on the subject of Art and Architecture, including *Art and the Nature of Architecture, A History of Renaissance Architecture, The Country Life Companion to British and European Architecture* and *The Great Tradition of Western Architecture.* Under his own name and using the pseudonym Simon

Grindle, he has also written many novels, among them *The Naked Flame, To Kill a King, Return of the Pagan, The Loving Limpet* and *Blow up the Ark*.

In 1940 he was lecturing at the Leeds College of Art, when he felt compelled to volunteer for the newly formed Air Sea Rescue Service. However, things didn't go exactly as planned and the next five years presented a mixture of influences on his various artistic aspirations. Bruce Allsopp writes:

> I volunteered at the time of Dunkirk and, in response to a radio appeal for people with experience of small boats to join the Air Sea Rescue Service. I went to the recruiting office, but they knew nothing about it and I emerged, having taken a day's pay, with a posting to 41st Survey Training Regiment Royal Artillery at Brighton: a foretaste of the quirky vicissitudes of wartime military life! From Brighton I went to the School of Survey at Larkhill on Salisbury Plain and thence to the adjacent 122 OCTU (Officer Cadet Training Unit). My military career was to be technical, unambitious and varied, starting with a survey through the Welsh mountains, then checking the bearings of anti-aircraft guns, rockets and latterly the first radio location unit.
>
> I think I became rather bored with Artillery Survey and hoped that by transferring to the Royal Engineers I would become involved in a more creative kind of survey and the making of maps, but it didn't work out that way.
>
> To become a 'sapper' I was posted to Aldershot and the RE Officers' Mess for a crash course in field engineering. The Mess was, and no doubt still is, steeped in proud tradition, heavy furniture, formidable portraits and strict etiquette. You dressed for dinner – or else! The course was quite arduous and involved bridging, demolition with explosives and landmines. I emerged with a posting to an Artisan Works Company at Luton when my experience in the building trade was utilized in my job as site officer i/c the building of an RAF Command HQ in the park of Luton Hoo, but this congenial job came to an end when 724 Artisan Works Company RE had to provide an experienced officer for overseas and I was the only one available. So, from Halifax we went via the old railway line through Rickerton Junction to Glasgow and the Clyde, where we boarded the Union Castle liner *Durban Castle* and went to sea in a large convoy.

But for the ever-present awareness of the possibility of a torpedo, it was a pleasant cruise, taking, I think, three weeks to reach Gibraltar, where we came under the wings of the RAF along the Barbary coast, skirted Algiers and landed at Philippeville. I had learnt to play bridge and started to write a novel on the ship.

The reinforcement depot at Philippeville was a tented camp in a cork oak forest, half a mile from a bathing beach. We had been left behind by the victorious First Army whose achievement, including Americans under Eisenhower, has been largely eclipsed by Montgomery's campaign from Alamein. I traversed the terrain between Philippeville and Tunis four times, once as a draft conducting officer and OC train with a squad of anti-tank gunners whom I was to deliver to First Airborne Division at Kairouan. The French train consisted of cattle trucks and took us to Tunis from where there was no organized transport to Sousse so we hitch-hiked on the metre-gauge railway in open trucks, along with miscellaneous machinery, and then phoned for transport to divisional headquarters. When I eventually got back to Tunis I was able to take the very comfortable Rapide back to Philippeville. From there I was offered a posting as admin officer to 137 Mechanical Equipment Company RE at Hammamlif, while Eighth and First Army merged and prepared for the invasion of Italy. A tank landing ship of the US Navy took us to Pozzuoli, a place noted in the history of architecture as a source of Roman cement.

The role of the engineers in the Italian campaign was significant because from Naples up to Florence the country is crossed by many rivers and demolished bridges had to be replaced. The role of bull-dozers was extremely important in making approaches to fords or to new bridges which would allow the tanks to go ahead. It was a largely mobile war except for the hold-up at Cassino which, including the famous monastery, was completely destroyed. (Note 1)

Back in Naples 137 Mechanical Company RE took machinery and civilian personnel from the Alfa Romeo factory and set to work to make various kinds of equipment and especially piston rings for Albion tank transporters. These were turned from cast iron water pipes, just one interesting example of the versatility of the sappers. Whereas in other arms many things are done to a drill, the sappers are presented with innumerable problems which often require thought and improvisation. While we were in the vicinity of

Naples I was told to form and lead a mechanical spare parts section which would go forward with much-needed spares mainly for bulldozers along the Eighth Army front. North of Rome, Eighth Army was moved as secretly as possible to the other side of Italy and we went on to a final assault across the River Po (Note 2), after which I was sent back to Bari to take charge of the base spares depot.

After a long spell in hospital I was promoted to Captain and the staff of GHQ in the former Royal Palace of the kings of Naples, but I found this taste of military bureaucracy uncongenial and asked to return to regimental duties. Following VE Day this included command of a complete German engineer company which worked as efficiently for me as, no doubt, it had done on the other side. After the insanity of the war years we were back to a normal human relationship. In this job my demobilization from the army was deferred because I was considered to be operationally vital, which I thought was incredible, and the delay in getting back to civilian life was distressing.

During the war years I had tried to be a good soldier and the creative side of my mind as an artist had been numb. I emerged into the utilitarian bleakness of postwar 'civvy street' with very wide experience of people and places, which I certainly would not have had if I had remained a lecturer at Leeds College of Art instead of joining the army. I think this has affected my writing both of fiction and of history, especially the latter, because it awakened me to the utter stupidity of warfare and a distrust of the conventional teaching of history as a succession of struggles for power and the glorification of war. In retrospect I was deeply affected by the prolonged and solitary experience of Stonehenge, near Larkhill, and its mystical fascination. This has led me to experience other megalithic monuments from Mycenae and Delos to Carnac, Castle Rigg, Cairn Holy and ultimately the splendour of Callanish – a kind of pre-Christian pilgrimage.

I kept a paintbox and sketch book with me throughout the war but was rarely moved to use them and I do not think war service had any positive effect on my work as a painter. Musically it was a disaster: not that I had any talent or aspiration to be a professional musician but six years away from the piano proved to be a permanent frustration of my very limited talent as a pianist.

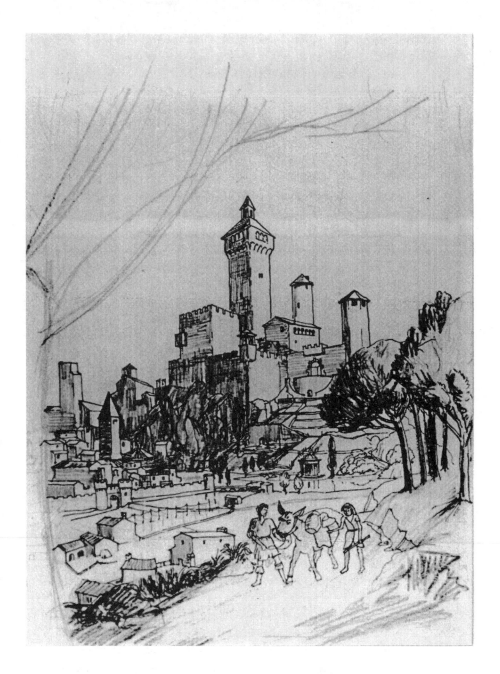

Drawing of an Italian Castle made by Bruce Allsopp, and used as a study
for an illustration in his novel 'Cecillia.'
(*Reproduced with the permission of Bruce Allsopp*)

Demobilization was a strange experience for a soldier because civilians had sometimes been in far greater danger than some of us. There was a 'hero's welcome' for troop trains passing through Lausanne but it was not like that in Britain – a rigorous examination by Customs officers at Folkestone, and when I got home and went to an off licence to buy a bottle of beer, I was told that I could only have it if I returned an empty bottle!

In retrospect the assignment to write this article stirs a myriad of memories, pleasant and unpleasant, and I have vivid pictures in my mind of scenery and people – the potentially idyllic rocky cover at Philippeville, the pretentious little seaside villas of the French, the Arab market stalls with intricate jewellery made from old tin cans, not to mention fresh dates stuffed with cream and covered with flies, the occupational tasks which were invented by somebody 'up there' to discourage boredom. One such which came my way was to take a squad to a place called Jemappes to restore an alleged RAF camp which, in fact, when I got there had been completely removed by the Arabs. I reported back and was told to build a field kitchen and deep trench latrines, but the site was, in fact, solid rock. I reported this and was told there will be deep trench latrines so I asked for gelignite and detonators and produced what was required.

I was fetched to my new posting by a corporal and driver in a utility and I still have a very vivid impression of the journey through what was once the granary of Ancient Rome but was now very sparsely cultivated and there was no sign of a great army having passed that way only a few months before. This savage terrain, with distant views of the saurian-like Atlas mountains combined with my knowledge of the history of Barbary, has remained vividly with me and is embodied in an unpublished novel.

Tunis is a beautiful French-style city with an ornate opera house and an avenue which echoes the Champs-Elysées. Unfortunately, it was littered with slit trenches, into one of which I fell after dark and acquired a grazed knee which developed into a desert sore, as they were called, and took a great deal of healing, which was eventually achieved by the newly available drug, sulphanilamide.

Over in Italy we were parked for a night at Afragola and saw mothers sitting on doorsteps picking lice out of their daughters' hair, but the really dangerous lice were not head nits, and one of the unsung achievements of the British Army in which my company was

'intimately' involved was the disinfesting of pubic lice of the whole population of Naples – thus arresting the onset of the plague typhus. On the south side of Cassino I visited my brother's artillery regiment. He was a captain in the 78th division which had taken a great deal of punishment all the way from Alamein and I think they were extremely tired. He was killed a few weeks later when the Germans tried briefly to halt, or delay, their retreat south of Rome. Rome itself was spared but the road to the north was littered with burnt-out trucks and equipment and made one vividly aware of what it was like to suffer from the allied total air superiority. This was the reverse, a retribution one might almost say, for what had happened in Flanders and northern France in 1940, reports of which on radio and in the press had made me join the army.

NOTES:

(1) Monte Cassino was one of the fiercest battles of the entire war. The advancing Allied armies faced the German 1st Parachute Division, commanded by Lieutenant-General Richard Heidrich. The Allies, believing that the abbey of Monte Cassino was being used by the Germans as their military headquarters and stronghold, bombed the site on 15 February, 1944, dropping 453 tons of high explosive, and reducing the historic buildings to rubble. In actual fact, at the time of the bombing, the only Germans who occupied the monastery were two military policemen, who were there to afford it whatever protection they could.

(2) On 20 April, 1945, the German army retreated to the River Po, which forms a natural barrier across the north of Italy. All bridges across the river had either been totally destroyed or were completely blocked by burnt-out armour. The 5th Army, the 6th South African Division and the 8th Army completed a pincer, which cost the Germans 67,000 casualties, 35,000 prisoners and most of their equipment. The German commander, General von Senger, managed to cross the Po with some of his army, but after the Royal Engineers had helped to bridge the river, the war in Italy was all but over. The remaining German and Italian troops, almost a million men, surrendered unconditionally on 2 May, 1945.

SIR MARTYN BECKETT MC BA RIBA
(ARCHITECT AND PAINTER)

Sir Martyn Beckett is one of the leading British architects to emerge since the end of the Second World War. Educated at Eton and Trinity College, Cambridge, he enlisted in the Green Howards in 1939, completing most of his war service with the Welsh Guards. He is also an accomplished painter of watercolours and he has held several one-man shows. His work has been exhibited at the Royal Academy.

After qualifying in 1952 he spent much of his early career reconstructing and renovating listed buildings and country houses, at the same time working on several projects in the community: hotels, libraries and housing estates, etc.

In 1960 he was appointed Architect to King's College Chapel, Cambridge, where he made extensive internal renovations. He has also been consultant architect to Gordonstoun, the Savoy Hotel Group, Temple Bar Trust, Charterhouse and Eton College. He has been trustee and chairman of the Wallace Collection, trustee of the British Museum, chairman of the Yorkshire Regional Committee of the National Trust, a member of the North Yorkshire Moors National Park Committee, president of the Friends of York Art Gallery, a member of the council of management of the Chatsworth House Trust and a Freeman of the City of London.

Sir Martyn Beckett served during some of the most important campaigns of the allied victory, after landing in France shortly after D-Day with the Guards Armoured Division. Before the war had finished, he had accompanied the Welsh Guards on its now famous thrust towards Arnhem in 1944, to relieve General Urquhart's 1st Airborne Division. After Arnhem he also took part in the successful

crossing of the Rhine in March, 1945. For his actions during the advance to the Rhine – just inside Germany itself – he was awarded the Military Cross. Sir Martyn writes:

I joined the 7th Battalion Green Howards as a Private in October, 1939; they were stationed at Bridlington. I was with them until April, 1940, when I went to Sandhurst as an Officer Cadet. The Green Howards went to France at the same time and were badly cut up at Dunkirk. I was commissioned to the 2nd Battalion Welsh Guards who were part of the 20th Guards Brigade – the only fully equipped Brigade defending London. We did endless exercises in buses by day and night, attacking aerodromes, supposedly captured by the Germans. In 1941 the Guards Armoured Division was formed and I became a tank officer in the Welsh Guards. (Note 1)

The Guards Armoured Division was part of the Army's mechanized programme after Dunkirk and the German Army's spectacular victory in France, principally with a mechanized Blitzkrieg. The cavalry regiments had already become mechanized and I imagine it was thought that the Guards would more easily adapt to mechanization than the line regiments. In the 2nd Battalion Welsh Guards we took to the change with great enthusiasm, officers doing a 3-month armoured course at Sandhurst.

We trained on Salisbury Plain with Covenanters and Crusaders, eventually getting the Cromwell tank, which was an improvement on previous models, but still a long way behind in armament with the German Tiger and Panther tanks. After exercises on the Yorkshire wolds we went over to Normandy on D+12 as a 'follow-up' Division. In our first battle near Caen, 30 Corps lost over 200 tanks in one day to the dreaded 88mm anti-tank gun, and we also lost Rex Whistler as our first battle casualty.

Not only was Rex an exceptional artist and stage designer, but also a life-enhancer and companion. When the war started he could have applied to become a war artist, but he said he would rather join a fighting battalion. He joined the Welsh Guards in 1940. Wherever we were stationed Rex left his mark – a dreary Nissen Hut for the Officers Mess was transformed in a few days into a pleasure dome – walls painted with 'trompe-l'oeil' of Squadron Leaders in Roman Consular togas and wreaths, against an Arcadian background. He even covered

the inside of his tank with Disney animals. Officers and other ranks fell under his spell.

One further memory of Rex was a D&M course (Driving and Maintainance) we went on together. The Sergeant Instructor lectured us on the epicyclic gear box which was of such complexity that he drew a cartoon of the Sergeant going mad with wheels, springs and ratchets, all twisted round him in hopeless confusion, which made the whole course very entertaining and bearable.

Rex was killed in the battle of Caen, when three Armoured Divisions were meant to break out of the Normandy bridgehead and divert German armour from the American sector. The 11th Armoured Division led the attack through a minefield, followed by the Guards Armoured Division, and lastly the 7th Armoured Division. The 11th Armoured were held up by 88mm guns, dug in and well camouflaged, and consequently lost 100 tanks. The Guards Armoured Division lost fifty tanks and the attack was called off. Rex was killed by a mortar bomb which fell at his feet when he got out of his tank to investigate his sergeant's tank, which had got stuck.

My battalion was the first into Brussels, an experience never to be forgotten, and, after some heavy fighting on the Albert and Escaut canals, we spearheaded the 2nd Army in its effort to reach the British Airborne Division at Arnhem (Note 2). This is a sad episode, much described in many books. I was promoted to Captain, commanding the Reconnaissance Squadron of twelve tanks, and we had a tough task fighting our way to the Rhine. After the crossing I was instructed by the Divisional Commander, General Alan Adair, to return to England and pick up six prototype Centurion tanks and try them out in action. They were to be the answer to the Tiger tank. Mercifully the war ended before this could take place, and I spent the next three months, with a mixed contingent from other Guards regiments, visiting several armoured battalions in BAOR [British Army of the Rhine] to report their view on the new tank to the war office. The Centurion became the main battle tank in the Israeli wars of the 50's and was the ancestor of the Challenger 2 – now the most formidable battle tank in the world.

I was demobbed in 1946 and started my career as a student of architecture, qualifying as an ARIBA in 1952.

NOTES:

(1) During the Second World War one of the most dramatic changes to affect the organization of the Foot Guards, which had traditionally been infantry soldiers, was the decision to convert certain infantry units into tank battalions. Consequently, in September, 1941, artists Rex Whistler and Martyn Beckett, suddenly became tank commanders in the newly formed Guards Armoured Division, which they accompanied to France in 1944. Guardsmen at this time also featured in other specialist formations, particularly Commando and Airborne operations.

The 2nd (Armoured) Battalion Welsh Guards was initially equipped with Cruiser Tanks Mark V, which had previously belonged to the Royal Tank Regiment. Between 5 September and 31 December, 1941, while stationed at Codford, the Battalion received thirty tanks, upgrading to Covenanter IIIs in March, 1942.

(2) General Urquhart's 1st Airborne Division had dropped into Arnhem at the start of 'Operation Market Garden' in September, 1944. His task was to capture and hold the bridge over the Rhine. Unfortunately, the plan went horribly wrong and the Guards Armoured Division was delayed through enemy action and the unsuitability of the roads. At Arnhem itself, the British troops were pitted against a crack Panzer Corps. Consequently, of the 9,000 paratroops which had gone into Arnhem, only 2,000 men returned across the river. There is a fine painting by David Shepherd, who kindly wrote the foreword to this book, that shows the intensity of the fighting around Arnhem Bridge on the second day of the battle.

EDWARD HOLLAMBY OBE FRIBA FRTPI Dip.TP (Lon) FCSD Hon.ALI FRSA

(ARCHITECT AND TOWN PLANNER)

One of the most impressive and influential restoration and land development schemes of the late twentieth century, the London Docklands, was largely designed by Edward Hollamby, who was chief architect and planner to the London Docklands Development Corporation between 1981-85.

Educated at the Hammersmith School of Building & Arts & Crafts, and University College, London, he served during the war with the Royal Marine Engineers. After the war he became a senior architect with London County Council, and, following the London government re-organization, became the first Borough Architect for the London Borough of Lambeth, and then, when the new London Borough received its planning powers, Director of Architecture and Planning. He has worked on a wide range of projects, including schools, housing estates, conservation and historic building restoration, parks and open spaces, sheltered housing, old people's homes, health centres, doctors' GP practices, community centres, and commercial and civic offices, some notable examples being Christopher Wren and North Hammersmith Secondary Schools, housing at Elephant and Castle and Central Hill, Crystal Palace, the study for Erith Township in Kent, which was used as a prototype study for Thamesmead, and the Lambeth Borough Council Brixton Town Centre Development Plan.

His extensive work in the London Dockland area has included an Urban Design Guide for the Isle of Dogs in 1982, development strategies for Limehouse, Surrey and Greenland Docks, Bermondsey and Wapping 1982-83, the Royal Docks Development Strategy,

1984, and the overall layouts for, among others, Western Dock Wapping, Greenland and Surrey Docks, Southwark, London Bridge City, and Shadwell Basin. He was also chairman of the design group for the Docklands Light Railway. His numerous publications include *Docklands Heritage: Conservation and Regeneration in Docklands*, published in 1987.

During the Second World War Edward Hollamby served with the Royal Marine Engineers, largely in Ceylon. His unit arrived at the Trincomalee Naval Base, shortly after the loss of HMS *Prince of Wales* and *Repulse*. His job was to help design and build defences around the base and fleet, and in this capacity he was able to utilize his architectural training and experience in a professional capacity.

From the relative safety of Ceylon, Edward Hollamby was able to observe the historic events taking place in South East Asia, as he now describes.

September, 1939, found me studying architecture at the School of Building & Arts & Crafts, at Hammersmith – where May Morris, the daughter of William Morris, taught in the early thirties. The war disrupted my studies, and after a month or two, the course closed, though I continued to attend some of the art classes.

In March, 1940, I went up to Liverpool, where the Kirkby Royal Ordnance factory was being built, producing detailed construction drawings on site.

I also prepared sketches of the surrounding countryside, with specific objects distance dimensioned; supposedly to aid the defending Home Guard to aim their rifles more accurately. I joined the Home Guard and learned how to fire a Lee Enfield rifle, albeit, like the rest, without any ammunition. 'Called up' for the Royal Marines in August 1941, I was directed to Eastney barracks for basic training, spit and polish, parade ground drill, etc. The history of the Corps and ceremonial were also regarded as important, and we would march out behind the band – the mace bearer throwing his mace over the arch and catching it on the other side – the old ladies waving and crying. We marched round the local streets, then back again, but without band, mace bearer, or old ladies.

In September I was posted to Hayling Island to join the Royal Marine Engineers doing field training as part of the MNBDO [Mobile Naval Base Defence Organization] and later that year to Alton,

Hants, where we had to build an assembly/base camp in the grounds of Bentworth Hall. The winter of 1941–1942 was a particularly harsh one, and almost everyone was under canvas. I was lucky; my drawing office was located in the mansion, and, with a new-found serviceman's cunning, I managed to scrounge another room to live in. It was reasonably furnished, and best of all, had a much-coveted open fire. I suddenly made a lot of friends. Evening visitors included the Chaplain, and on occasion even the Company Commander would drop in for a chat. But it did not last long; the sergeant-major found out and I was banished to the harsher comforts of a Nissen hut.

One bright day in early March we moved off to an undisclosed destination – though we all knew it was to be the Far East. A long and seemingly directionless rail journey eventually landed up in Liverpool, in a stinkingly dirty warehouse in the docks, where we were kitted up with tropical gear. The conditions in the warehouse were so foul that we were allowed to board our transit vessel earlier than planned. It was a modern liner, the *Cape Town Castle*, and although it had to find room for a large number of troops from all three services – conversion work was in fact going on all round us when we boarded – conditions were better than might have been expected. The little armament the ship possessed was manned by the Navy and us Marines. I was part of the multiple-rocket-gun team. It was only when we sailed out of the Mersey and into the Irish Sea that we realized the size of the convoy we were to join.

Our voyage which took us out into the Atlantic and south to Africa – midst rumours that the French (Vichy) fleet had put out to intercept – brought us into Freetown. Anchored in the wide river, and besieged by hordes of would-be traders, standing up in danger-ously overloaded canocs, for most of us it was our first experience of the beauty and colourful atmosphere of tropical Africa. Then on round the Cape to Durban. Disembarked, we enjoyed a couple of weeks of further discovery of Africa. Marching through Durban with massive cheering crowds, we experienced the glamour that was the false face of a terrible conflict. Feted by white residents, some of us travelled up the beautiful 'Valley of a Thousand Hills' to a garden party at a place called Kloof. Quenching our thirst with fresh limes out of the garden, who would have believed that bloody battles and humiliating defeats were being experienced by our comrades in the Mediterranean and North Africa?

Resuming our voyage, past Madagascar and up into the Indian Ocean and Arabian Sea – I had never before experienced the vastness of the great oceans and the huge sky above, nor the extraordinary quality of light – this was more like a world cruise, or so it seemed at times. We were even able to enjoy piano concerts, played by the ships 'civvy' pianist. We arrived in teeming Bombay, so different, yet with a familiar architecture. A glimpse of the British in India, with such buildings as Gilbert Scott's university, Alfred Stevens' great Victoria Terminus – shades of St Pancras; George Willet's Gateway to India and Prince of Wales museum – shades of the V&A. My world cruise was embracing the exotic architecture of India and the Empire. But not for long!

At Bombay we RMs transferred to a very different sort of vessel – no world cruise on this one – a former cattle ship. We sailed out into the Indian Ocean, escorted by a tiny sloop. The stench below deck, and heavy seas – we could seldom see the sloop – produced violent sea-sickness in everyone. Weren't we glad to see Colombo harbour!

A few weeks in Colombo, a very civilized city, and we headed north for the great harbour of Trincomalee, naval base of the Far East Fleet (Note 1) – a fleet mourning the loss of two great capital ships, *Prince of Wales* and *Repulse* (Note 2), incredibly, sent out into the Indian Ocean towards Singapore without escort. Malaya had fallen to the Japanese (Note 3) and, with Indonesia shortly to follow, the 'world cruise' had most certainly come to an end. Burma was soon overrun and India itself threatened. Trincomalee was bombed and the battleship *Valiant* was crippled.

Encamped in the grounds of the historic Admiralty House, our task was to provide the infrastructure needed to support and protect the fleet. The possibility – indeed the likelihood – of a Japanese invasion demanded attention as first priority, with suitable exercises, but after a reported approach by a Japanese fleet did not materialize our work turned to building up the naval base for the assembly of the fleet as a major task force.

I worked with a couple of civilian engineers and an Indian draughtsman designing all sorts of structures including Anti-Submarine and Control Mine bases. I designed an Officers' Mess, which is still used by the Sri Lankan Navy.

The focus of the war shifted to Burma and the Arakan, and life settled down to a routine. I was promoted – to corporal. It became possible to visit historic places such as the Great Dagoba and the rock

carvings at Anuraghapura, and the sculptures at Polonarua. Kandy, the former capital of the Sinhalese kings, exemplified the splendour of Sinhalese Buddhist architecture and town planning in the great lake, palaces and temples such as the Dalada Maligawa or temple of the Sacred Tooth of the Buddha. Similar qualities of civic planning could be seen in the gracious sweep of the Esplanade in Colombo, with the lake and distant view of Adam's Peak.

The countryside was also staggeringly beautiful – from the green jungles of the north and the coastal scenery of coconut palm to succeeding levels of plantations. Stepped paddy (rice) fields following the contours, then rubber, tea – all man-made – then on toward the open highlands above Kandy to Nowara Eliya. Much of this is best experienced by railway, from hot, humid Polgahawela up to cool Kandy.

It was on a superb hillside site, overlooking the lake at Kandy that I saw and photographed a fine modern movement house, having seen others in Colombo. Who designed them? It was only after returning to the UK that I was introduced to Andrew Boyd who turned out to have been the designer, a chance meeting that brought about a friendship and architectural collaboration for many years until his untimely death in 1962.

At Trinco we were receiving *SEAC News*, South East Asia Command's forces newspaper, edited by Frank Owen, and through this I got to know of the existence of a body of architects serving in India. It had been founded by Percy, later Professor, Johnson Marshall. I wrote to him, we corresponded, and I set up a similar body, ASAC, Association of Service Architects of Ceylon. Later on, at the London County Council, where we both worked after the war, I was to meet Percy, and another friendship was born.

Much influenced by *SEAC News*, forces in the area were being encouraged to facilitate discussion and debate on a wide range of social, political and cultural matters. Lt (Jock) White was our education officer and I was his assistant. We held a regular programme of extraordinarily well-attended lectures, discussions and debates – even poetry reading – and a regular 'wall newspaper', which I edited. We also made up visual displays on such subjects as current affairs and post-war reconstruction. Incredibly, I regularly received my copies of the *Architectural Review* – courtesy of the Royal Navy.

An unusual commission came my way. The Bishop of Colombo was deeply concerned with the steep rise of prostitution in the island

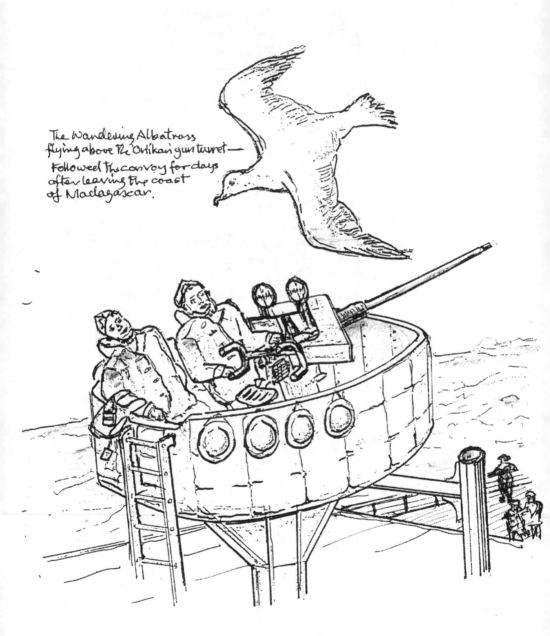

The Wandering Albatross
flying above the Orlikan gun turret —
followed the convoy for days
after leaving the coast
of Madagascar.

A drawing made by Edward Hollamby, from his journey to the
Far East, which shows an Albatross that followed the convoy
after leaving the coast of Madagascar.
(*Reproduced with the permission of Edward Hollamby*)

and launched a campaign among the forces to combat it. I was asked to design a poster illustrating the dangers of VD. I was required to produce a full-size mock-up of the poster for approval and subsequent printing. I decided to make a feature of an alluring young native girl in the background, with a recognizable image, taken from page three of the *Daily Mirror* in the foreground. But I needed a model. She was duly supplied in the form of an attractive young Tamil girl, accompanied by a chaperone. She was an excellent model, so quiet and still, and curiously dignified.

I designed firing range structures, and, as I was Assistant Education Officer, I was responsible for weekly displays on current affairs, which were displayed on boards in the canteen. I also designed a 'Paracart' (parachute and bicycle) which was made up in HMS *Maidstone*'s workshops: it was intended to be used for jungle raids, dropped from the air.

Towards the end of 1944 we left Trincomalee. After some weeks of training exercises in swampy riverine conditions, we got orders to move. Where were we going? At Colombo we boarded the *Christian Huygen*, a fast, modern MV, bound, as we learned to our joy, for the UK. Back across the Indian Ocean, but this time up into the Red Sea, and through the Suez Canal. Christmas Day was spent in Suez. Out into the Mediterranean to join up with a great convoy of ships from all over. Through the Med in a great storm – waves towering over the ship. And then the great stern coming out of the water. All decks out of bounds, except to me as NCO ship's police. The exhilaration of defying the elements was unbelievably exciting. By contrast, as we left the convoy, using our speed up St George's Channel, past Anglesey, on a morning of clear skies, calm seas and brilliant clarity of light, I could clearly see the sheep grazing in the fields. We were returning to Liverpool, the city we had left nearly three years earlier. It all seemed strangely symbolic.

After spells of duty at a number of RN establishments including Lewisham in SE London, supervising emergency repairs to houses damaged by V2s, I finally got a posting to Exmouth, where I was demobbed, shortly after the birth of my daughter, Marsha, in January, 1946.

Then back to studies at home and evening school at Hammersmith once again, and preparation for that post-war reconstruction I had lectured about in Trincomalee.

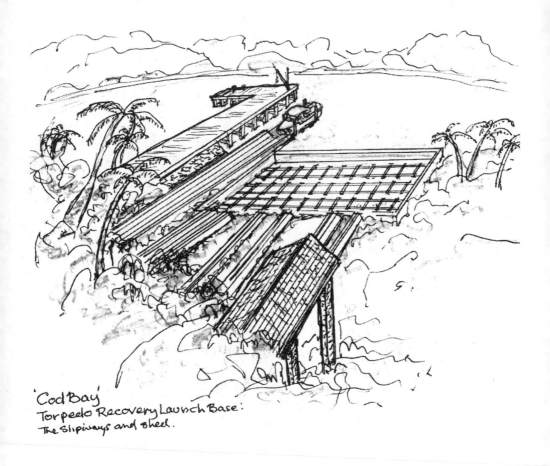

'Cod Bay'
Torpedo Recovery Launch Base:
The Slipways and shed.

Edward Hollamby's sketch of the Torpedo Recovery Launch Base,
the slipways and shed at Cod Bay, which he worked on as a
Royal Marines Engineer.
(*Reproduced with the permission of Edward Hollamby*)

NOTES:

(1) Trincomalee was the main base for the British Far East Fleet, situated on the east coast of the island of Ceylon, north of Kandy. Although the Japanese bombed Ceylon at regular intervals, including the naval base at Trincomalee, they never invaded the country. It therefore remained extremely important to the British, at a time when the rest of South East Asia fell beneath the Japanese onslaught. In December, 1941, the British Far East Fleet consisted of two battleships and two battle cruisers, one heavy cruiser, seven light cruisers, and thirteen destroyers: no aircraft carriers or submarines. The Japanese, on the other hand, had eleven battleships and battle cruisers, including the *Yamato* the largest battleship ever built, with nine 18.1-inch guns, eleven aircraft carriers, eighteen heavy cruisers, twenty-three light cruisers, one hundred and twenty-nine destroyers, and sixty-seven submarines.

(2) In December, 1941, Admiral Sir Tom Phillips had sailed north from Singapore with several ships including the battleship *Prince of Wales* and battle cruiser *Repulse*. His intention was to seek out and destroy the Japanese amphibious armada which was supporting the invasion of Malaya. After a fruitless search, Phillips turned south along the Malayan coast. Japanese aircraft from bases in southern Indo-China attacked his ships and the two great vessels were sunk with horrendous loss of life. The final attack was made on 10 December, some 322 kilometres north-east of Singapore. Phillips had already been informed that the RAF were unable to provide his ships with fighter cover, leaving him almost defenceless, against fifty-two torpedo planes, thirty-four bombers and eleven reconnaissance aircraft, which had been sent from Saigon by Rear-Admiral Matsunga. 840 officers and men lost their lives during the attack. HMS *Prince of Wales* was the Royal Navy's newest battleship, which only a month before had been used by Winston Churchill for a meeting with President Roosevelt at which the Atlantic Charter was signed. HMS *Prince of Wales* and *Repulse* had been key factors in the defence of Malaya and Singapore. Their loss was a significant blow to British forces in the Far East.

(3) In January, 1942, the last remaining British troops on the Malayan Peninsula, commanded by Lieutenant-General A.E. Percival, were completely infiltrated and outflanked by the Japanese, supported by overwhelming air power. The British were beaten back to the Johore Line, just north of Singapore and by 31 January they had evacuated Malaya, crossing

the Strait of Johore to Singapore. The strait was only a mile wide and bridged by a narrow causeway which the British destroyed after they had crossed it. Singapore was now an island and considered to be impregnable. During February, however, and after a sustained air bombardment, the Japanese, commanded by General Tomoyuki Yamashita, began to cross the strait in force, having repaired the causeway. The British garrison surrendered unconditionally on 15 February, 1942. The campaign had cost the Japanese 3,507 dead and 6,150 wounded. The Allies lost 9,000 dead, and 130,000 troops were about to suffer appalling inhumanities as prisoners of war.

Chapter Two

A BRUSH WITH THE ENEMY

This chapter is devoted to leading painters who served in the armed forces during the Second World War. All three services are represented, the army by Anthony Eyton who served with the Cameronians, and A. Stewart Mackay who served with the Royal Artillery and Pioneer Corps, the Royal Navy by Arthur Hackney and the RAF by Claude Harrison.

Other painters who served in the Army include William Brooker and Ian Jenkin, who served in the Royal Artillery; Sir William Coldstream, Dennis Flanders, Colin Hayes, Charles McCall, John Ward and Ronald Searle in the Royal Engineers; William Baillie in the Royal Corps of Signals; Aubrey Davidson-Houston in the Royal Sussex Regiment; Sir Roger de Grey in the Royal West Kent Yeomanry; Frederick Gore in the Middlesex Regiment and the Royal Artillery; Edward Middleditch in the Middlesex Regiment; Louis Osman in the Intelligence Corps; Denis Peploe in the Royal Artillery and Intelligence Corps; Sir Robert Philipson in the King's Own Scottish Borderers. Bill Ward, another famous painter, who served in the King's Own Yorkshire Light Infantry and the Royal Welch Fusiliers, tells his own story in a future chapter, which looks at the military service of illustrative artists.

Worthy of a special mention is Terence Cuneo who died in 1996. Although a master artist of steam railways, Terence Cuneo was well known for painting epic war scenes and other military subjects. His canvases include 'The Opening of the Minefields at the Battle of El Alamein in 1942,' which is an atmospheric study of British soldiers in mine-detecting equipment under heavy bombardment, heroically marking a path through the German minefields, wide enough for

25

Montgomery's Eighth Army tanks to break through. 'D-Day' is a spectacular study of British troops and small armoured vehicles storming out of landing craft on to one of the Normandy beaches in the British sector on 6 June, 1944. Another painting depicts Lance-Sergeant J.D. Baskeyfield of the South Staffordshire Regiment manning a 6pr anti-tank gun at Oosterbeek on 20 September, 1944, for which he was awarded a posthumous VC, one of only four Victoria Crosses earned during the Battle of Arnhem. 'The Battle of the Tennis Court at Kohima' is a poignant study of hand-to-hand combat against Japanese troops over a carpet of bodies.

Well-known painters who served in the Royal Navy include Harry Eccleston, Michael Ffolkes, Patrick George, Tristram Hillier and Ruari McLean. Lucian Freud served with the Merchant Navy, which was often termed the 'fourth' service during the war because the officers and men who served in her ranks were subjected to the same dangers as the Royal Navy, especially during the Battle of the Atlantic, when they bravely maintained our supply links with the rest of the free world.

Of particular note is Sir Peter Scott, the son of Robert Falcon Scott, the British explorer who died in 1912 while attempting to cross the Antarctic. Sir Peter was an accomplished painter of wildlife subjects, particularly birds, and was the founder of the Wildfowl and Wetlands Trust at Slimbridge. During the war he served in destroyers during the Battle of the Atlantic and with Light Coastal Forces in the English Channel. He was mentioned in despatches on no less than three occasions and was awarded the Distinguished Service Cross and bar.

Like Claude Harrison, whose story you will read in a moment, a number of painters made their way into the RAF, notably Sir Brian Batsford, Wilfred Fairclough, Edward Hall, Edward Halliday, John Leigh-Pemberton, George Mackie, Keith Shackleton and Norman Hoad.

CLAUDE HARRISON Hon.RP ARCA
(Painter)

Claude Harrison was at Preston College of Art in 1939 and remained both there and at Liverpool College of Art until 1942, when he joined the Royal Air Force.

In the Far East Claude Harrison was a member of two small radar units which went into Burma with the Indian Army and were supplied and generally serviced by them on the Arakan, and with them took part in the seaborne invasion of Rangoon in southern Burma.

Immediately after the war Claude Harrison was sent to Hong Kong to establish an art department at St Joseph's College, after being transferred to the Armed Forces Education System.

Back in England, Claude Harrison studied at the Royal College of Art until 1950. He is known as a painter of murals, portraits, conversation pieces and imaginative figure compositions. He told me that the addition of the Hon to his RP was because he was a member of the Royal Society of Portrait Painters for many years, but finally wished to do no more, in order to concentrate on more personal works, so they made him an Hon member.

He has exhibited with the RA and RSPP, among others, and held numerous one-man shows in London, Italy, the USA, Holland and elsewhere. He lives and works in the inspirational surroundings of the Lake District, with his wife the painter Audrey Johnson, and has written a number of books, including *The Portrait Painter's Handbook* and *The Book of Tobit*, which was published in aid of UNICEF.

It has been stated that the work of Claude Harrison 'exudes mystical value' and that 'his bizarre theatrical themes incite irresistible impulses in the viewer to give his imagination free rein'.

As an influence on his career, the Second World War had a practical effect on Claude Harrison, which he now explains.

Although in the Royal Air Force I spent almost all those long war years either on troopships or with the Indian Army. I had been an art student before the war and should have drawn and painted far more often than I did whilst in the services, for enough time was spent waiting for something to happen. Awaiting training in Radar (then so secret that we had no idea of what lay ahead) I was for some months loading ammunition near Altrincham from which hateful task my only brief respite was when asked to make drawings of the ideal layout of kit for inspection, a task no doubt undertaken by many another Artist at War, certainly by Rex Whistler in the Welsh Guards.

During a brief arcadian spell in Eastern Bengal in 1943 I did pencil portraits of my fellows in exchange for cigarettes or for a sitting for my benefit. For the following two years I was with the 21st Indian Division on the Arakan front in Burma and did little or no drawing, something that I very much regret.

My Radar unit, which had advanced with the 14th Army, had unwisely driven past the artillery and even the front line troops, who were standing to in their trenches at dusk. We came to rest at the foot of some jungle-clad hills, still firmly held by the Japanese. There we remained for three weeks using old abandoned slit trenches and coming under occasional rifle fire by day, and machine-gun fire at night. We began to assemble a large wooden mast on the open paddy fields only to have its erection vetoed by the horrified artillery, after they had seen it slowly begin to rise.

In anticipation of the monsoon and a military stalemate, we were withdrawn a short distance to higher ground where we shared an abandoned village with a Sikh ambulance unit. There we lived a strange Robinson Crusoe-like life for a lengthy period of time. Our clothes rotted to rags and we were re-equipped with second-hand army gear. To camouflage the khaki we were given large blocks of dye that we boiled up in empty oil drums with our clothes. We would sit and watch the ineffectual dive-bombing of the same hills, and the war ground on and on. To our delight we were given an issue of rum but strangely only on every other day. We collected it from a barrel, guarded by a lance-naik who never seemed to believe our lying claims

to having double the unit's actual strength. Mail was dropped from a light aircraft.

My recollections are very fragmentary and letters home were censored, because the work of our unit was so secret that we could never explain what we did. The reality was that when things worked well we could overlook almost 200 miles of enemy-held territory and from our cabin direct our own fighters on to their aircraft. I well remember the excitement of this happening at night.

I was eventually sent on a course in Northern India and on my return to our HQ at Chittagong found my unit about to embark for the island of Ramree in the Bay of Bengal. From the beaches we were carried by lighter out to the larger ships of the force assembled for an assault on Rangoon (Note 1). As we clambered, heavily laden with rations and ammunition, up the ship's side we heard over the tannoy news of the end of the war in Europe. We hopefully but fruitlessly asked for a drink to celebrate: no rum!

I remember sleeping on the foredeck as we sailed overnight and then scrambling to the shore over moored landing craft. On the empty grass-grown streets of the hopelessly neglected city half-burnt Japanese rupee notes blew about. The only civilians to be seen were the Chinese shopkeepers, who were open for business. The Japs had gone and so had the Burmese. The next day I watched the tragic sight of the long column of the surrendered 'Indian National Army' winding in from the north, their ragged clothes a mixture of British and Japanese kit and their sick and wounded piled on to bullock carts.

Six weeks later we were shipped out and for the second time sailed up the Hooghly to Calcutta, and then across India by troop train to Belgaum, where our unit prepared for an assault on Borneo. Then came the atom bomb and the war was over, so after a notably boozy party our little convoy went off in a dense cloud of red dust, back across India to Madras. From there we sailed in a hospital ship and through a typhoon in the South China Sea to Hong Kong (Note 2), to find yet another almost empty, twice-looted city, and to watch yet another defeated, though still formidable Chinese Nationalist Army march through Kowloon to embark on American ships for Taiwan.

I was soon transferred to the Educational System set up for all three services in St Joseph's College and there I established an art department that could be used by sailors from the ships, and soldiers

and airmen, much as they might use a technical college at home in civilian life.

I came by a copy of the Roman letters from the Trajan column and taught myself lettering so that I could instruct others, notably Indian soldiers who aspired to painting regimental signs, a skill I was later to use when I painted inn signs for two or three years before I became established as a painter of family portraits and imaginative figure compositions.

When the Indian soldiers were set to draw the classical façade of the college they all depicted it in the delightful style of a Hindu temple. I made drawings of ships' officers and others and finally a portrait in oil of the then Governor and Commander-in-Chief, General Festing. Canvas and primer were scrounged from the Navy and the colours and brushes were bought on the market, the loot no doubt from some unfortunate painter when Hong Kong changed hands.

As the president of a Sergeants' Mess I ran a bar and this I decorated with murals of Chinese girls being chased by soldiers, now dust beneath the skyscrapers, and there I was able to entertain potential sitters in a style that I would not see again for some years. My apotheosis as a figure in the artistic life of the colony came when I was asked to make a speech at the opening of an exhibition of Sung Scroll paintings lent by a Dr Fu Man Chu-like figure in a long blue gown. Unused to public speaking, I remember only the sensation of knocking knees rather than the paintings. Thankfully he spoke no English. Although I would welcome the influence of Chinese painting on my work there seems little trace of it, but I collected Chinese paintings, ceramics and especially snuff bottles. No excitement has ever yet equalled the joy of returning to England on a foggy night in December, 1946, in the Mersey, to three years at the Royal College of Art and *freedom*.

In the early fifties I was to my horror recalled to the RAF during a few weeks of Russian threat, time spent yet again in inexcusable idleness, and wearing a beard to the confusion of the military police.

Artists were more of a rarity earlier this century and one was something of a novelty among the wartime mix of men. The experience was a salutary one for it exercised much romantic nonsense and many fears and convinced me that I should live the life of my choice rather than that advised by others, however well-meaning. I realize that involvement in the war and especially in the campaign

in Burma must have changed me as a person and therefore as a painter, but I can only guess at what I might have been without that experience.

NOTES:

(1) On 1 May, 1945, an amphibious landing was made at the mouth of the Rangoon River, but the Japanese had already evacuated the city. Rangoon was actually liberated by an RAF pilot called Wing-Commander Saunders, who, having flown over the city in a Mosquito twin-engined fighter bomber, observed that the Japanese had already withdrawn. His attention was initially drawn by a sign painted on the roof of the jail which read, 'Japs gone. Extract digit'. Wing-Commander Saunders landed at Mingaladon airfield, walked into town and freed the Allied prisoners who were being held in the city jail. He then found a boat and rowed down the Rangoon River to where the British troops, including Claude Harrison, had landed and informed them that he had liberated the city. The landing craft then proceeded up the river and 26th Division occupied Rangoon.

(2) Hong Kong had been invaded in December, 1941, after the 38th Japanese Division had swept across the border from mainland China. The 12,000-strong British garrison under Major General Maltby withdrew to Hong Kong Island and put up a strong defence. Maltby refused to surrender but after the Island had been heavily bombarded by Japanese aircraft and artillery, his troops were unable to resist the subsequent amphibious landing. The British finally surrendered on Christmas Day, 1941.

ARTHUR HACKNEY RWS RE ARCA
(PAINTER)

Arthur Hackney was educated at the Burslem School of Art and the Royal College of Art, from where he was awarded a Travelling Scholarship in 1949. He began a long association with Farnham School of Art in 1950, when he became a part-time painting instructor. He later became Head of the Graphic Department and Head of the Printmaking Department, until eventually, between 1979–85, he was Deputy Head of the Fine Art Department of West Surrey College of Art and Design (Farnham).

His works can be seen in many public galleries in cities like Bradford, Nottingham, Wakefield, Sheffield, Preston and Stoke-on-Trent, as well as the Victoria & Albert Museum, Ashmolean Museum and Wellington Art Gallery, New Zealand.

He was a member of the CNAA Fine Art Board between 1975–78 and his work was reproduced in Francis Spalding's *20th Century Painters* in 1990.

During the Second World War Arthur Hackney served with the Royal Navy, taking part in the Arctic convoys to Murmansk in northern Russia, the Battle of the Atlantic and the operations that followed D-Day.

Arthur Hackney also gives us a brief insight into what it was like getting back to the Royal College of Art in 1946, and how the war had affected both the students he worked with and the art they produced.

After ten weeks' basic training at HMS *Collingwood*, Fareham, in Hampshire, we were bombed out on the first night. Off we went to the United States on the *Queen Elizabeth* to commission a frigate escort ship at Boston (Mass), HMS *Cotton*.

Just before my call up I had taken the entrance to the Royal College of Art. During our trials in Bermuda, at the British dockyard (Hamilton), our mail caught up with us after several weeks. I received a letter from the Royal College of Art indicating that, when it was convenient, there was a place available to me at the college. Before the outbreak of the war I was employed as an apprentice engraver with Johnson Bros, the pottery manufacturers, and attended Art School in the evenings.

Back in the UK, we became part of the Western Approaches escort groups. These were convoys that went to the South Atlantic, but mainly the North Atlantic, including the Murmansk run (Note 1). Just to mention one Russian convoy, as we arrived at Kola Bay, the entrance to the River Kola, leading down to Murmansk, the escort group took up station ahead of the convoy. All hell was let loose! The U Boats had been waiting for the convoy. All the escorts had Asdic pings and began to drop depth charges. Usually when U Boats were sunk, the records indicate the group, but the one we sank independently is referred to in Captain Roskill's *Official History of the War at Sea* (Vol 4), an excellent reference and highly commended.

The U Boat was obviously damaged and came to the surface. They started firing. Our four-inch guns and twin Oerlikons soon sorted them out.

During the D Day landings, probably during the first week, we escorted several parts of the Mulberry Harbours which were being towed to Arromanches (Note 2). We hadn't a clue what these floating monsters were, but they arrived safely.

After VE day we were given our final instructions; to go out into the Atlantic and rendezvous with three U Boats and escort them to a loch on the west coast of Scotland.

Once back at Gladstone Dock (Liverpool), HMS *Cotton* was to be refitted as a radar direction ship to take part in the Japanese war. Nagasaki and Hiroshima halted that and we returned the ship to New York for mothballing.

Whilst in the Navy I tried on several occasions to paint ashore but the military police in various countries must have thought that I was a spy, as I was ushered politely away.

Starting at the Royal College in 1946 was quite an experience. There were students who had spent time on the Burma Road, prisoners of war back from Poland or Germany, men of all ranks. On

reflection, the work we did was for a reasonable label, 'Social Realism', very much reflecting the situation we were in and the post-war period, rationing etc.

Nevertheless, after all the war experiences, we all appreciated how fortunate we were. We also had ex-servicemen's grants. It was good to play soccer on Wednesday afternoons. It was a different kind of camaraderie, not a question of life or death, but as students we all had something in common. I often wonder if the younger generation at Universities have the same enthusiasm.

After VE Day one of my brothers came to Liverpool and visited me onboard ship. He still talks about it now: the limited space we lived in, no radios, newspapers or contact with the outside world for weeks on end. It was like being in jail, but much more dangerous.

NOTES:

(1) During the Battle of the Atlantic Allied ships endeavoured to keep the supply routes open, while the German Navy, particularly its U Boat arm, attempted to disrupt the vital sea lanes to the United States and the USSR. Murmansk was the only sea route to Russia which was available to the British and Americans, so the Germans intensified their presence in the area. Consequently the Arctic convoys, as described by Arthur Hackney, were extremely hazardous affairs, but if Russia was to stay in the war and mount an effective Eastern Front, she had to be supplied. Every sailor knew that sailing up the River Kola to Murmansk was tantamount to 'running the gauntlet', and Allied shipping losses were heavy.

(2) The Mulberry Harbours were prefabricated floating harbours, towed across the channel to avoid the necessity of capturing a heavily defended port at an early stage in the campaign. The Mulberry Harbour supplied the army as it attempted to break out from Normandy to liberate France. By 1 September, 1944, 2 million soldiers, 438,000 tanks, armoured cars and other vehicles, and approximately 3 million tons of essential stores had been landed in France, much of which had entered through the Mulberry Harbours.

ANTHONY EYTON RA
(PAINTER)

Today the work of artist Anthony Eyton can be seen in collections like the Tate Gallery, the Arts Council, the Government Picture Collection, the Contemporary Art Society and the Guildhall Art Gallery. He has also held one-man exhibitions principally at Browse and Darby Gallery, London and in 1983 his work was displayed in the Imperial War Museum.

Anthony Eyton studied art at Reading University's Department of Fine Art and the Camberwell School of Art. He won an Abbey Major Scholarship in Painting in 1950 and since 1963 he has been a visiting teacher at Royal Academy Schools. In 1958 he was elected a member of London Group.

During the Second World War Anthony Eyton was commissioned into the Cameronians (Scottish Rifles), but also served in both the Hampshire Regiment and the Army Education Corps.

For most painters at war, other than official war artists, the facility and time to paint was a rare luxury, but from the period he spent as a second lieutenant with the Cameronians, Anthony Eyton remembers one particular incident, after which, and due to his own indiscretion, he found ample opportunity. Anthony Eyton recalls:

> My father served in the 1914–18 War in the Cavalry. For most of the time they were held behind the lines in reserve. He had an Army Career that a young boy could aspire to and I listened with fascination to his wartime stories. One particular episode stuck in my mind. In 1917 he had to act as a spy and was dressed up like a cabbage, or so I remembered, to climb up into a tree so as to observe the German positions until the German artillery started ranging on the tree and he

35

was forced to hastily withdraw. My own wartime experiences were of a less heroic nature.

We were both in the Army in the Second World War. In 1942 I volunteered for the 60th Rifles full of youthful enthusiasm, but missed going to OCTU with my friends due to getting Abortus Fever which took two months in those days to recover from. Somehow by the time I was commissioned into the Cameronians (Scottish Rifles) my ardour had cooled and the pace was slower.

My battalion was part of the 52nd Division and was being trained in mountain warfare for a possible invasion of Norway. A month-long exercise was held in the Cairngorms in which I was a Platoon Commander in charge of Glasgow miners. A strict divisional order forbade all entry into human habitations. During the third week my platoon was bivouacked near a farm house. The farmer invited me to come into his house and take a bath. Though I am a conformist by nature, the idea appealed to me. After three weeks of washing in the cold waters of a burn it would indeed be a luxury. That I might be found out probably never occurred to me. Anyhow I made no provisions to cover my tracks. So, rather pleased with myself, I made myself at home in the bathroom. It was small and narrow but the bath was large, full of the most delicious steaming water. I stripped down

A drawing from Anthony Eyton's wartime sketchbook dated January, 1943, while he was serving with the Cameronians.
(*Drawing courtesy of Anthony Eyton*)

as far as my string vest (for cold climates) and tested the water with my foot for temperature. Then came a knock on the door. 'Come in,' I said. The door opened to reveal the Company Piper. 'Major Grey to see you Sir!' and the Company Commander came forward. He was a tall man and with his shepherd's crook looked even larger. My relations with the Major had been very wobbly, definitely a personality clash. Actually, for the moment, I had been in his good books as two days before I had successfully moved my platoon to a distant hilltop, though, if the truth be told, it was Sergeant Farrell, with his excellent compass-reading, who achieved this feat. But I got praise from the Major which was much needed for the record.

So he had me in a trap of my own devising. He admonished me severely. What sort of example was this to my men considering the divisional order? 'You are under Close Arrest.'

I let the water out of the bath, got dressed and walked out to be escorted across a ploughed field, the Major in front and the Piper behind, until we arrived at Battalion HQ.

Among some rhododendron bushes the Colonel, nicknamed 'Tiny', was shaving. It was early in the morning. He was very tall, a kind man. He could only order me back to 'B Echelon' and relieve me of my platoon.

To me it was a sad farewell. I liked my miners. Tearfully I bid them goodbye. 'Ach Sur, you were too cushy,' said the most thick-set of them all.

There followed an uncertain period. The Hon Andrew Elphinstone who was attached to the unit and the Padre were very sympathetic. I had no real duties and had visions of applying to the Camouflage Corps. I did a lot of painting. Eventually the War Office gave me another posting. My father who was in Traffic Control in Glasgow thought the Army had not got it quite right. I was a square peg in a round hole. The war had a long way to go.

All the protagonists as far as I know, and certainly Major Grey and the Colonel, were killed in Normandy.

I sometimes think this could also have been my lot if it had not been for that fateful decision to accept the invitation to have a bath.

A. STEWART MACKAY ROI

(Painter)

A. Stewart Mackay was educated at the Regent Street Polytechnic School of Art, where he became an assistant lecturer in 1936, continuing to lecture after the war until 1960. Between 1960–1968 he lectured at the Hammersmith College of Art. He has exhibited at the Royal Academy, the Paris Salon, and many important galleries in Europe and America. His paintings hang in the Imperial War Museum and he has written the book, *How to Make Lino Cuts* and articles for *Artist* and other magazines.

During the Second World War A. Stewart Mackay served with the Royal Artillery, until he was commissioned into the Pioneer Corps and seconded to the Canadian Army. He landed on Juno Beach and participated in most of the major campaigns on the Western Front until the end of the war. His story particularly speaks of the Rundstedt Push – better known to history as the Battle of the Bulge – Hitler's final great offensive.

After the war A. Stewart Mackay remained on the continent for a period of time as a Staff Captain, as he now explains:

> At the beginning of the war I was teaching full time at the Regent St Polytechnic School of Art. When the blitz started the students disappeared, so the staff, wishing to do something useful, took over Cosway St Rest Centre. Whilst on duty one night with Sister Buchanan I did a painting of her, constantly interrupted by air raids. When the bombers were overhead I looked for somewhere to dive, but Sister Buchanan just knitted on. The painting is now in the Imperial War Museum.
>
> Two weeks later I was called up and eventually posted to the Royal

Artillery at Larkhill. Here I did numerous drawings and paintings, including the Colonel, and for two packets of cigarettes persuaded a fellow soldier to pose in my painting 'The Barrack Room Artist'. This painting is also in the Imperial War Museum.

By this time I had reached the noble rank of Lance-Bombardier and an officer bought my small painting of 'Approaching Storm, Salisbury Plain' for 10/-. Next came three months at OCTU, delayed a month with congestion in hospital for 14 days, but I still had to start again.

During that time I made many quick pencil portraits of officers and fellow cadets and have photographs of these drawings which bring back many memories. Wishing to go into camouflage, I was advised to get a quick commission in the Royal Pioneers. This I did, but as it was near D Day camouflage was out of the question.

I was seconded to the Canadian Army and landed with them in June, 1944, on Juno Beach. For the next nine months I had more to think about than drawing. The Canadians were wonderful people to work with; they just cut through red tape.

We moved up via Caen, through villages destroyed in the First World War, now mostly untouched in this war of movement. By this time I became Assistant Adjutant, eventually Captain and Adjutant on the promotion of the former to Major.

The war seemed to be moving on quite smoothly when suddenly the Germans counter-attacked, in what was known as the 'Rundstedt Push' (Note 1). I was in the Belgian town of Turnhout just on the border with the Netherlands. Information came that the Germans intended dropping a parachute regiment on Turnhout. In apprehension we duly prepared, but it was with much relief when we heard that Monty's Highland Division was moving up a quarter of a mile away. I'm not sure of the exact Division, remembrance is not easy after 52 years.

We then moved up to Hertogenbosch to follow up the Arnhem drop. This was unsuccessful, but later from Nijmegen we took part in the successful Battle of Arnhem. My unit crossed the Rhine at Cleve. It was now a matter of follow-up and eventually collecting thousands of German prisoners, who were only too glad to throw their rifles etc. away.

Representing the Colonel, I visited many prisoner-of-war camps, where they told me through an interpreter that they feared the Russian front, and were happy to be prisoners of the British.

After the war, and contrary to my wishes, the Army kept me on as Staff Capt in Brussels. My only artistic work, during that time were two humorous cartoons in *Blighty* and a painting in the Royal Academy.

At this time Count Bentinck called at our HQ and I interviewed him (Note 2). He was worried that the local people would suppose that he was a collaborator and he wanted our protection. He invited the Colonel and myself to dinner at Middachten Castle, where we enjoyed some of the wines left over by the German officers who had occupied the place for the previous two years.

I was demobbed and crossed the Channel and listened on the radio to the Victory Parade in Hyde Park, with Churchill, Attlee, and Monty etc. It was the end of an experience.

NOTES:

(1) After the Liberation of Paris and the Allied invasion of southern Belgium, Field Marshal von Rundstedt was appointed supreme commander of the German forces in the west and prepared to make a stand along the Siegfried Line. The line, otherwise known as the Westwall fortified zone, ran from Switzerland, through Lorraine to Aachen, before turning north-west to Maastricht and along the Albert Canal to Ostend on the coast. The Allied advance had begun to slow down because of supply problems, especially a shortage of fuel. Suddenly the Germans made a brilliant and quite unsuspected counter-attack through the forests of the Ardennes, which threw the Allies into confusion. Hitler's bold plan had split the allied forces down the middle and cut off their supply lines. For the first time since landing on the Normandy beaches the Allies were in retreat.

The Germans made a three-pronged attack with the Sixth Panzer Army under General Dietrich to the north, the Fifth Panzer Army under General Hasso von Manteuffel in the centre, and the Seventh Army under General Ernst Brandenberger to the south. The plan worked well until the Germans encountered the American forces of Brigadier General McAuliffe at the town of Bastogne, who refused to surrender and put up tremendous resistance to the German armoured divisions. On Hitler's orders von Rundstedt laid seige to the town which gave the Allies a chance to regroup and bring up reinforcements and supplies. The furious seige of Bastogne was the turning point in the Battle of the Bulge. The Germans had

wasted the opportunity of pushing straight through to Antwerp and were running short of their already limited resources. In early January, 1945, the Allies began their counter-offensive on all fronts and the Battle of the Bulge came to an abrupt halt.

The defeat has traditionally been put down to the fact that the German tanks ran out of fuel. Von Rundstedt only had a limited amount of gasoline and he had planned to capture the Allied fuel depots. However, Hitler's stubborn refusal to call off the seige of Bastogne lost von Rundstedt the element of surprise and any chance of capturing the Allied fuel reserves.

(2) Count Bentinck's castle at Middachten had been used by German officers during the occupation and he was worried that he would be looked upon as a collaborator. Count Bentinck had been born in London of an English father and Dutch mother. He had inherited property in Germany and served in the German Army during the First World War, and, although losing his Dutch nationality, it was re-instated in 1920. However, during the occupation his daughters Sophie and Isabelle were made to serve in Germany with a Searchlight crew, even though both he and the Dutch Foreign Office had protested. As the US Army approached, their unit was ordered to retreat, but they made their way to some relations who lived nearby and were finally repatriated to Holland.

Chapter Three

ART BY APPOINTMENT

As pointed out at the beginning, the purpose of this book is not to study official war artists but to look at artists who served in the Armed Forces during the Second World War. It was therefore inevitable that at least one or two of our contributors would have been appointed an official war artist at some point in their military career.

On the outbreak of hostilities a War Artists Advisory Committee was set up, chaired by Sir Kenneth Clark. The job of this committee was to decide on who would be appointed an official war artist. In the main war artists were not employed by the Armed Forces and were often the same artists who had recorded events during the First World War. Their job rarely involved going to the front line, or being placed in a position of danger.

The best place to see the work of these war artists, a few of whom did find themselves in dangerous situations at some point in the war, is at London's Imperial War Museum. The museum houses the most important collection of war paintings in Britain, but, because of its size, only a small proportion of it is on show at any one time. The collection includes work by artists like Edward Bawden, Edward Ardizzone, Anthony Gross, Thomas Hennell, Edward Burra, Bernard Meninsky, Edwin la Dell, John Minton, Henry Moore, John Piper, Graham Sutherland, Richard Eurich, Mervyn Peake, Henry Carr, Evelyn Dunbar, Carel Weight, William Scott, John Trevelyan and Meredith Frampton. The collection isn't dedicated solely to official war artists but it contains a high proportion of their work.

Because of the restraints placed upon the official war artists, it was recognized during the Second World War that a valuable contribution to war art could be made by enlisting the services of people who

actually served in the Army, Royal Navy or Royal Air Force. Although this suggestion had its obvious faults – serving soldiers had little desire to be burdened down by painting materials as well as fighting materials – these men were nevertheless in a unique position. It was therefore decided that, as long as everyone concerned was agreeable, for certain periods of time such men would be afforded the privilege of being a war artist in preference to their military duties. How this all came about, as well as a clear description of how the War Artists Advisory Committee worked, is better described by war artist Richard Seddon himself after this introduction. Some of these artists, as you will also discover in this chapter, were often appointed on a temporary basis, and after their stipulated tour had finished returned to their regimental duties.

In this chapter you will be reading the stories of four such men: Richard Seddon, John Napper, Leonard Rosoman and Eric Taylor. I begin with Richard Seddon, who served with the Royal Army Ordnance Corps, because he accompanied the British Expeditionary Force to France in 1940. John Napper served in the Far East with the Royal Artillery, as did Leonard Rosoman with the Royal Marines. The last story is that of Eric Taylor, whose pictures from Belsen Concentration Camp are a permanent reminder to us all of the terrible suffering inflicted in the Holocaust.

RICHARD SEDDON PhD PPRWS Hon.RI ARCA
(PAINTER)

Richard Seddon trained at the Royal College of Art, where Paul Nash, one of the great war artists during the First World War, was his tutor. When the war began Seddon joined the Royal Army Ordnance Corps and had actually been serving for several months when a War Office Order arrived for his Colonel to allow Seddon to make war drawings in the theatre of war when the war situation allowed. Soon, as a lance corporal, he was in a small ordnance unit attached to the 51st (Highland) Division, as part of the French army line in front of the Maginot forts in the Metz area, servicing regiments of legendary fame, including the Argylls, the Black Watch, the Seaforths, the Camerons and the Gordons.

In early June the 51st (Highland) Division held the perimeter so that the Dunkirk evacuation could succeed but much of the division was captured in consequence. A tiny group which was rescued from Veulettte on the French coast included a party of five ordnance men under Seddon's command.

After Dunkirk he was invalided from the army, having held on to his sketchbook, so that he was able to work up his drawings and exhibit as a war artist.

In 1943 Seddon became a demonstrator of life drawing at the University of Reading whilst reading for his Ph.D. In 1947 he was Staff Tutor in Fine Art in the Extra-Mural Department of Birmingham University, being appointed in 1947 as Director of Sheffield City Art Galleries, in charge of the Mappin Art Gallery and the Graves Art Gallery and the Ruskin Collection.

Other appointments since then have included that of director of Art History and Liberal Studies in the famous school of Design and

Furniture of the Buckinghamshire College of Higher Education, and as president of Ludlow Art Society, president of the Royal Watercolour Society, president of the Yorkshire Federation of Museums and Art Galleries, honorary member of the Oxford Folk Art Society, the Sheffield Society of Artists, the Sheffield Photographic Society, the Royal Institute of Water Colours and the Mark Twain Society, USA.

His influence has been exercised as secretary of the Yorkshire Museums Regional Fact-Finding Committee, Chairman of the Sheffield Design Council, for the Gold, Silver and Jewellery Trades, honorary treasurer of the Artist's League of Great Britain, and consultant to the ancient Cutlers' Company of Sheffield and the Merchant Venturers of York.

He has exhibited at the RA, NEAC, the RWS, the RI, the RBA and in west-end galleries. His drawings and paintings are in the collections of the V&A Museum, the Pilgrim Trust, the Imperial War Museum and other official and private collections.

Richard Seddon has written hundreds of articles on art in most of the art journals of the UK, and in the USA, Australia and India. His several books include *A Hand Uplifted – War Memoirs*, *The Academic Technique of Oil Painting*, *Art Collecting for Amateurs*, *A Dictionary of Art Terms* (with Kimberly Reynolds), and *The Artist's Studio Book*. For ten years he wrote the technical page in *The Artist*.

As a student at the Royal College of Art in 1938, where Paul Nash was my tutor and being free on Wednesday afternoons, I used to go sometimes to the Nash's house in Hampstead, where I was occasionally his studio assistant. In 1945 I wrote in my war memoirs *A Hand Uplifted*:

"Looking back across the years Paul Nash's house and his quiet studio have a golden glow that is not all nostalgia. In that room I remember Paul on many days standing at the easel on a length of grey carpet on which he paced to and from the canvas; or working at the water-colour table near one of the French windows.

"During the last year before the war the tension in the atmosphere of the times did not ruffle the calm of our pre-war existence, but we were aware of it just the same. In London, the yellow spoil heaps from the trenches in Kensington Gardens grew bigger – barrage balloons hung pearly in the autumn sky and the night was criss-crossed with searchlight beams.

"War was declared on that September Sunday in 1939; a warm sunny day when all should have been right with the world. I immediately tried to join the Army or the Navy, but recruits were not wanted because of lack of equipment for them. I wanted to do camouflage or to be a war artist, like the war artists in the last war. Paul had been the first and one of the most famous. I sounded the Army and was told to wait until I was called for. The Navy were not recruiting and all I had to do was wait and see.

"One day my sister said that a friend of hers was an officer in an army unit which was completing its strength, and he would have a word with the Colonel about my attempts to volunteer. The Adjutant told me that the unit was fully up to strength, but that they would take me on and send my papers late to the War Office, who would assume they had been mislaid.

"Once in the Army my immediate worries were over, but I still had to work out plans for being a war artist . . . On a weekend leave I took the train and went to London. I rang up Percy Jowett (principal of the RCA) and he asked me to go and see him at the Royal College. 'We've formed a committee,' he told me, as we sat in the study I knew so well. 'At least, the government have. It's under the Ministry of Information and is called the War Artists Advisory Committee. I am on it with Muirhead Brown, Sir Kenneth Clark and Sir Walter Russell . . . I don't know officially but I'm fairly certain that in addition to selecting the Official War Artists, some of whom will be the same people as in the last war, we shall have a very restricted few of another kind of war artist; we shall draw up a list of a limited number of artists – people who are younger than the Official War Artists and who are in one or another of the services in an active-service capacity. These people will receive an order from the War Office,' he continued, 'or their commanding officers will, that they are to be given full facilities, when the strategic and tactical situation allows, to make records in the actual theatre of war.' (a)"

The mostly elderly Official War Artists were not expected, or indeed permitted, to wander about in a combat area, and indeed, even in the service areas of the rear echelons, they were expected to be accompanied by a military 'minder'. The younger, enlisted war artists on active service, thus filled a serious gap.

I had a letter from Percy Jowett some time later, telling me that he had put my name forward and suggesting that I mention it to

my commanding officer. In due course, the order came through when I was with a Light Aid Detachment of the RAOC, with the 51st Highland Division. We were 'lent' to the French Army and stationed in front of the Maginot Line (Note 1); and I was an official war artist. (b)

I took a supply of watercolour paper and my battered old paintbox and made endless sketches in a sketchbook as J.M.W. Turner used to do. Also, like him, I painted studio watercolours from these sketches and I kept them in my truck; but I carried my sketchbook in the capacious pocket above my right knee, universally provided in battle-dress for the NCO's or officer's notebook.

On June 10, a week after the beaches at Dunkirk, unknown to us, had cleared up the last of the withdrawal, our unit was at the tail end of a large convoy trying to reach St Valery on the French coast. I was in the very last truck, because I could speak French and stay with any breakdown, whilst it was put right, and then get it back in its right place in the convoy – if, that is, we could find where on earth the convoy had got to. As 'other ranks' we were forbidden maps or even to know the route and destination.

We did not know then that the whole Dunkirk withdrawal was over, and as Vivian Rowe describes in *The Great Wall of France*, the French 10th Army and the 51st Highland Division were cut off and Fécamp was already in German hands, due, as Winston Churchill related in *The Second World War* Vol II (1949), to a case of gross mismanagement by the French command. (c)

At noon my truck and the mechanics were at the bottom of a hill with a breakdown, when big bangs somewhere over the crest ahead told us that the front of the convoy was being attacked – from the sound of it by General Rommel's tanks near St Valery where later that day almost the entire 51st Highland Division was to be captured, including our own small RAOC unit – all except us, thanks to the breakdown possibly arranged by my guardian angel. We had guessed that something dodgy was going on because, approaching St Valery, a written order, which I still have, had been handed up from a military policeman at a crossroads, ordering 'change of route-make for Fécamp'.

As I crawled up the hill in the shadows of the roadside hedge to take a look, I was joined by a French 10th Army infantry platoon in pale blue uniforms. Our main convoy was about a mile ahead on the

wide plateau of the hilltop, and the tanks sparsely dotted about on the right-hand distance. The convoy was halted and being attacked noisily, with some trucks on fire. The Frenchmen suddenly obeyed a shouted command and went down the hill and away, leaving me alone.

I dodged back down the hill to rejoin the others. As a lance corporal with four privates and a truck I was now in charge and we held a quick council of war. So far, the Germans did not know we were there. The five of us only had ten rounds of rifle ammunition each and I decided not to waste it on tanks, and, obeying the last order, we piled into my truck and set off to get help from Fécamp. Were we lured to that trap by an agent posing as a British military policeman – or was the mismanagement not entirely on the French side? At no time did anyone suggest surrender, though the mechanic and my driver had driven off, and I later learned they had surrendered. We had a vague idea of bringing a unit from Fécamp with anti-tank guns to knock out the German tanks.

After driving towards the coast for about two miles we ran into loud machine-gun fire coming from somewhere, and, abandoning the truck which was rather conspicuous, we went down to the shingle beach below the cliffs. We knew that Fécamp was some ten miles south-west along the shore. The tide was rising and the tideline on the chalk cliff-face was depressingly above our heads. We gambled on having about two hours to make it.

Everything was open to aerial attack and, under the cliffs, as we trudged, we watched a fishing lugger half a mile offshore going to Fécamp, until two German planes flew over and shot it to a standstill with well-aimed cannon fire. The German pilots could have seen us if we had moved about and if they had not been so busy, but they flew away. Then, like a London taxi, a British destroyer gliding along towards Fécamp hove to by the lugger. They saw us and flashed a signal when we waved. We were a bit puzzled when they then sailed away, and we set off once more for Fécamp, but after we had clambered over the fallen chalk from the cliffs for about twenty minutes another destroyer hove in sight, which we learned later was HMS *Boadicea*. Their whaler with oarsmen and a petty officer coxswain came into the heavy surf regardless of any Germans on the cliff top, and took us on board – plus one or two army and civilian stragglers who had joined us. As I checked the beach for any others, the whaler

had to move out beyond the breakers, and I had to swim to it, holding my rifle above the waves.

Naval historian Peter C. Smith later described in *Hold the Narrow Sea* how the German planes attacked and damaged the first destroyer which was HMS *Bulldog*, and also HMS *Boadicea* who stopped and took us on board, and how they rescued my small group of British soldiers and French civilians. He recounted how the remaining troops on shore had been captured. (d)

The German planes soon returned in force. Three heavy bombs hit *Boadicea* killing eight of the crew. One blew up the boiler room and main steam pipe; another hit the stern and jammed the rudder to starboard and the third failed to explode and remained in the bilges. All this left us with a list and a bulging bulkhead. We had no engines, and no electrics, so no radio, and drifted helpless on the calm sea in darkness and silence. Yet, in the small hours, in darkness, the damaged *Ambuscade*, limping home unexpectedly from a similar encounter, discovered the stricken, blacked-out *Boadicea* adrift, and, all night

'The Army under canvas in Hyde Park, July 1939.'
Sketch in watercolour by Richard Seddon.
(*Reproduced with the permission of Richard Seddon*)

and all the next day, towed her gently to Portsmouth. During the day the Captain read the funeral service with the crew and my squad at attention, when the flag-draped bodies of the gallant dead were consigned to the sea.

Subsequently I met some of the crew again under happier circumstances including Mr Reynolds, the coxswain of the whaler, at the annual reunion of HM Ships *Beagle, Boadicea* and *Bulldog* 1938–1945 Crews Association aboard HMS *President*, headquarters of the Royal Naval Volunteer Reserve, the gunboat moored on the Thames Embankment at Blackfriars. (e)

I was invalided out with an army pension and no longer a soldier. In hospital I started to write *A Hand Uplifted*, which was put away on completion until the war was over. I painted my watercolours again and in 1943 I was showing in Sir Kenneth (later Lord) Clark's first War Artists' Exhibition at the National Gallery. Ten of my watercolours went to the Imperial War Museum collection; one was acquired by my home town for Sheffield City Art Galleries. After the war I gave a watercolour of a dummy anti-tank gun emplacement pointing up the Rue St Jaques in Neufchâtel for lack of a real gun. It now hangs in the town hall office of the Mayor, who sent me a beautiful medal, which, to preserve its mint condition, was accepted for safe keeping by the British Museum.

RICHARD SEDDON'S NOTES:

(a) Cf. Richard Seddon, *A Hand Uplifted*, (London: Frederick Muller, Ltd, 1963).

(b) Ibid.

(c) Cf. Vivian Rowe, *The Great Wall of France*, (1959).

(d) For a fuller account cf. Peter C. Smith, *Hold the Narrow Sea*, (Moorland Publishing Co. Ltd., 1984), pp. 69 and 70–74.

(e) A letter in 1990 to Richard Seddon from Michael Back, Hon Secretary of the HM Ships *Beagle, Boadicea* and *Bulldog* Crews Association states: 'Dear Richard: Just a line to let you know that at the Chatham Naval War Memorial on Wednesday week, we shall be specially commemorating the loss fifty years ago of eight of the

Boadicea's Ship's Company in the action off St Valery, an action in which you were, of course, very much a participant.'

On 31-5-91 Michael Back wrote: 'Dear Richard: Just to say that Lt Cdr Hubert Fox attended our very successful Plymouth Reunion, and especially asked to be remembered to you. He was saying that *A Hand Uplifted* was far and away the best account of the St Valery episode ever written.'

I value his opinion as he was First Lieutenant on HMS *Boadicea*.

NOTES

(1) The British Expeditionary Force, under the command of Field Marshal Lord Gort, had been sent to help defend France against a possible German attack, following Hitler's invasion of Poland and the declaration of war on 3 September, 1939. Having said that, France was considered to be almost impregnable thanks to the Maginot Line, which stretched along the French border from Belgium in the north to Switzerland in the south. It was considered to be the most secure fortification that had ever been built, consisting of three lines of reinforced concrete forts and bunkers, which were defended by huge guns and literally tens of thousands of soldiers. If the Germans decided to attack the Maginot Line they would be cut to pieces – so they didn't! At dawn on 10 May, 1940, they launched the Blitzkrieg and the Maginot Line was ignored. The Germans simply went around it to the north, unleashing a lightning assault in Holland and Belgium. Most of the British troops on the continent found themselves along the border with Belgium and were now faced with the full weight of the German advance. The Allies fell back to Dunkirk and 338,226 British, French and Belgian troops were evacuated from the beaches.

JOHN NAPPER
(PAINTER)

In 1943 John Napper was appointed a temporary official war artist while he was serving in Ceylon with the Royal Artillery. During his tour as a war artist he travelled around India and the Pacific Ocean and even met the girl who later became his wife.

John Napper was educated at Frensham Heights, the Dundee School of Art and the Royal Academy. After the war he taught life painting at St Martin's School of Art in London from 1949–57, after which he lived and painted in France until 1970. He has held one-man exhibitions in most of the top galleries on both sides of the English Channel, such as The Leicester Galleries and The Adams Gallery in London, and La Maison de la Pensée Française and the Galerie Lahumiere in Paris. He has also exhibited across the Atlantic at New York's Larcada Gallery, and many other locations.

The paintings of John Napper have been purchased by major collections like the British Museum, the Contemporary Art Society, the Courtauld Institute, the Musée d'Art Moderne Paris, Musée Municipale Dieppe, the National Gallery of Kenya, the Columbus Gallery of Fine Arts Ohio, and other public and private collections.

John Napper has been awarded several prizes, including an award at the International Exhibition of Fine Arts, held in Moscow in 1957. He was also awarded the International Association of Art Critics Prize in 1961. In 1994 he published a book entitled *The Rose and the Flame*.

I was twenty-two when war was declared in 1939 and painting in Scotland but the following March I joined a Royal Artillery anti-aircraft training camp, near Devizes in Wiltshire. To begin with I was

52

lost, having been filled with tales of horror about the 1914-18 war, put there by friends and relatives who had endured it. But thanks to those like John Tittle, John Luce and John Lander I soon settled down. All day we marched up and down or fired off rifles on the range at imaginary enemies, enemies that we called boredom. But outside the camp the Battle of Britain had begun. After a winter month and a half near Bristol, where the screaming never stopped in the skies, I spent three months under canvas in Surrey near Weybridge, with London in flames on the horizon.

In March I was posted to the OCTU establishment at Shrivenham where I fell in love with the theory of Predictors, those early computers. I made many friends and the Wiltshire Downs were lovely that springtime, with fields full of snake's head fritillary. On being commissioned, I was posted to the 52nd (City of London) Heavy Anti-Aircraft Regiment, which was stationed then in the far east end of London.

At Barking I saw at first-hand the real bombing of London and was nearly killed by an oil-bomb. Then to Wales, where I managed to do a little drawing before my Regiment was posted abroad in the early spring of 1942.

After a brief spell in South Africa we went on to Ceylon, that mysterious island where birdsong and the perfume of frangipani delighted me day and night. But as far as the war was concerned, little was happening. In 1943, owing to the good offices of Brigadier Leslie, whom I'd first met at Shrivenham, and Major David Barrow, who was AMS on the staff of Ceylon Command, I was made a temporary War Artist. During this time I travelled a lot, all over the island, parts of India and around the Pacific Ocean, this last in a Dutch submarine.

Whilst I was a War Artist, I had the good fortune to be asked to paint an official portrait of a Wren, as a great number of these gallant women had lately arrived on the island. The one that I painted became my wife after the war and we celebrated our golden wedding anniversary in 1995.

When my tour of duty as a War Artist came to an end I transferred to the Royal Naval Volunteer Reserve and, after a year spent in East Africa attached to the Staff at Kilindini, I returned to England to join Combined Operations in Whitehall. I spent my last few months in the Services at the Admiralty. I was demobbed at the end of 1945, owing

to the fact that I had been commissioned to make a mural decoration by the Treasury Solicitor's office in Storey's Gate.

Despite some heart-breaking incidents, the war had been kinder to me than it had been to many. I lost very dear friends and can only say that but for the Grace of God, I might have had to join them. God rest their brave souls.

LEONARD ROSOMAN OBE RA

(Painter)

Leonard Rosoman joined the Fire Brigade when the war began, but after being appointed an official war artist, he was commissioned into the Royal Marines. He was educated at Durham University and became a teacher of drawing and painting at the Reiman School of Art in London in 1938. After the war he taught at the Camberwell School of Art, Edinburgh College of Art and Chelsea School of Art. Between 1957–78 he was a tutor at the Royal College of Art.

Leonard Rosoman has held one-man shows at St George's Gallery, London, Roland Browse and Delbanco Gallery, London, and the Fine Art Society.

His works have been bought by Her Majesty's Government, the Arts Council, the British Council, York Art Gallery, the Contemporary Art Society, Adelaide Art Gallery, the Victoria and Albert Museum and the Lincoln Center, New York.

He has executed large mural paintings for the Festival of Britain in 1951, the British Pavilion at the Brussels World Fair in 1958, Harewood House and Lambeth Palace Chapel.

During his service with the Fire Brigade, Leonard Rosoman maintained his interest in the arts and was even instrumental in setting up a group of artists within their ranks, shortly before his appointment as an official war artist, as he now describes.

> When war broke out in September, 1939, I was teaching drawing at the Reiman School of Design in Westminster, London. This was a German school that moved to London to escape the Nazis and I found it interesting as the staff and students were very cosmopolitan and the work showed great imagination and variety.

During the summer of 1939 people could see that war was inevitable and I decided to do something about it, so I tried to join the River Thames Fire Service. This was fully manned so I became a member of the ordinary fire service and was stationed in Hampstead. We drilled in the evenings twice a week and right from the start I found the company stimulating as I was being given a chance to get to know men and women from many different walks of life.

London was fairly unprepared and when I was called up I spent the first weeks living in and out of the backs of cars in an underground garage in Swiss Cottage. Air raids didn't happen for some time and we came in for a certain amount of banter from the public. When they did start they were terrifying and we became heroes overnight. Our duties were forty-eight hours on and twenty-four off and during this time I was able to do a certain amount of painting of the extraordinary fires. Eventually, of course, by the time of the City Blitz we were out all night and sometimes part of the day. (Note 1)

A number of artists had joined the service and we formed a group of Fireman Artists which was of mixed talents. We held exhibitions in various places including the National Gallery. I was rather unhappy for a while about the work I was producing. Being pitched from a fairly isolated studio life into this fantastic drama was deeply disturbing. I had no time to digest it and the results were superficial and sentimental.

The news that I was an artist must have got around as I was transferred to the Home Office to illustrate a Fire Service manual. I was doubtful about this at first but eventually enjoyed travelling all over the country drawing pumps, turntable ladders, knots and lines, and other equipment. I had more free time, too, so I painted more pictures, a lot of which were bought by the government. Then I had a letter from Sir Kenneth Clark, the head of the War Artists Advisory Committee, asking me to come to see him. I went along to Whitehall and was very excited when he asked me if I would be interested in becoming an Official War Artist. I thought I'd had a lucky war so far but this was really something. I was made a Captain in the Royal Marines, sent to cover the Japanese War and soon found myself on the troop ship HMS *Nieuw Amsterdam* on my way to Australia.

I was rather sad to miss VE Day but was restored by the magic of Sydney Port and the wonder of aircraft carriers, one of which, HMS *Formidable*, I chose to sail in. On the carrier I found a new life that

was interesting: man, as it were, trapped in the flower-like interior of a radar predictor, insect-like aircraft on the flight deck, and as the poet Alan Ross described it, 'objects in an almost parasitical relationship to larger entities'. I felt these things emotionally, they weren't just interesting shapes.

Formidable was Admiral Vian's flagship and I found him very interested and helpful. The Navy personnel used to visit me in my cabin and talk about my pictures and borrow my books. I liked this very much as it made me feel part of the life of the ship. I felt that I belonged somewhere and this is a rare feeling for an artist even in peacetime.

When the Japanese surrendered I was ordered to Hong Kong. The idea of the Japanese handing over their swords didn't appeal to me so I painted the bomb damage in the naval dockyard. I had never seen a real Chinese junk before and they looked like floating grand pianos and I had thoughts of Salvador Dali. The glimpses of the landscape around Hong Kong were a revelation. Instead of the subtle tones and muted colours of Chinese painting there were strident reds and chrome greens spattering the hills and the greenish black of the coolies' dress gave out a spooky smell.

Looking back on these four to five years I'm convinced that they were the most significant of my whole life. At the age of twenty-three to be able to open one's world so wide, to find oneself face to face with such a variety of things, to experience them first hand, was a miracle. I am the painter I am largely because of it. Most of the pictures I painted during this period are now in the Imperial War Museum.

NOTES:

(1) The Blitz really began on 23 August, 1940, with the first all-night air raid on London by the Luftwaffe, in which civilian targets were indiscriminately bombed. The following months saw an intense bombardment of the city. Each night several hundred German bombers flew across the Channel and dropped high explosives on the heart of the capital. Their intention was to deliver a 'knockout blow' and totally destroy London in a few weeks by targeting power stations, railways, docks, airfields and industrial centres. For the first time, also, civilian housing was targeted on a huge scale. As well

as attempting to destroy London's communication networks, power supplies, defences and essential industries, in a bid to cripple the British capital, the Germans also wanted to destroy the morale of its civilians – they only helped to stiffen it.

Between September, 1940, and May, 1941, over 50,000 high explosive bombs were dropped on London. In September, 1940, between 40,000 and 50,000 people lost their homes every week. By December, 1940, 12,696 civilians had lost their lives, with a further 20,000 seriously injured. By May, 1941, over 1,150,000 houses in London had been destroyed or badly damaged and 1,400,000 people had been made homeless. London was ablaze.

ERIC TAYLOR RE ARCA

(PAINTER AND SCULPTOR)

As early as 1928 Eric Taylor was producing free-lance illustrations for the *Radio Times* and murals in London stores. He studied part-time sculpture at the Central School and in 1932 was awarded a British Institution Scholarship which he used to study at the Royal College of Art. He was elected an Associate of the Royal Society of Painter Etchers in 1935 and up until the war was employed part-time at Camberwell School of Art and the Central School of Arts and Crafts. In 1937 he had won first prize in the International Print Exhibition at the Art Institute of Chicago, with his etching 'The Bath'. In 1948 he was elected a Fellow of the Royal Society of Painter Etchers and spent the next 23 years at the Leeds College of Art, first as the Head of Design and then as Principal. He was also Assistant Director of Leeds Polytechnic from 1969–71, after which he became a full-time artist.

Eric Taylor has held one-man exhibitions in the Art Galleries at Wakefield, Menston, Middlesbrough, Harrogate, Settle and the Design Innovation Centre, Leeds. He has exhibited at London Group, New English Art Club, Royal Academy and during the war itself, by invitation of the British Council, his work was exhibited in many countries around the world. Today his work can be seen in collections like the Art Institute of Chicago, the National Gallery of Art in Washington, the Imperial War Museum, the British Museum, Victoria & Albert Print Rooms and the Ashmolean Museum. His work can also be seen at Leeds University Gallery, where a Retrospective Exhibition of his work was held in 1994, which he considers to have been the most meaningful exhibition of his career.

As a war artist Eric Taylor produced numerous studies of refugees fleeing across Europe and historic moments like the crossing of the Rhine at Nijmegen, but his most harrowing pictures were made at Belsen Concentration Camp in 1945. In the Imperial War Museum is a drawing of a woman on a bed, with dark ringed eyes. Before making the drawing the artist asked her, 'Do you mind if I draw you like this?' She replied, 'No, your drawing will let people know.' Other drawings show sad images of human suffering; one in particular shows a near-naked man on a makeshift structure, with his thin arms raised to show his ribcage, his shaven head fallen back with parted lips. Is he still barely alive, or dead?

Eric Taylor's paintings of Belsen Concentration Camp, now in the Imperial War Museum, are one of the saddest records of human suffering ever made, and a poignant reminder to future generations of why the Second World War had to be won at all costs and Hitler's Third Reich defeated.

Eric Taylor writes:

I was working part-time at Camberwell School of Art and the Central School in London, teaching life drawing when war was declared. All part-time employment ceased at that stage, so, finding myself un-employed, I joined the first batch of volunteers and was enlisted in the Royal Artillery. Freda and I had agreed to marry before I started training at Deepcut near Aldershot. We were married by special licence and two weeks later I was in the army, where I remained for six years.

After two years' square-bashing and gun drill on 25 pounders I was posted to somewhere near Worksop, where I helped with the training of 1500 young conscripts under canvas. They were ill equipped for marching and blistered feet was a common ailment.

I next found myself at Seaton Carew near Hartlepool in charge of a gunpit in a dugout on the sand dunes. With the wide sweep of the bay including Hartlepool, we waited for an expected attack by the Germans. We longed for the Germans to appear as the boredom and isolation became increasingly worse. I spent most of my time drawing a very detailed panorama of the bay giving details of all gun ranges and this was fixed to the wall above the gun in readiness.

One day a Brigadier arrived to inspect the gun pit and its crew and after seeing the panorama exclaimed, 'You are too good to be wasting your time here. I will have you moved to something else.'

I was next moved to Newcastle to await orders. I was posted to a Glaswegian Regiment whose vocabulary I couldn't understand for the life of me. I suffered a week and was then posted to the Darlington Camouflage School, where I studied camouflage and was later a lecturer to all ranks. I was made a sergeant and put in charge of all personnel. Among the practical jobs we completed was the concealment of radio location posts along the coastline. One of these at Craster in Northumberland had to be a veritable full-scale imitation landscape over the cliff tops.

After two years of this I was posted to Aldershot again, for a short course on explosives as an invasion was then feared. I was then sent to join a small group of infantrymen in Bishop's Lydeard, Somerset, to be in charge of explosives and tuition in readiness to blow up bridges, roads and railways – a sabotage unit. I was transferred to the Royal Engineers.

Our other duties were to dig large dugouts all over Somerset in which corrugated Nissen huts were buried to hold ammunition and explosives. These were also very well concealed but it involved bringing in the Home Guard units in the area to help in the event of an invasion. As many units consisted of reckless farmers, field exercises became one of the most dangerous events of my war. If the Germans had arrived they would have met a worthy bunch of saboteurs. At Bishop's Lydeard I found a farm near our billet where I went to ride horses when I had time off. This farm proved to be the home of Arthur C. Clarke the science fiction writer and inventor. He was then in his late teens at Taunton Grammar School. After the war he lodged with us in London whilst he took his degree at London University. We have kept in touch with him and his family ever since.

The next event involved our own plans for invasion with the Normandy landings being prepared. I was posted to Three Bridges to assist the landing with a small camouflage unit. It turned out to be little like the camouflage that I had learned, as it was entirely concerned with offence. We landed at Arromanches from a tank landing vehicle about four days after D Day and were soon involved in bombardment. Eventually we camped in a wooded area, at that time holding about seven square miles of territory. The Germans dropped leaflets telling us to give up as our position was hopeless. Next, however, was the Battle of Caen for which our job was to conceal our attacking tanks.

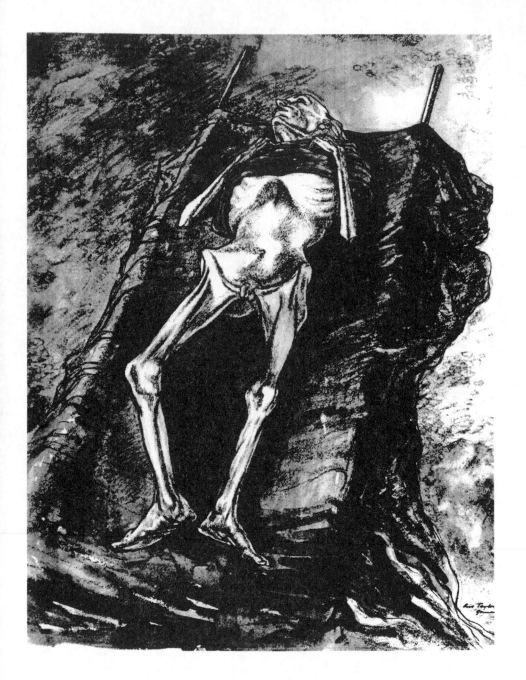

A living skeleton at Belsen Concentration Camp
watercolour painted by Eric Taylor in 1945
(*Reproduced with the permission of
The Imperial War Museum, London*)

When the war started I had applied to become a war artist, but found all such jobs had been filled months before. I obviously did not know the way of things, but as it turned out I was lucky. War artists seemed to be posted largely to 'home affairs', but I was getting a chance to make notes of actual events in the progress of the war, which later proved beneficial to the pictures I was able to send to Sir Kenneth Clark who was the chairman of the War Artists Advisory Committee at the National Gallery. He suggested I send home whatever I could as things developed.

The Falaise Gap was my next horrific experience, where the German Army was surrounded by British, American and Canadian troops. We found the Germans were even using horse-drawn vehicles in desperation, as the Russian front had also started by this time.

The stench of death, both animal and human lived with me for many years.

Soon after we landed I had the most miraculous escape that you could imagine. My Lieutenant and myself had taken a jeep on a reconnaissance of the front line and in a convoy of vehicles came to a point being bombarded by mortar fire. One exploded about five yards in front of us and shrapnel perforated the jeep everywhere. A spade strapped to the side of the jeep next to me was completely shattered, like most of the vehicle. The entire chassis beneath and the hood above were perforated and we found the young driver to be dead. All I had was a small piece of shrapnel in the neck. The Lieutenant was untouched. We carried the young driver on a garden gate to the nearby MO station where the shrapnel was removed. When the effect of the blast had cleared I could only thank the Lord for my survival.

We eventually broke out and one day came a major advance that went so far as to include the relief of Brussels – a memorable day. And so on into Holland and Germany.

We remained in Holland for some months bogged down at first by the mud. We were then billeted in local houses where I made lifelong friends. We still correspond and there have been many visits either way with the extending family.

On our way through Germany we had to cross the Maas and the Rhine, the latter being quite a major operation. Our job was to conceal the assault boats on the banks where the crossing was made. We worked for two weeks under a smoke screen and a

continual artillery barrage. The crossing was made at night and the Engineers constructed a complete bailey bridge during the night to transport tanks etc. We crossed to encounter thousands of stunned Germans who were taken prisoner and after that resistance seemed to crumble.

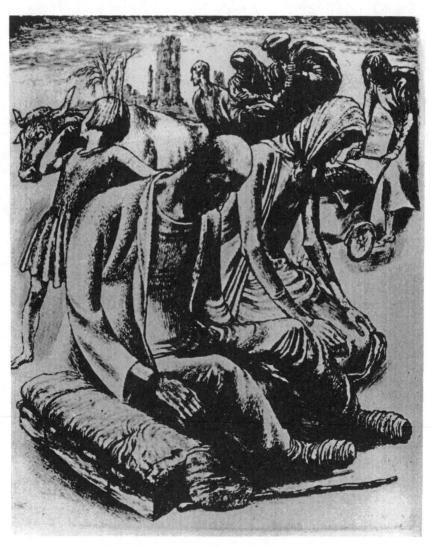

An etching of refugees in Normandy by Eric Taylor, which was made some time after D-Day. The etching was purchased for presentation to the Print Collectors Club in 1945
(*Photograph courtesy of Eric Taylor*)

I finally reached Lübeck on the Baltic and on the way we had encountered Belsen and all its unbelievable horrors. (Note 1)

At Lübeck, after the war had finished I was asked to run an Art School for the three services stationed nearby in a Shipping Office.

I had to indent for all material and items required and get approval from the Town Major. I indented for two artist's models and submitted it to him.

'Models!' he exploded, 'What is the army coming to? No!' A word with HQ reversed his decision and I got two art students from Berlin and with these I was able to run a life class and renew my skills of drawing.

My work had gained much from the experience of war as I think it does from all experience. After a few months I was demobbed and returned to a bomb-damaged house in London and my family.

NOTES:

(1) After the crossing of the Rhine in March, 1945, and the Soviet invasion of eastern Germany, the full horror of Hitler's Third Reich began to emerge. As the concentration camps were overrun, Allied soldiers, hardened by the horrors of the battlefield, were sickened by the discovery of thousands of men, women and children, who had been subjected to a cruel policy of deliberate starvation. There were two types of camp in Germany and Poland, concentration camps and extermination camps, although in reality, at many of the concentration camps, where prisoners were often used by the Third Reich for slave labour, the Jews were so badly treated and poorly fed that thousands died while in captivity there. Bergen-Belsen was a concentration camp, while at Treblinka, Chelmno, Sobibor, Belzec, Majdenek, and Auschwitz-Birkenau, all of which were located in Poland, prisoners were taken for extermination. However, towards the inevitable collapse of Germany, many of the concentration camps also became the site for mass murder. Prisoners were often killed in specially built gas chambers, after which their gold teeth were extracted and their bodies opened and filled with tar, in order that they would burn more efficiently in the ovens of the crematorium. Hitler was responsible for the extermination of six million Jews, and millions of Soviet and other ethnic prisoners.

Chapter Four

IN REMEMBRANCE

This chapter is dedicated to the memories of two more leading artists who served in a branch of the armed forces during the Second World War, but unlike the painters in the last two chapters, their stories are largely told by other people.

The first of these is the highly acclaimed Scottish painter William Gear, who served in the Royal Corps of Signals. When I began my research for this book, William Gear very kindly provided an article for inclusion and the first part of his story was written by himself in November, 1996. Sadly, William Gear died in 1997, but I have been able to enlarge upon his story thanks to his son David, who has provided me with his own recollections of his father's war service and information gathered from other sources available to him.

The second artist in this section is Rex Whistler, who served in the Welsh Guards. You may remember that in the first chapter architect Sir Martyn Beckett, who also served in the Welsh Guards, told us something about Rex Whistler. He is the only artist featured in this book who was actually killed during the war, and he is included because of his influence on the post-war art scene. His story is written by his artist brother Laurence Whistler, who served with the Rifle Brigade, and is therefore a reflection of his own memories from the time, as well as an account of his brother's life and death.

WILLIAM GEAR RA

(PAINTER)

Artist William Gear was Head of the Department of Fine Art at Birmingham Polytechnic until his retirement in 1975. His work hangs in collections around the world, including the Tate Gallery, Victoria and Albert Museum, the Contemporary Art Society, the British Museum, the Arts Council, the Scottish Arts Council, the Scottish National Gallery of Modern Art, and in galleries from Tel Aviv to Canada, New Zealand and the USA. He was elected a member of London Group in 1953 and also designed furnishing textiles for various firms.

William Gear was educated at the Edinburgh College of Art and Edinburgh University. He won a Travelling Scholarship in 1937 and spent a year in France, Italy and the Balkans. Between 1958–1964 he was the curator of Towner Art Gallery, Eastbourne. Then, until 1966, he was a guest lecturer at the National Galleries of Victoria and Melbourne, and the University of Western Australia.

During his career he has been the chairman of the Fine Art Panel for the National Council for Diplomas in Art and Design, and chairman of the Fine Art Board, CNAA.

War service with the Royal Corps of Signals and the Cheshire Yeomanry took him through Italy and Germany, where the destruction and horror had a profound and lasting effect on his outlook, reflected in his work. Before following the war into Europe he had already served in the Middle East, mainly in Palestine, with trips to Transjordan, Lebanon, Syria and Cyprus.

Although William Gear's talent as a signals officer was used on many fronts during the war, the interesting thing about his story is the amount of art he was able to produce, even during the campaigns in Italy, which he now explains.

In early 1940 I was teaching Art in Dumfries. I was called up and posted to the Royal Corps of Signals at Whitby. After only a few weeks I was sent to the Signals OCTU at Aldershot, where I was commissioned. There followed a 'luxury cruise' from Liverpool to Suez, via Freetown and Durban.

I was posted to 5 L of C Signals based in Jerusalem, and spent periods in Haifa and Gaza, with side trips to Transjordan, Lebanon and Syria. (Note 1)

Around this time the Cheshire Yeomanry were being converted into Signals and I became one of the 'regular' signals officers with the Cheshire Yeomanry. (Note 2)

During my time in Palestine I was able to do some painting and even exhibited with some of the local artists.

I was then posted to Cyprus for several months with a company of Cypriot troops, building telephone lines across the island.

There followed several postings in Italy in early 1944, and, since I spoke Italian fairly well, I was taken on as the Signals Officer of a British Liaison Unit with an Italian Combat Group, 'The Folgore'.

I had made a special point of meeting Italian artists· and knew several in Rome and Siena. I had a one-man show in Florence.

During my military service there would be periods when one was busy and other times when one had the chance to do some painting. I would work wherever I happened to be stationed, sometimes in a tent or in some farmhouse billet. Since I painted only using water-colours this was no problem. Generally I was able to procure materials from one source or another.

When the war was over, having spent four and a half years overseas, I was eligible to return to the UK. I still had a few months to serve before normal demobilization. I opted to go to Germany.

After a few weeks with a Scottish Division near Hamburg, I was selected to join the Monuments, Fine Art and Archives Section of the Control Commission. I was based in Celle, a charming, though small town.

We had taken over the Schloss as a Central Repository for the hundreds of cases of treasure from the German Museums which had been stored in nearby salt mines during the war.

I arranged a series of exhibitions of some of this material. These exhibitions were mounted in the Schloss itself, where the treasures were stored. In the course of time, as the German authorities were

able to rehouse their collections, having restored their Museum premises, the treasures would return to them.

At the same time I did some painting myself, and had a one-man show in Hamburg.

I had signed on for an extra year and in April, 1947, having reached the rank of major and therefore in receipt of a useful gratuity, I was demobbed, and more or less made straight for Paris, where I spent the next three and a half years.

NOTES:

(1) The trouble in Syria started in 1941 when pro-German Vichy French forces under the command of General Henri Dentz, threatened to invade the Middle East from the north. General Wavell sent an army of 20,000 men from Palestine and Iraq into Syria, backed up by Free French forces commanded by General Catroux. Damascus was captured on 21 June and the area transferred to the control of the Free French. Most of the Vichy troops volunteered to join Catroux's command and British involvement in the area came to an end.

(2) Many cavalry units had arrived in Palestine, complete with horses, but it was decided to try and give them a more practical role in a modern war. The Cheshire Yeomanry had seen action in Syria, clearing out the Vichy French, after which there was little use for them. They were trained to become Signals and were organized into squadrons, backed by proper Signals officers and men, such as William Gear.

The following article about William Gear RA 1915–1997, has been compiled with the help of his son, David Gear.

While working near Dumfries in the spring of 1940 William Gear was called up for military service, and had to report to the local recruiting office. Asked about his interests, he replied that he liked listening to music. The interview board wondered how this was possible, implying that Dumfries could not host many concerts. When he explained that he listened to music on the radio, the questioner wrote

down the word 'radio', and William Gear suddenly found himself in the Royal Corps of Signals.

He reported to Whitby for his basic training, which was a major establishment for Signals. However, while he was still at Whitby, Dunkirk took place and he, along with all the other men under training, were sent to defend a stretch of fortified coastline in case the Germans invaded. William Gear was put in charge of a section of twenty men, armed only with rifles, who lived in tents and had to dig slit trenches along the coast. After things had quietened down a little, the Signals training battalion was relieved by a regular army division.

After being commissioned at Aldershot, he was posted to Bakewell in Derbyshire. Reporting to the adjutant at headquarters in Haddon Hall, a stately home near the town, he was asked, 'Have you got your tropical kit, Gear?' Which of course he hadn't, so during the next five or six weeks, as he prepared to move abroad, he had a tropical uniform made by a local tailor.

Sailing from Liverpool, William Gear landed in Egypt and was posted to a Signals Base at Mahdi, near Cairo, for a short period, where there were roughly twenty officers and five hundred men. Each officer was interviewed at Regimental headquarters to decide where in the Middle East theatre to send them. William Gear was subsequently posted to 5 L of C Signals in Jerusalem – L of C meaning Lines of Communication.

He arrived in Jerusalem by train from Cairo in July, 1941, and was immediately inspired by the beauty of the city. He was met at the station by the adjutant and the sergeant-major, who incredibly took him to a local estate agent to find suitable accommodation. The estate agent asked him if he had any preferences, and, pointing out that he was an artist, he was even found lodgings with a studio, which belonged to a Jewish-German family who lived in a fashionable part of Jerusalem called Rehovot.

Gear soon realized that he had entered a very different world from many other wartime officers. British troops had been engaged in a war in Palestine before the Second World War had begun and the area was garrisoned by regular troops who still worked under the old Colonial system. This meant that officers were afforded all sorts of perks, such as Colonial, Servant and Fan Allowances.

He soon became Signal Master, and 5 L of C Signals were the main Signals Unit for the 9th Army, providing communications between

Cairo, Jerusalem and all British troops in Lebanon, Syria and Jordan. However, although he was a competent soldier, Gear was first and foremost an artist and he soon got to know many of the local painters and galleries. During his stay in Jerusalem he stayed in three different digs, and by obtaining an easel and painting materials, he was able to produce and exhibit paintings in several of these galleries, even exhibiting work in Tel Aviv and Cairo of British artists in the forces.

After becoming a Signals Officer with the newly converted Cheshire Yeomanry, Gear was posted to Gaza. The strange thing about the situation in Palestine was that before the war the British Army had been dealing with Arab revolts, and as soon as the war was over the fighting began again, but during the Second World War itself it was perfectly peaceful and Gear was able to paint, enjoy life, and even had time to find a girlfriend – who was a painter herself.

While in Gaza he commanded the Line Section of about sixty soldiers, doing communications in the area down to Rafa and Beersheba. His company commander took him aside one day and told him that he had been put forward for promotion to Captain. However, a fortnight later he was told that 'something's gone wrong'. He was to be sent to Cyprus, where there was already a senior lieutenant. This other lieutenant was going to come back to Gaza and get his job – and the promotion! Gear later reflected that in his opinion he didn't get the promotion because of his local girlfriend. He had been seen out one night at a restaurant in Jerusalem by the top brass in the Signals and the military authorities didn't like their young officers getting too close to the local girls. So it was off to Cyprus. Gear didn't enjoy his work in Cyprus and, as the invasion of Italy had begun, and as he could speak Italian, he wrote to his CO asking for a transfer to the Italian front.

In Rome there was a considerable community of painters and he soon found many friends. He arrived in Rome in 1944 with a large metal trunk. Maybe his army colleagues expected a Signals officer to have important radio equipment in such a trunk. So when asked to carry it up the narrow, winding stairs of the pensione they had requisitioned, they were prompted to ask what it contained. He replied, 'Just a few rather good frames I bought in Naples, and of course my pictures and painting materials.'

Shortly afterwards he put on an exhibition of his paintings in Florence. There were about thirty items, framed, but without glass,

as glass was unobtainable. The organizers even produced a sort of catalogue and invited local Italian and Florentine artists to an opening.

However, it was soon back to war. With the collapse of Italy, the Italians provided troops to fight against the Germans – several divisions plus ancillary troops. With each Italian division was a British Liaison Unit and Gear was appointed as a Signals Officer with one of these units.

The division was being equipped and trained near Naples, but eventually took up its position north of Florence, relieving an Indian division. Gear was a Signals Officer in command of one junior officer and a section of about thirty British troops. They provided signals, in the first instance, to their British headquarters, and then to the Italians. The division included the San Marco Brigade of marines and a brigade of Italian parachutists.

At the time the war finished Gear was in the north of Italy near Bolzano. There was a system in operation called 'python' which meant that if you had served four and a half years overseas you were entitled to go home. Gear qualified and, after taking a jeep – with driver – all the way back through Italy to Naples, he was flown back to England in the nose of a Lancaster bomber.

He reported to Scottish Command at Edinburgh Castle, as he still had a few months before demobilization, and rather than hanging around Scotland he opted to go to Germany. He was posted to the 15th Scottish Division at a base near Bielefeld. It was noticed that he had studied the history of art and he was approached to join the Monuments, Fine Arts and Archives section of the Control Commission, based in Celle. The Archives looked after anything to do with museums, galleries, libraries, loot, and Nazi treasure. To preserve their art treasures the Germans had put literally hundreds of packing cases full of works of art in salt mines near Celle, at a place called Grasleben, very near the Russian zone. All of this treasure had to be taken back to the Schloss in Celle, which was their central repository. The idea was to check through it and catalogue it – and where possible return it to its original home – employing the services of many of Germany's original museum and gallery curators. Much of the treasure had come from Berlin and there were dozens of cases of porcelain, incunabula, ancient manuscripts, Greek and Roman pottery and jewellery. Exhibitions were organized, including

one based on a portfolio of Degenerate Art which contained the work of Picasso, Matisse, Chagall and Munch.

By now Gear was a Major and found himself very actively assisting Germany's post-war cultural renaissance. He gave authority for the local Hanover Art Society to hold an exhibition, but on attending the show's opening he thought the standard of work being displayed was dreadful. However, un-hung, and pushed behind a screen, he stumbled upon some modern works which he described as 'extraordinary'. He demanded, 'Hang them, bloody well hang them,' and the organizers jumped to the orders of Herr Major Gear. Delighted and intrigued by his discovery, William Gear sought out the artist. He found him living with his family in straitened circumstances in a tiny room above a cowshed in the middle of nowhere. The name of the artist was Karl Otto Gotz, who went on to become one of Germany's finest painters. Gotz had been a pilot with the Luftwaffe during the war and his type of modern painting had been unappreciated and banned by the Third Reich.

After demobilization William Gear went to Paris, which is where everything was happening at that time in the artistic world, only returning to England some four years later, when an exhibition of his work was staged in London.

REX WHISTLER
(Painter)

The second painter in this chapter is particularly relevant because, unlike all the other contributors to the book, he was actually killed on active service in July, 1944, leading his troop of tanks into action in Normandy.

The name, Rex Whistler, has already been mentioned once or twice in the book by other contributors, which helps to illustrate his standing and influence. Yet during his own lifetime, common to many great artists of the past, he was almost disregarded by the critics. Today, he is considered to have been one of the most talented artists of the inter-war years.

Rex Whistler is particularly well remembered for his wonderful murals, perhaps his best known being at Plas Newydd in Anglesey. His illustrations can be seen in books like *Gulliver's Travels* and *Hans Andersen's Fairy Tales*. He was also a very gifted theatre and film designer, and today his paintings are very sought after. At only twenty years of age, Rex Whistler was invited to paint the murals on the walls of the restaurant at the Tate Gallery in London. Imagine, if he had survived the fifty years of peace which followed the Second World War – as our other contributors have – what he could have achieved.

The remarkable story of Rex Whistler is written by his younger brother Laurence, himself an artist of some renown. As a poet he was awarded the first Royal Gold Medal. As an engraver he was appointed the first president of the Guild of Glass Engravers, and was largely responsible for a revival in glass engraving. His poems have been published in books such as *The View from This Window, Audible Silence* and *To Celebrate Her Living*. He has also written books about engraving and architecture, as well as the highly

acclaimed *The Initials in the Heart: the Story of a Marriage.*

During the Second World War Laurence Whistler was commissioned into the Rifle Brigade; he was awarded the CBE in 1974. He has produced several books about his brother, and the article which follows abbreviates material from his 1985 biography *The Laughter and the Urn: The Life of Rex Whistler*, re-published by Weidenfeld & Nicolson Limited.

At the time war was declared on 3 September, 1939, Rex Whistler had been commissioned to paint the murals at Mottisfont Abbey near Romsey, which is where the story begins.

Rex was up a scaffold by the bay window at Mottisfont with his portable radio beside him. Dipping his brush, he wrote a message on the top of the cornice, and then left at once for Salisbury, to be with his parents on their way to the cathedral. The message was not found for many years. 'I was painting this Ermine curtain,' it reads, 'when Britain declared war on the Nazi tyrants. Sunday, September 3rd, R.W.'

Kenneth Clark, as Director of the National Gallery, was assembling a body of Official War Artists on the model of those who had memorably recorded the First World War. His committee was approaching artists whom he knew and admired, and inviting others to apply. Here Rex was at a disadvantage. The truth is, he did not come to mind. Always lacking serious critical acclaim, he never seemed to be a serious artist. Also, he was 'not of this age'. It was hard to see him usefully in contact with a war.

At the first committee meeting in November, 1939, Clark announced that 'care was being taken that none who might reasonably have a claim for consideration were omitted'. Fifty-one artists were listed, increased to eighty-six by Christmas, and with a Scottish contingent to about a hundred. Rex was not included so far. But in January, 1940, his name appeared on a list of a hundred and eighteen more, with a 'no' pencilled beside it. A month or so later, when seven hundred and fifty had been considered, he was one of those thought to be worth keeping in reserve. I doubt if he knew. It was too late, in any case. Friends tried to get him for a battery recruited from the arts, because it was 'so unlike the army', but he did not think this much of a recommendation. If one had to be a soldier one might as well be with the best. He failed when recommended to the Grenadiers

by the Queen's Treasurer, but succeeded in the end with the Welsh Guards.

He was given a platoon and was despatched to protect Hampton waterworks from paratroops. Another task was to guard Heston aerodrome and be billeted in empty Victorian villas, where a guardsman had committed suicide. Rex was not surprised, and painted the walls of his own platoon's billet with flags, emblems, etc, as 'otherwise all our soldiers will commit suicide'.

At Sandown (where the training battalion had moved) he was granted, for studio, the upper room of the grandstand, all arches and bastard Corinthian, from which he could see both Windsor Castle and Hampton Court Palace. Here he painted a plump master cook (Sergeant Isaacs of the Welsh Guards), one of his best portraits; also a tough Jock Lewes with a bren-gun on his knee, then about to leave for Libya, where he would inspire David Stirling to create the SAS with him, and die too quickly on a raid ever to receive his share of credit. Also he painted a landscape target, over nine feet long, to practise street fighting at the miniature range, with three street vistas and a sniper here and there. The King, after a visit, left a message with the CO that he ought to put in 'many more quislings'. Rex was quite content for it to be shot to pieces, but obviously it could not be spoilt. For his platoon he drew out on roller-blinds the correct kit lay-out for two kinds of inspection, absolutely factual though bordered by palm leaves, etc.

He now had to share his studio for a while with the other Welsh Guards artist, Simon Elwes, whom Rex described as 'that pompous lump of Elwes'. There came a moment when some art-work was needed, and thoughts turned first to Elwes, who had long since been in *Who's Who*, as Rex never was, earning more with one adroit portrait of a notable than his companion with a painted room. 'We can't ask him – he's an artist!' said the second-in-command. 'I expect Rex will do it.' After mutual dislike had resulted in words and the throwing of a ham bone in the mess, Simon Elwes had the Colonel's approval to move on, and presently became a lieutenant-colonel in public relations.

To meet a German invasion, still thought probable, new armoured divisions were required and in 1941 Alan Brooke recommended forming one in the Brigade of Guards – traditionally infantry. Being given the choice himself, Rex chose tanks, as less wearisome than

endless foot slogging, more dashing and more interesting. The Welsh Guards were to have lighter tanks, for fast-moving reconnaissance, and accordingly he was posted to the Second Battalion at Codford St Mary.

At this time Rex agreed to illustrate *The Last of Uptake*, by Simon Harcourt-Smith, as well as completing *Königsmark* for A.E.W. Mason, both produced in army huts between fatiguing days of training. The baroque inventions for *Königsmark* are in sepia with delicate touches of pink. Mason left the illustrations to the Tate Gallery.

There had to be a symbol designed for the new Guards armoured division and the GOC consulted Rex. In the end the Eye of the Guards Division in the First World War was revived, and Rex painted a different sample eyeball on each of twelve tanks.

In the months before D-Day Rex designed, in sequence, a play, a ballet, a film and a calendar. He had been asked by Sadler's Wells to redesign the ballet *Le Spectre de la Rose*. Osbert Sitwell persuaded him to do the designs for a film of his Edwardian story *A Place of One's Own*, and he discussed an important project with John Gielgud, who afterwards wrote of 'two memorable evenings with him while he filled a sketchbook with little vignettes and projects, creating and discarding by the hour an unending flow of witty and beautiful ideas.' These were for *A Midsummer Night's Dream*. He also decorated the officers mess in Brighton. It showed, very large, a corpulent 'Prinny' as Cupid, nude but for the Garter Ribbon and the Star that lolled on his right buttock – about to arouse from sleep a seductive Psyche, nude too, but with a wispier ribbon, bearing the word 'Brighthelmstone'. His lifted finger warned against interruption, and wherever the beholder went in the room a lewd and sidelong glance would follow him. The title: 'Allegory. HRH The Prince Regent awakening the Spirit of Brighton.' Warm as a Titian in its crimson, blue and flesh colour, it held satirical and classical in balance, being funny and beautiful at once. While this progressed, the rest of the room was undertaken: a plaque of George IV over the chimneypiece; the regimental leek, very bright and large, elsewhere; then chinoiserie trees all round, skilfully redeeming the villa-wallpaper frieze of fruit and flowers. The result was a painted room, signed and carefully dated, 'June 5th-7th 1944' – as if to say, done while the world held its breath over D Day.

NOTES:

Rex Whistler, as troop commander, led his three tanks into 'Goodwood', the British attempt to break out of the Normandy bridgehead in July, 1944, and was killed by a mortar bomb – the first of his battalion to fall. His brother, Laurence, going on leave, bought an *Evening Standard* at Waterloo Station, and under a reproduced drawing of bowler-hatted bandsmen in a garden, which looked familiar in style, he read, 'One of Rex Whistler's last sketches. Art and the Stage suffer a considerable loss.'

Laurence Whistler later wrote:

'A wave of heat brimmed up in me from chest to scalp, and a decision seemed to be made for me that instant to say nothing, show nothing, to the others in the compartment. It was too intimate to be told, too enormous to be made visible.'

Following *The Times* obituary, the editor received more letters about Rex Whistler than about anyone killed in the war, but found room only for John Gielgud's.

Rex Whistler was killed during 'Operation Goodwood' in July, 1944. After D-Day the Allied advance across the French mainland was slow. German garrisons at Cherbourg and Caen put up strong resistance and the countryside wasn't very suitable for the movement of armoured vehicles. But if the war was to progress further, a breakout from the Normandy bridgehead would have to be attempted. Then, in mid-July, Sir Bernard Montgomery – still only a general – launched 'Operation Goodwood'. The Allied troops in the area were suffering under a tremendous bombardment from the Luftwaffe and German artillery, so Montgomery pushed ahead with three armoured divisions between Caen and Falaise, across the Bourguebus Ridge.

'Operation Goodwood' didn't achieve the breakout that the Allies had expected, because the Germans reinforced the area with their own armoured divisions. However, it did succeed in drawing the Germans away from the area around Avranches in the south, which enabled the Americans under Lieutenant General Omar Bradley to attempt their own breakout on 25 July – codenamed 'Operation Cobra'. After carpet bombing the area with more than 4,200 tons of

explosives, the Americans opened a gap in the German front line, wide enough for General Patton's Third Army to break through with whirlwind speed on 1st August. Although the Germans made a counter-attack at Avranches between 6-10 August, by the 20th they were in full retreat, leading to the liberation of Paris on the 25th.

Chapter Five

THE SHAPE OF DESTRUCTION

Kenneth Armitage and Franta Belsky, who recount their experiences in this chapter, are two of the most highly respected sculptors in the world today. Both served with the Royal Artillery and both were able to utilize, to a certain degree, their training as artists in the service they provided.

Among other well known sculptors who did military service is Sean Crampton who also spent three years with the Royal Artillery, before being commissioned into the London Irish Rifles after attending the Middle East OCTU in Palestine and serving a further four years. He served through three major campaigns, finally losing a leg in the Battle of Monte Cassino, in Italy, in 1944. He was awarded the Military Cross in 1943.

Sean Crampton recalls, 'For me the war was a profound, immense, bitter yet magnificent experience, which deeply affected my subsequent life. As a student I visited Nazi Germany in 1937, which convinced me that war was inevitable, so I joined the Territorial Army in 1938. My service left so many memories which now come tumbling out in a kaleidoscope of images. There is the wild blazing drama of a full-scale infantry attack; the intense highly strung excitement of night patrolling within yards of the enemy positions; the grim reality of cleaning up the mess after a battle; the burial parties; drum head services; the intense boredom of isolated gun sites; the four-month journey on a trooper; crunching through smashed glass on the pavement during the blitz. Images of savagery; friends' marvellous courage; bitter enmities; blood and salvation!'

Other sculptors who served during the war include Edward McWilliam, Bernard Meadows and Aharon Remez, all of whom

served in the Royal Air Force, Michael Rizzello who served with the Indian Army and David Wynne who served in the Royal Navy. A particularly fine example of David Wynne's work can be seen at the Goldsmiths' Hall in London. The bronze head of Her Majesty Queen Elizabeth II, wearing the St Edward's Crown, was presented to the Goldsmiths' Company in 1973 by Andrew Grima, jeweller by appointment to HM The Queen, who recalls some of his own war experiences later in the book.

In the following account of his own military service Franta Belsky describes how he was inspired to model a statue of Winston Churchill, after his regiment had been visited by the prime minister at Cholmondeley Park, where they were stationed at the time. Another famous statue of Sir Winston Churchill stands in Parliament Square, and was sculpted by Ivor Roberts-Jones, whose other works include the Augustus John memorial at Fordingbridge in Hampshire and the Rupert Brooke memorial at Rugby School.

Ivor Roberts-Jones was educated at the Goldsmiths' College School of Art in London and during the war, like fellow sculptors Kenneth Armitage and Franta Belsky, he was employed as a gunner. After being sent to India with the Jungle Field Artillery he eventually served on the Arakan front in Burma. His future work was greatly influenced by the temple sculptures he saw in India, at Ajanta and Ellora, where he noted how the great Buddhas had an ability to draw space into themselves. He also emerged as a distinguished war poet and his poems exude similar qualities and influences which later emanated from his sculpture, the essential characteristic of which observed sculptures as being containers of light. Although he crafted numerous works on a heroic scale, he is best remembered for his portrait heads of people like Yehudi Menuhin, Viscount Tonypandy, Paul Claudel and Kyffin Williams. The work of Ivor Roberts-Jones can be seen in the National Portrait Gallery, the Tate Gallery and the Contemporary Arts Society Collection. He held Retrospective exhibitions at the Welsh Arts Council's Oriel Gallery in Cardiff and the Eisteddfod in 1983. One of his most spectacular works can be seen at Harlech Castle in Gwynedd, North Wales, and shows an episode from the medieval *Mabinogion*, which powerfully depicts the pitiful folly of war.

KENNETH ARMITAGE CBE RA
(SCULPTOR)

It's fascinating to discover how military service influenced the post-war art scene. Not always heroic and epic paintings in the style of Lady Butler, but the subtlety and almost subconscious influence of shape and movement. The work of sculptor Kenneth Armitage, who served with the Royal Artillery during the Second World War, is represented in the Victoria and Albert Museum, the Tate Gallery, Museum of Modern Art (New York) and the Musée D'Art Moderne (Paris).

Better known for producing solid, sturdy 3-dimensional shapes, his work in the early 1950s often had a resemblance to aircraft in flight. People said they couldn't trace the influence and it was only after several years that the sculptor himself realized he had been working subconsciously from images he had observed during the Second World War, when he was employed to study tank and aircraft silhouettes.

Kenneth Armitage studied at the Leeds College of Art and the Slade School of Fine Art, London. After the war he taught at the Bath Academy of Art until 1956 and was a Gregory Fellow of Leeds University. Through the years his work has seen many transformations, from massive and extremely abstract groups, to smooth, doll-like figures. Always original, he is one of the most respected sculptors of the 20th century.

During the early stages of the war quite a common occurrence was for British aircraft to be wrongly identified by gun crews and consequently shot down by friendly fire. In order to redress this situation a school was set up near Aldershot to run courses in tank and aircraft recognition and Armitage was tasked with its running, which he now explains.

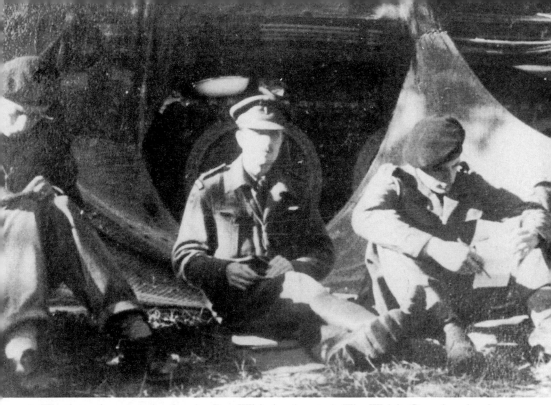

1. The last photograph of artist Rex Whistler (centre). The Welsh Guards relax in an orchard in Normandy, a few days before their first action after D Day. *(Photograph courtesy of Sir Martyn Beckett.)*

2. "On the job at Cod Bay." Edward Hollamby during the construction of slipways, a traverser and a jetty for a Torpedo Recovery Launch Base. *(Reproduced with the permission of Edward Hollamby.)*

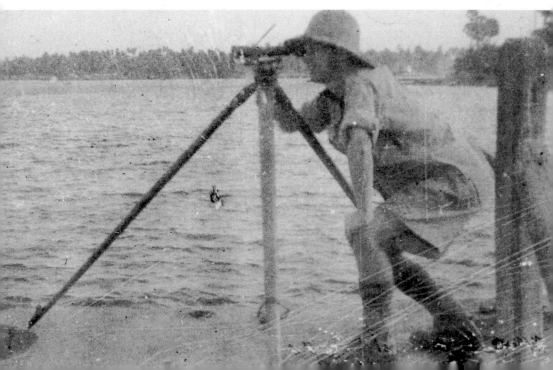

3. Somewhere on the Arakan: Claude Harrison in Burma in 1943 wearing a civilian shirt dyed dirty brown. "Before the issue of jungle green battledress," he says, "the troops were sent blocks of dye which they boiled up with their kit in oil drums."
(Photograph courtesy of Claude Harrison.)

4. Photograph of painter Arthur Hackney taken in New York in 1943.
(Photo courtesy of Arthur Hackney.)

5. HMS *Cotton*, the ship on which Arthur Hackney served during much of his war, returning to the USA for 'mothballing' in October, 1945.
(Photo courtesy of Arthur Hackney.)

6. Painter Anthony Eyton pictured in 1943. *(Photograph courtesy of Anthony Eyton RA.)*

7. Artist Richard Seddon in uniform. *(Reproduced with the permission of Richard Seddon.)*

8. After the war painter A. Stewart Mackay (right) served as a Staff Captain in Brussels. In this picture he meets Count Bentinck, who approached the British Army for protection, worried that local people would suppose him a collaborator after his castle had been occupied by German officers and his two daughters forced to serve in Germany with a searchlight crew. *(Photograph courtesy of A. Stewart Mackay.)*

9. Colombo, Ceylon, early 1944. War artist John Napper (right) acting as best man at the wedding of Captain Peter Hewett-Hicks. *(Photograph courtesy of John Napper.)*

10. Painter William Gear, as a 2nd Lieutenant in the Royal Corps of Signals photographed in Jerusalem in 1941. *(Photograph courtesy of David Gear.)*

11. Lieutenant Rex Whistler photographed by S. Smith, at Pickering, c1943. *(Reproduced with the permission of Laurence Whistler.)*

12. Photograph of No. 15 Troop, 3 Squadron, 2nd (Armoured Reconnaissance) Battalion, The Welsh Guards, Pickering, c1944. Rex Whistler front row (centre). *(Reproduced with the permission of Laurence Whistler.)*

13. No. 7 Holding Company, Welsh Guards. Correct layout for Kit Inspection, drawn by Rex Whistler in 1941. *(Reproduced with the permission of Laurence Whistler.)*

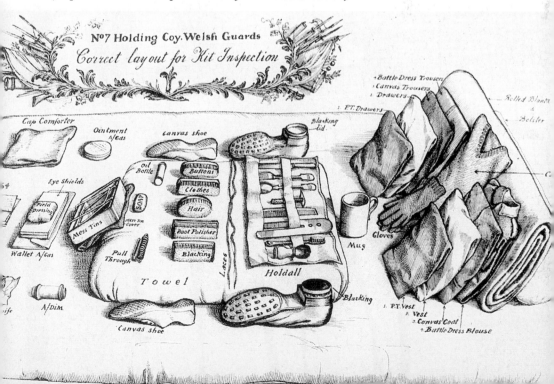

14. Sculptor Kenneth Armitage, CBE, RA, taken in 1994. *(Copyright Sue Adler)*

15. CHILDREN PLAYING, bronze by Kenneth Armitage, 1953. During the Second World War Kenneth Armitage studied the shapes of aircraft and tanks while serving with the Royal Artillery. In later years, the shapes he had studied became an influence on his work. *(Photograph courtesy of Kenneth Armitage.)*

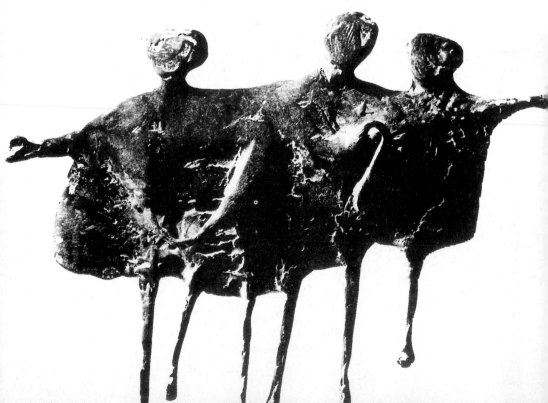

16. Sculptor Franta Belsky in December, 1944.
(Photograph courtesy of Franta Belsky.)

17. Hardy Amies, Dressmaker by Appointment to Her Majesty The Queen, pictured during the Second World War while serving with Special Operations Executive.
(Photograph Courtesy of Sir Hardy Amies.)

18. Andrew Grima (centre) - Jeweller by Appointment to Her Majesty The Queen, pictured in Burma during the Second World War, where he commanded the REME Divisional workshop of the 7th Indian Division, under General Messervy.
(Photograph courtesy of Andrew Grima.)

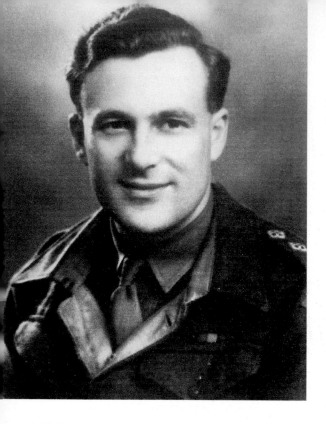

19. Bill Ward as a General Staff Officer Intelligence, Grade 3, at the time of working on the invasion of Europe.
(Reproduced with the permission of Bill Ward.)

20. Bill Ward (far right) in the Far East during the period of tidying-up at the time of the Japanese surrender. Bill Ward says, 'The three girls were Shahn's and the jeep belonged to a combined intelligence unit.'
(Reproduced with the permission of Bill Ward.)

1. James Bostock re-creates from memory a sketch he made of his commanding officer in the Middle East, under difficult circumstances explained in his article. However, the drawing hc did at the time was a straightforward head-and-shoulders pose, but this re-creation illustrates the CO's instruction to 'Get these in!'
(Drawing courtesy of James Bostock.)

22. Author and Film Producer Shaun Sutton when he was a Sub-Lieutenant in the Royal Navy during the Second World War.
(Photograph courtesy of Shaun Sutton)

23. An eye for design: the crew of HMS *Airedale* celebrate the crossing-the-line ceremony on their way to the Mediterranean via the Cape of Good Hope. Photographed by Shaun Sutton who had been an actor and stage manager before the war, using a camera given to him by the actor John Pertwee during their training together as officer cadets.
(Photograph courtesy of Shaun Sutton.)

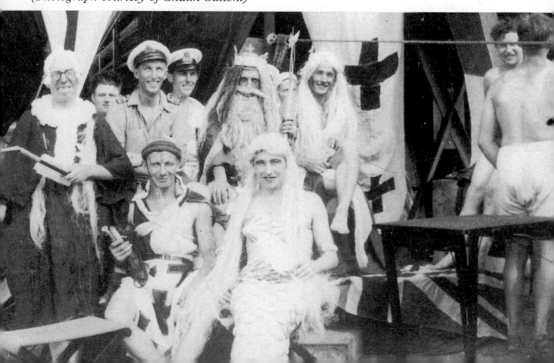

24. Author George MacDonald Fraser, whose screenplays have included the James Bond Film *Octopussy* and Arnold Schwarzenegger's *Red Sonja*. During the Second World War he served in Burma with the Gordon Highlanders *(Photograph courtesy of George MacDonald Fraser.)*

25. Crime writer Michael Gilbert served with the HAC before, during and after the Second World War. The above photograph was taken during the first post-war TA training camp at Larkhill on Salisbury Plain in 1947. *(Photograph courtesy of Michael Gilbert.)*

26. 'Y' Troop, 'D' Battery, HAC, pose for fun at the end of 1942, just before going abroad, with author Michael Gilbert on the far left. *(Photograph courtesy of Michael Gilbert.)*

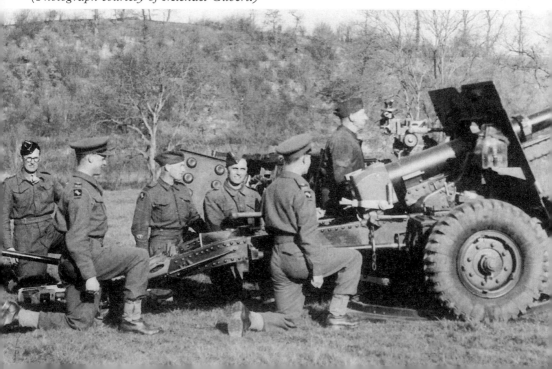

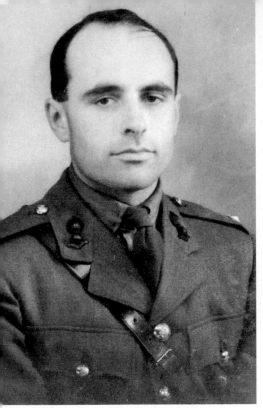

27. 2nd Lieutenant Ralph Hammond Innes. *(Reproduced with the permission of Cambridge University Library.)*

29. Along the Maas: author John Prebble photographed on 15 November, 1944 while serving with the Royal Artillery. *(Photograph courtesy of John Prebble.)*

28. Author Richard Hough pictured during the Second World War while serving as a fighter pilot in the Royal Air Force. His 1972 publication *Captain Bligh and Mr Christian* won the *Daily Express* Best Book of the Sea Award and was turned into a major Hollywood film *The Bounty* starring Mel Gibson and Sir Anthony Hopkins. *(Photograph courtesy of Richard Hough.)*

30. Novelist Nigel Tranter, pictured during his period at OCTU. *(Photograph courtesy of Nigel Tranter.)*

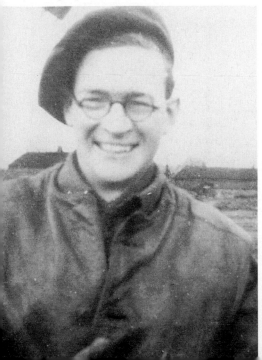

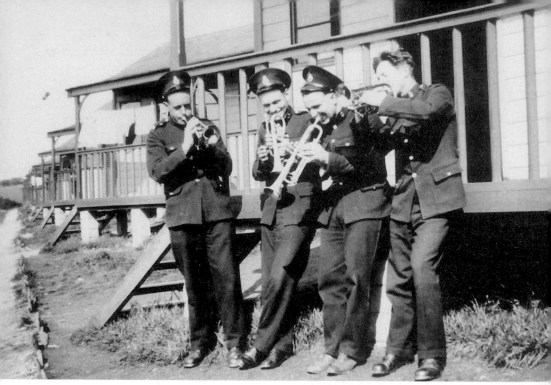

31. Composer George Lloyd (right) and fellow Royal Marine bandsmen in front of their barracks at Heybrook Bay near Plymouth, before joining HMS *Trinidad*. *(Photo courtesy of Mrs N Lloyd)*

32. Poet Paul Griffin (right) watching an air battle from a slit trench on a Chindit airfield in March, 1944, accompanied by John Napier-Munn and Peter Mead, who later commanded the Army Air Corps. *(Photograph courtesy of Paul Griffin.)*

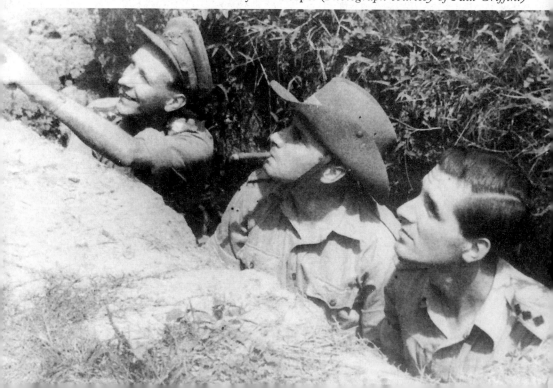

33. Poet John Press pictured in
 Mombasa in 1942, with George
 Newberry (batman) on the right,
 and Daudi (dhobi) on the left.
 (Photograph courtesy of John Press.)

34. A study of Mombasa on the coast of East Africa, photographed by John Press in 1942.
 (Photograph courtesy of John Press.)

35. Gavin Ewart, Poet, Tunis, July, 1943.
(Photograph courtesy of Margo Ewart.)

36. Poet Randle Manwaring (left) with Group Captain Jack Harris, Commandant of the RAF Regiment in the Far East, and Wing Commander Reggie Mein, at a central Burma airstrip. *(Photograph courtesy of Randle Manwaring.)*

37. Major R. A. Strand, 1st Battalion, Queen's Royal Regiment, photographed in Bangkok in 1945, aged 23. *(Photograph courtesy of R. A. Strand.)*

38. Portrait of Major-General Adachi Katsumi, accused of crimes against humanity on the Burma-Siam Railway, sketched by Robert Strand at Bangkwang Jail in 1946, before he was sent to Singapore to stand trial as a war criminal.
(Photograph courtesy of Robert Strand.)

39. Study of a Japanese Private 1st class, sketched at Bangkwang Jail in 1946 by Robert Strand.
(Photograph courtesy of Robert Strand.)

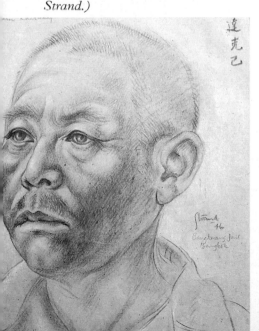

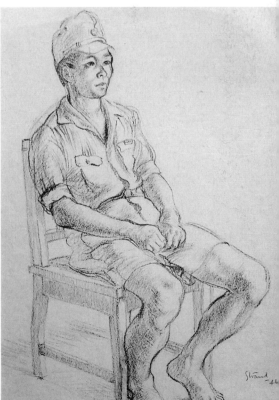

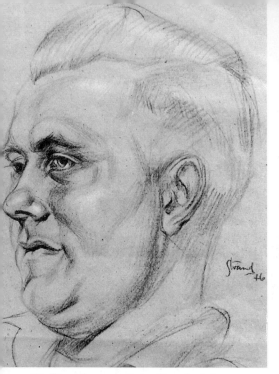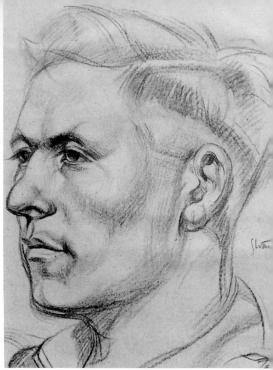

40. Drawing made in Bangkok in 1946 of Sergeant Stone, Officers' Mess Sergeant, 1st Queens, drawn by Robert Strand. *(Photograph courtesy of Robert Strand.)*

41. Drawing made in Bangkok in 1946 of Captain D. W. Kirby, 1st Queens, drawn by Robert Strand. *(Photograph courtesy of Robert Strand.)*

42. Painting in oils by Robert Strand, from drawings done during war crimes trials at Singapore in 1946. *(Photograph courtesy of Robert Strand.)*

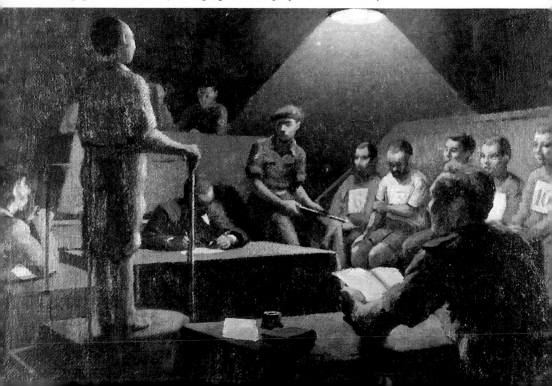

Although I am an artist and therefore with work tend to be more privately involved than most, I did have six and a half years in the army in the Second World War. As a young man in the Forces, the feeling of allegiance to the Flag and a warm and caring Sovereign was a tenuous bond with long tradition and history.

Hitler's screaming harangues and rapacious conquests finally sparked off our declaration of war and Churchill's speech, which resulted in an electric English national unity. That was half a century ago.

I volunteered the day after war was declared in 1939 and opted for the Royal Artillery – the 25 pounder gun which, if one could have affection for a destroying machine, I have never forgotten and can still remember the firing orders.

Posted to an artillery unit at the time of Dunkirk (evacuation) where we destroyed some of our own tanks and aircraft by mistake, the War Office decided training in aircraft and tank identification was necessary, which, it was hoped, would seep through all ranks and branches of the army. I forget how, but it was found (or assumed) I had exceptional skill in identifying shapes due to my art school training immediately before. So I found myself running a small unit of officers and men attached to the artillery training units near Aldershot. We had two-weekly courses for all ranks and once for top brass only. I found it fascinating being near the Royal Aeronautical Establishment where operational aircraft both friend and foe were kept, plus new designs under construction. We saw the first tiny jet with the Whittle engine flying at first only at night for secrecy. Also the Brabazon, a monster with 6 engines and a wing so thick you could walk along it inside for a third of its length. It was not put into production.

But while vastly involved I felt my life was too soft when so many were being killed on service. I was a Major, and went to my Commandant, a Colonel Buckland DSO RA, due soon to retire – a man of exceptional intelligence and eccentricity known at the War Office as Barmy Bill – to ask for transfer to the Parachute Commando Regiment. To my great surprise he said, 'Go away and think more about it. Come back tomorrow. Better to be a live donkey than a dead horse. Nobody will thank you for this in 20 years' time.' I thought and decided he was right – so became a live donkey for what remained of the war.

On being de-mobbed I destroyed all evidence of the war I had kept, and faced the future grateful for being saved for my real work in life. But I had learned much from the army experience, and the tank and aircraft shapes I had studied so assiduously for so long had unwittingly sunk in and helped give character to the sculpture I have made ever since. So it all fitted together.

FRANTA BELSKY FRBS ARCA (Hon D. of Fine Art)
(SCULPTOR)

Franta Belsky was educated at the Academy of Fine Arts, Prague, and the Royal College of Art, London. He has taught at several art schools and was president of the Society of Portrait Sculptors, a governor of St Martin's School of Art, and for many years was on the Council of the Royal Society of British Sculptors. His work, including a head of The Queen, can be seen in the National Portrait Gallery and other collections in Europe and America.

Some of his major works include the Paratroop Memorial and Royal Air Force Memorial in Prague, the statue of Cecil Rhodes in Bulawayo, and the statue of Sir Winston Churchill in Fulton, Missouri, the US Memorial to Winston Churchill. Subjects of his sculptures include Her Majesty The Queen, Prince Philip, the Queen Mother, Prince Andrew, Prince William, Admiral Lord Lewin, Lord Cottesloe and President Truman for the Presidential Library in Independence, Missouri. His work can be seen in prestigious locations such as Trafalgar Square, Horse Guards Parade, the Queen Elizabeth II Conference Centre in Westminster and The National Theatre. He has also done numerous reliefs and fountains in public places and sculpted the Queen Mother's 80th Birthday Crown coin. His 'Joy-ride' in Stevenage Town Square is among the few Grade II listed sculptures of Britain.

Unlike many other artists in the army, Franta Belsky was able to continue his art training at the Royal College Sculpture School while he was still in the services waiting to participate in the invasion of Europe. This was because of a scheme in 1941 enabling students of essential subjects to go back to college, which must have been a pleasant change from the boredom of sitting in a lonely gun position.

In 1944 Franta Belsky made a triumphant return to France, as in 1940 he had withdrawn from the continent with the rest of the British Expeditionary Force. Franta Belsky writes:

Now, you cannot say that I was an artist at war; I was an art student at war. I had just started at the Central School of Art in London and hearing that a Czechoslovak army was being formed in France, I trotted off to the Embassy and joined up – I was 18. We were impatient for the first transport to go and I waited and sculpted and had time to take my Entrance to the Royal College of Art before we left.

We crossed the Channel with British troops, but as civilians – oh, those eggs and bacon served to them. We entrained at Le Havre for a journey across chaotic France, taking five days and four nights. We kept stopping all the way and I kept asking the railwaymen for coloured chalks and started decorating the front of the engine, gradually down the sides of the train with a panorama of Prague castle, slogans, songs, fighting soldiers.

On arrival at the depot camp in Agde (a concentration camp built for the Spanish Civil War Republican refugees) I was called to the Education Officer: Would I like to stay as the resident artist?

'Sir, I came to fight. Kindly send me to a unit,' was my reply. I still designed a few Field post stamps and badges before getting to a battery of First World War 75's, horse-drawn.

We were idealistic students, all lumped together under ex-Foreign Legion NCOs. We decided to ask for a transfer to a new crack anti-tank battery. We lived to see the Fall of France; the sister battery had eleven survivors. Cut off from everywhere except the Southern ports, my lot made for Sete. Rumours abounded that we were going to Africa, to the Foreign Legion. We would have gone anywhere.

Back in London, unknown to us, the exiled President Benes asked Churchill for help. The nightmare of Munich was fresh; instantly, he diverted cargo ships to pick us up, take us to Gibraltar and from there to England, where we landed five weeks after the Dunkirk evacuation. We entered the British Army, swore allegiance to The King and regrouped in Cholmondeley Park. Then in 1940 Winston Churchill came to visit us. I stood in the first row in the review and he sidestepped to me, looking me in the eye for what seemed an age, chin thrust out, hat in hand, leaning on his stick. 'You wait,' I said

to myself, 'one day I shall model a statue of you, just like this.' I didn't get the chance till 1968, for Fulton in Missouri where he warned the world of the Cold War in his Iron Curtain speech. A few years ago Mikhail Gorbachev officially ended the Cold War with a speech delivered under my statue. He began with the words:

'The sculptor of this statue expressed the spirit of war-time Britain, etc . . .'

Cholmondeley put the colour back in our cheeks and I started drawing, modelled a Crucifix for the camp chapel and landed an order to go and carve a stone memorial to stand where our first camp in England had been established. This done and back to duties, my Battery commander called me:

'From now onwards, all that art is finished. Understood? Dismiss.' And from then, repeated to the end of the war, my personal record read: 'More artist than soldier,' in spite of my collecting good decorations from three nations.

Suddenly, in September, 1941, I was ordered to take my gun and tin hat and all, and spent two terms in the Royal College Sculpture school. There was a remarkable scheme on: University students of

Illustration from a wartime letter sent by Franta Belsky
to his future wife.
(Drawing courtesy of Franta Belsky)

essential subjects were sent back to College as there was a Sitzkrieg on anyway.

In all the years I never doubted that I should survive and I kept preparing myself for peace. I was a capable gunner and later signaller, but most of my free time was spent reading histories of art and design, or carting a tin of modelling clay around coastal batteries. I kept designing a memorial for Lidice, wrote essays, painted awful murals in the canteen, painted ruins, bomb sites, and resting soldiers.

Still in England, I made a woodcarving and sent it to the Royal Academy Summer Exhibition, 1943. This was the first of many exhibits until some RAs, and wartime Conscientious Objectors too, thought I was beginning to cast a shadow and stopped my progress – or tried.

After Normandy, when wet feet, sleepless nights and loud bangs were normality, I drew a lot. After a busy night, I would have a morning off and, young as one was, I would go for walks. Once I settled on a hillock to draw the battle. I had finished and, feeling cold, started down the hill. Mere seconds later an accurately placed 88mm shell removed the top on which I sat.

Silent muse inter arma – not quite and when it was over: oh boy!

Illustration from wartime letter sent by Franta Belsky to his future wife.
(*Drawing courtesy of Franta Belsky*)

Chapter Six

DESIGNS FOR PEACE

The title of designer can be awarded to a broad mix of craftsmen. In fact, in terms of artistry, the title is almost limitless. In this chapter three designers from very different areas relate their stories. The first story is written by William Maving Gardner, whose career is so diverse that he can only really be described as a designer and craftsman. To try and focus his title on one particular area would be at the neglect of others. This is often the way with people we call designers, who are usually multi-talented.

William Maving Gardner served with Army Camouflage, which was an important issue during the war, so inevitably other designers were employed in its service. Two good examples of this are graphic designer and painter Christopher Ironside who became Deputy Senior Design Officer with the Directorate of Camouflage, and photographer Richard Levin, who became a camouflage officer for the Air Ministry. Richard Levin was employed as the designer for British Army exhibitions.

Graphic designer Abram Games, who had served with the infantry, became a poster designer for the War Office once his talents had been noted. And other designers who served in the war include graphic designer William de Majo, who was a pilot with the RAF, book designer and illustrator Charles Keeping, who was a telegraphist with the Royal Navy, illustrative photographer and book designer Reece Winstone, who served in the RAF, and designer and potter David Leach, who served in the Duke of Cornwall's Light Infantry.

The second story is written by Sir Hardy Amies, the fashion designer and dressmaker by appointment to Her Majesty The Queen,

who served with the Intelligence Corps and Special Operations Executive.

Another talented dress designer is John Cavanagh, who trained before the war in London and Paris, and in 1940 joined the Intelligence Corps. He attained the rank of Captain and also worked in army camouflage. The first John Cavanagh boutique was opened in 1959. He has designed clothes for many royal persons, including wedding dresses for the Duchess of Kent and Princess Alexandra.

The last story is recounted by Andrew Grima who is one of the world's most successful jewellery designers. Andrew Grima served with the Royal Corps of Mechanical Engineers on the Arakan front in Burma.

WILLIAM MAVING GARDNER ARCA FCSD FSSI FRSA

(DESIGNER AND CRAFTSMAN)

Art is presented in a myriad of formats and the work of some artists can be seen almost daily within the community, often being taken for granted. Most British adults have about their person, almost every day of the week, an example of the next contributor's work. In 1982 William Maving Gardner designed the new twenty pence coin, having shared the design work of the Queen's first coinage in 1953. As an artist his career is hard to define as he has worked in so many media. He trained at the Royal College of Art from 1935–1939, after which army service interrupted his career, as it did with so many young men of his generation.

His designs after the war include HM Privy Council Seal in 1955, HM Greater and Lesser Royal Signets 1955, the Seal of HM Dependencies 1955, and seals for the BMA and RSA. He has also designed coinage for Jordan, Cyprus, Algeria, New Zealand, Guyana, Dominican Republic and the Falkland Islands among others. His medallic works include the Britannia Commemorative Society Shakespeare Medal 1967, Churchill Memorial Trust's Foundation Medal 1969, National Commemorative Society Audubon Medal 1970, International Iron and Steel Institute Medal 1971, Institute of Metals Kroll Medal 1972 and 36 medallic engravings depicting the history of the Royal Arms. He also participated in a series of Commonwealth Silver Jubilee Crown pieces, and in 1977 was awarded the Queen's Silver Jubilee Medal.

Calligraphy works include Rolls of Honour for the House of Commons, London Transport Executive, Life Guards, Royal Horse Guards, and all five regiments of Foot Guards. He also crafted the

Warrants of Appointment by Queen Elizabeth the Queen Mother as Lord Warden of the Cinque Ports, the Royal Marines Corps Book of Remembrance, and works for Canterbury Cathedral, Eton College and the Royal Society of Arts.

He designed works for the Tercentenary of the Royal Society in 1960, and King's College London in 1971. He has designed stamps and written a number of authorative books on the subject of calligraphy.

During the Second World War the artistic talents of William Maving Gardner were put to good use by Army Camouflage and he organized and ran several camouflage schools.

At the outbreak of the war William Maving Gardner enlisted with the Middlesex Regiment, but after OCTU he was sent to train in Army Camouflage at Farnham Castle. His military career contained him within the British Isles, but, as he now explains, it was, nevertheless, varied, interesting and certainly worthwhile.

Having completed my design training at the Royal College of Art I was enjoying the Design School's Travelling Scholarship in Scandinavia late in 1939 when avoidance of internment brought me home to London, to volunteer at once for the Middlesex Regiment where square bashing and lengthy route marching produced physical fitness never experienced before or since.

However, OCTU at Aldershot provided a commission with some knowledge of leadership at platoon level and the use of the 303 Vickers machine gun.

Yet I was not destined to be at the sharp end of the war, since Records noticed my design qualifications and I was posted for training in Army Camouflage to Farnham Castle, followed by duty in South Midland District – Oxfordshire, Berkshire and Gloucestershire – very fully engaged during the week, also for the Home Guard at all week-ends, plus liaison at RAF and civilian airfields.

Posted later from South Midland District to run the Camouflage School at Barnby Moor, Yorkshire, courses were combined with help for Coastal Command.

Next, to General Staff HQ – London District, where I was able to set up camouflage training and accompany the Guards Armoured Division by flying from Hendon airfield over their Home Counties exercises and showing on screen afterwards photographs of their

patterns of activity impressed upon the ground for either avoidance or even deliberate falsification in the likelihood of enemy air photography or observation.

Towards D Day I was seconded to London District's Chief Engineer and the Head of Q Branch who were responsible for the parks and open spaces increasingly crammed with British forces. The need was to fly over these areas regularly and report on any serious breaches of security from the point of view of possible enemy air photography. Anti-Aircraft Command was informed but I was warned that in the event of a red alert, the balloons would go up regardless of whether I was in the air or not. Fortunately all went well.

From London District to HQ Scottish Command, Edinburgh, to organize and run the Command Camouflage School with courses for many units including the Polish Armoured forces. Stress throughout was upon visual awareness and deduction and many stiff and ingenious tests were evolved.

We were fortunate to have the use of the ideally large studio of a well known sculptor. From the many who went through the courses, none were more interested than the experienced officers of higher rank. But by then camouflage had been renamed by us as Visual Training, and high rank did not necessarily provide full awareness of what was being seen.

Slides were projected of trails to be followed from memory. Our indoor exercises included models of various types of countryside at floor level, upon which were placed scale models of weapons, transport etc., to be viewed and reported on: some were easy, others were positioned to make them difficult to see. Groups of four needed to lie down and report to the leader what they could make out from ground level, with a barrier placed to prevent a higher viewing point. Another group were to cycle once round the model without stopping, to represent fleeting low-level enemy air reconnaissance. A further viewing was photography from the very high ceiling of the studio, and these 'vertical air photographs' had to be interpreted. All groups then compared the intelligence so gained, and accuracy or otherwise was examined in detail together.

Colours were compared as to their relative visibility in diminishing conditions of lighting and night exercises in visibility were contrived with the help of special goggles on loan from the RAF.

The whole time a non-stop stream of quickly fired questions, as to

what was significant, in addition to what was being looked at, produced the keenest degree of observation after a week.

An awareness of what can be seen and interpreted sparked off many successful concealments and ruses. Dummy armoured vehicles, trucks, landing craft, artillery and aircraft are now well known about, but other very successful devices are still confidential.

A final posting was to Southern Command's Camouflage School at Tunbridge Wells until its closure.

It had been continuous activity with very little leave to see my family, and I was glad to begin my professional calling some six years after qualification.

SIR HARDY AMIES KCVO
(DRESSMAKER)

After the war there was a fashion explosion, typified by the emerging styles of the 1950s. A number of dressmakers and fashion designers had seen military service. Among them was Sir Hardy Amies, later to become dressmaker by Appointment to Her Majesty Queen Elizabeth II.

Hardy Amies served with the Intelligence Corps and Special Operations Executive during the war, eventually commanding the Belgian section in Brussels, where he was posted after the invasion of western Europe in 1944, at the rank of Lieutenant Colonel.

Before the Second World War Hardy Amies had already worked in tailoring for a dress house called Lachasse. However, an advertisement in *The Times* in 1939, announcing that there were vacancies for potential officers with two languages, set him on a very different course. Although his pre-war dress design and tailoring experience was of little consequence to the army, he had spent several years on the continent, where his fluency in speaking both French and German qualified him adequately.

By the early 1950s the Savile Row studio of Hardy Amies had attracted a distinguished clientelle. One of his clients was Lady Alice Egerton, lady-in-waiting to Princess Elizabeth. After admiring Lady Alice's coats, Princess Elizabeth and Princess Margaret made an appointment for a private viewing at the studio. A few days later Hardy Amies was summoned to Clarence House to discuss a collection for the forthcoming tour of Canada by the newly married princess. This resulted in the design and purchase of two overcoats, two day dresses and two evening dresses.

When Princess Elizabeth became Queen she continued to order

clothes from Hardy Amies, and still does over forty years later. In most cases, these dresses and coats have been designed specifically for the Monarch, or by using a different material for a variation of a proven design, they have maintained an aspect of individuality. Royal garments aside, Sir Hardy Amies is one of the most respected and influential designers, whose trademarks have always been quality and sophistication.

I remember the day The Great War broke out, I was five. My father, a reservist, was called up and quickly commissioned. I can still see the trampled grass when we visited him under canvas and the sound of bugles is miraculously evocative in Benjamin Britten's War Requiem. On Armistice Day, 1918, we cheered in the playground of my school in Hammersmith.

Minor public school (Cadet Corps) and two and a half years in France and Germany led to the offer of work in a dress house called Lachasse which still flourishes. It specialized in tailor modes. I love tailoring. I was a success and given a very strict contract, forbidding me to work within a mile of present premises.

In 1939 an advertisement in *The Times* announced that there were vacancies for potential officers with two languages. I was accepted and after OCTU joined Special Operations Executive. After training with Kim Philby at Beaulieu I was put into the Belgian Section. Our job was to support resistance groups in Belgium. We recruited and trained wireless operators to be dropped into Belgium. Eventually senior officers were allowed to do five parachute jumps. It was rumoured in Brussels that I had volunteered to drop behind the enemy lines. I had to confess it was really behind Manchester Airport.

At first we were told that such operations were to be kept secret from the exiled Belgian Government and the Belgian Army Headquarters. Our protests led to officially blessed co-operation. We had many casualties. Belgium was heavily protected with flak. My fluent French made long friendships and eventually I became head of the section and moved with it in 1944 into Brussels with the rank of Lieutenant Colonel. The Germans had left Brussels three days ago. Battles still blazed in the Ardennes but for me the war was over. We mourned our losses with relations and drank their Burgundy.

Free of all restraints of my contract with Lachasse, I made plans to open my own business. In the Spring of 1945 I was told by the Board

of Trade that I would be released from the army to help the export drive. When General Templer, the Commander in Chief of the British Forces, told me, with apologies, that my Belgian opposite number considered me unco-operative (I had refused permits to buy coal to owners of centrally heated flats) I asked permission to leave at once.

I opened my business in October, 1945. A world starved of fashion during the war flooded in. In 1951 Princess Elizabeth newly married, went with Prince Philip to their first state visit, which was to Canada. As Queen, there have been over 200 journeys abroad. With very rare exceptions, we have had the honour of supplying clothes.

ANDREW GRIMA

(Jeweller)

Andrew Grima, the designer of some of the most exclusive jewellery in the world, has received commissions from The Queen Mother, Princess Margaret, Lord Snowdon and the Princess Royal. Between 1966-1986 he was a member of the Royal Warrant Holders Association, by Appointment to Her Majesty Queen Elizabeth II.

He was educated at St Joseph's College, Beulah Hill, and Nottingham University. His first shop, in London's Jermyn Street, was opened in 1966 and incorporated sculptures by two Royal Academicians, Geoffrey Clark and Brian Kneale. In the same year he won both the Duke of Edinburgh's Prize for Elegant Design and the Queen's Award for Industry. As a direct result of the former, Prince Philip purchased a carved ruby brooch from his winning collection, which he presented to the Queen. Shortly afterwards Andrew Grima was summoned to Buckingham Palace to discuss an idea of the Queen's, which was her intention to present foreign Heads of State or their spouses with specially designed pieces of jewellery during her official State Visits to foreign countries. Before that time it had been the custom to present her hosts with Wedgwood dinner services, which were stored in crates aboard the royal yacht *Britannia*. With the Queen travelling more and more by air, it became increasingly difficult to carry china, so Her Majesty came up with the idea of presenting specially designed pieces of jewellery. Andrew Grima was given the task of designing these set pieces, along with the occasional special jewel for more delicate situations, such as the visit to France in 1972, for which he created a golden sunburst with a large topaz in the centre, embellished by a subtle Royal Cypher. The jewel was presented to Mme Pompidou and became one of her most valued

possessions. When Andrew Grima borrowed the brooch twenty years later for his retrospective exhibition at the Goldsmiths' Hall in London in 1991, to mark his seventieth birthday, Mme Pompidou told him to be careful not to lose it as she loved it so much. Among his other achievements, Andrew Grima designed and made the prestige watch collection for Omega 'About Time' in 1971.

He was an outstanding figure in the renaissance of British jewellery design and his achievement in winning the Duke of Edinburgh's Prize for Elegant Design was a huge boost to British designers, as it was the first time the award was given to a designer of individual hand-crafted pieces as opposed to large-scale production works.

During the war he served in Burma with the Corps of Royal Electrical and Mechanical Engineers, quite oblivious to the fact that some of the best rubies and sapphires in the world could be found there. In later years he used the precious stones taken from Indian and Far Eastern ornaments to colour many of his wonderful creations. While in Burma he commanded the REME Divisional Workshop of the 7th Indian Division. The Division, commanded by General Messervy, took part in the Battle of Imphal-Kohima from March to July, 1944, one of the most decisive events of the Burma campaign.

He was made a Freeman of the city of London in 1964 and is a Liveryman of the Worshipful Company of Goldsmiths. Today he lives in Switzerland and owns shops all around the world. Andrew Grima writes:

> I was listening to the morning news at my parents' home near Harrow. I was nineteen and there was a special announcement for young ex-Public School boys who wished to volunteer before their call-up age and be trained in specialist technical units. I hated the idea of ever being in the infantry and thought that this was a Godsent opportunity.
>
> We were asked to report to our local recruiting office for a medical examination and our credentials. I mounted my bicycle and sped to the Hendon Territorial Army drill hall and I was immediately ushered into a room where a small bunch of young men were beginning to be examined. I joined them and passed with flying colours and was told to wait to see the Adjutant who would read my papers, welcome me to join the Army and give me the King's Shilling. I gave him my papers and a frown crept over his brow. 'I'm terribly sorry young man, your

mother was born in Rome of Italian parents. Italy is at war with us you know, we could hardly risk taking you into the Services. I really am extremely sorry.' I could feel the tears rising and quickly turned away and climbed onto my cycle. I had been to St Joseph's College in Beulah Hill which was in South London. There was an Army Drill Hall there. I'll go there, it's far enough away for them not to know what happened in Hendon. I pedalled furiously, thinking how I would overcome this terrible embarrassment of my mother's birth. Then it came to me, I'll tell them she was born in Malta where my father was born. I went through the same process as in Hendon, this time with one important difference, I clutched the King's Shilling in my hand.

I went through a crammer course in engineering and was posted to Burma where I eventually commanded the REME Divisional Workshop of the 7th Indian Division. The Division under General Messervy was sent to the Arakan Peninsula below Chittagong to stem the Japanese advance, which it did. Some weeks later the Japanese counter-attacked and the Divisional HQ including my workshop Company were surrounded in what was called 'the Admin Box' – an area of perhaps 40 acres surrounded by hills – and it was on these hills that the Japanese sat and lobbed shells and mortars for three weeks. The losses were great as the field hospital had been overrun by the Japs who killed all the doctors and patients, save one doctor who hid.

We were eventually relieved by the Royal West Kent Regiment and were sent north to a rest camp to recuperate. We were in a camp composed of 'Bashas' which are huts made of raffia and reeds and bamboo. If I had weighed then what I weigh now, simply leaning against it would have brought it to the ground. The other luxury of a rest camp was that your meat was supplied 'on the hoof' or in today's parlance 'live'. Every other day a goat was delivered and tethered to the cookhouse door post. Some nights after arriving, I was lying on my camp bed reading the first mail I had in seven months when I smelt a distinctly feline scent followed immediately by the shaking of the wall by my bed as a large animal brushed by. There was no doubt in my mind that in an area known for losing several villagers a year to tigers I might actually become a statistic if I were as much as to make a movement or a sound. I felt my heart beating at my throat faster and more violently than at any time when we were surrounded by the Japanese and were being dive-bombed by the kamakazi. Minutes went by and the tiger was gone. Next morning I went to the cookhouse and saw the piece

of rope that had once helped tether the day's ration, hanging forlornly from the gatepost. We had tinned spam and the tiger had baby goat.

Our stay in the rest camp was shortlived; within a week we were summoned to rush to Kohima where the Japanese had closed a pincer movement around a British division. (Note 1)

Kohima is a small town perched atop a steep hill with the roads into and out of the town being nothing better than mule tracks. The population was mainly composed of Naga hillfolk who were reputed to have been headhunters.

The 'roads' were mostly mud tracks and the Naga women had been recruited to break up rocks into small cobbles and to spread them over the muddy clay.

The fighting took on the same character as the fighting in the Arakan and eventually, after heavy losses on both sides, we were able to release the British troops who had been trapped. One must of course remember that, quite apart from the enemy, the 14th Army was also fighting a war against illness such as malaria and cholera. The ever-present leeches which got inside the boots and sucked the blood from one's legs and snakes were a constant danger.

I remember contracting malaria on my 21st birthday, despite the daily doses of Mepachrin which we all took and which gave one a jaundiced look. I remember once during the monsoon dropping one of these pills in a pool of water which instantly turned bright yellow. The malaria was to return from time to time on my return to Britain, but then gradually disappeared.

The victory at Kohima and Imphal was the signal to commence the operation which was to clear the enemy all the way down central Burma following one of the world's longest and widest rivers, the Irrawaddy. I was once foolish enough to take a swim in this river and was awakened in the middle of the night with the most excruciating earache. I went to see the MO early in the morning, who told me that the river was extremely polluted due to the many bodies (human and animal) that ended up in the water. He poured peroxide in both ears and all the offensive matter came foaming out, much to my relief!

The drive to rid the Japs from Burma that took us all the way down to Rangoon was a long, slow process. Until this point, the 14th Army – the Forgotten Army – had to make do with antiquated equipment. We were using Thornycroft lorries from the early thirties. Our armoured equipment such as tanks, Bren gun carriers and troop

carriers were mostly sent to us directly from the North African front once that war had ended. My own workshop's first task when this old equipment arrived was to clean the fine desert sand from every nook and cranny of the engines and moving parts, thereby assuring trouble-free operation at least until victory in Burma was ours.

As we progressed south and mopped up the Japanese prisoners, our own men, who had been prisoners, used by the Japanese to build roads and bridges, began to greet us. They were a truly sad and sorry sight. Without exception, they were walking skeletons, some sixty percent were missing a limb and walked with makeshift sticks or crutches. We had been warned by our Commander that under no circumstances should we allow these men to eat our normal rations. They were to be fed minute portions of food, mainly liquid with whatever white meat – such as chicken – was to hand. Eventually a system whereby these ex-prisoners were taken to special camps with qualified staff, was introduced, and worked well.

We reached Rangoon shortly before the capitulation of the Japanese to our Supremo, Lord Mountbatten, and his military staff.

Now that the war was over our only thoughts were to return home as soon as possible. The first disappointment was that the War Office actually expected some of us to stay on in the Far East and move to Thailand to start the peacekeeping. We made it quite clear that it was now the turn of the thousands of soldiers who spent the whole of the war 'at home' to broaden their horizons. The next delay was to await

Sketch made by Andrew Grima in 1941 (*courtesy A. Grima*)

a ship capable for taking us from Rangoon via Ceylon and the Suez Canal back to 'Blighty.'

I was now twenty-five years old and anxious to catch up with my career after six years in the Army. On arriving in Britain I was told there were many men older than I who could be demobbed before me. They told me that I was ideally qualified to run a 'rehabilitation' centre and education complex.

They made me Education Officer at the Mill Hill barracks in North London, close to my mother's home in Harrow. I lived at home and ran this complex as well as taking on the extra job of teaching Art. The Mill Hill Golf Club was a really luxurious building and it had been commandeered by the Army during the war. This, I thought, was the ideal place for my art lessons! The 'students' were both male and female and most had not experienced working in civilian life. I found the transition from war to peace very much easier as a result of these months, passed in relative calm amongst young people trying to find their feet in a world of tranquillity.

I had been interested in art from as far back as I remember. It ran in my family. My grandfather was an architect, my uncle an artist and my father a designer and manufacturer of beautiful hand-embroidered linens.

I went to art school as soon as I was old enough, but still too young to be permitted in the 'life' classes! Consequently, once in the army, I began sketching my companions. Once overseas and with the absence of cameras, many asked me to give them the portraits to send home, but I still have a few of them left, which I brought home.

NOTES:

(1) The Battle of Kohima was the greatest defeat ever suffered on land by the Japanese, who lost 53,000 men, compared to British losses of 16,700. The Japanese had attempted to invade Eastern India by an overland offensive from Upper Burma, so General Sir William Slim, the commander-in-chief of the Fourteenth 'Forgotten' Army, ordered a counter-attack in the Arakan. The British troops stood their ground, supplied by parachute, and for the first time in the war the Japanese were unsuccessful in enveloping and over-running their enemy.

Chapter Seven

ILLUSTRATING THE POINTS OF WAR

In earlier chapters you read the stories of artists, more famous for producing their work on a large canvas. There is of course another type of artist, who produces his work on a much smaller scale, often for reproduction in books, newspapers and other media. Grouping these together under the title of illustrators, their contribution to art is as diverse as the designers we met in the last chapter.

You will be reading the stories of three such people. First, Thomas (Bill) Ward, who is an accomplished painter, as well as an illustrator and etcher; indeed he has illustrated books for a number of publishers and could have been included in the earlier chapter about painters. He served in France in 1940 with the King's Own Yorkshire Light Infantry and finished the war in Burma with the Royal Welch Fusiliers.

David Langdon, the next contributor, was cartoonist for the *Sunday Mirror* for forty-five years. He served in the RAF and by the end of the war had become the editor of the *RAF Journal*, where he was able to use his talents with great effect.

During the Second World War cartoons became a major art form, not merely because of their ability to offer a comic, satirical, or even tragic commentary on world events, but because of their practicality in terms of printing techniques. Cartoons appeared everywhere – on advertising, recruiting material, technical instructions and other material appertaining to the progress of the war, particularly on the home front.

Characters appearing in wartime cartoons also tried to introduce a feel-good factor, not only for troops in far-flung corners of the world, but for people at home suffering the effect of the blitz. A particular

favourite was 'Jane,' who featured in a strip cartoon, in which her clothes seemed somehow to get ripped off with remarkable regularity, leaving her dressed in nothing but her underwear.

Another famous ex-serviceman worth mentioning briefly in this context, as he has been a cartoon strip writer, is George Melly, better known as one of our leading jazz singers. George Melly, who has also written books and screenplays, served in the Royal Navy during the war. But probably the most famous cartoonist of all was Carl Giles OBE, cartoonist for the *Daily* and *Sunday Express,* who served as a War Correspondent and Cartoonist in France, Belgium, Holland and Germany, and also produced animated documentary films for the Ministry of Information.

The last story is written by James Bostock who served with the Durham Light Infantry and the Royal Corps of Signals. Although his military career provided little outlet for his artistic talent, he did have the occasional, less formal, commission, one of which forms the basis of his memoir. Although James Bostock has produced work in many different media he describes himself as a wood engraver. Other notable engravers, or etchers, who served in uniform during the war include Bernard Carter, David Peace, Geoffrey Wales and Arthur Hall in the Royal Air Force; Raymond Cowern who served in both the Intelligence Corps and the Camouflage Corps; H. Andrew Freeth who, although serving with the Intelligence Corps, was attached to the RAF for a time, and was also an official war artist, and Gabriel White who served with the Royal Engineers as a Camouflage Officer.

THOMAS WILLIAM (BILL) WARD
ARCA RE RWS
(ENGRAVER, ILLUSTRATOR AND PAINTER)

Bill Ward was born in 1918 and studied at the Sheffield College of Art during the evenings between 1937–39. In 1935 he had been a cadet in the Merchant Navy Service and, because of this, wished to join the Royal Navy during the war. However, it was not to be and he was called up by the Army, serving with the King's Own Yorkshire Light Infantry in France, and later with the Royal Welch Fusiliers in Burma.

Bill Ward attended the Royal College of Art, School of Engraving, in 1946 and was elected a member of the Royal Society of Painter Etchers in 1949, and a member of the Royal Society of Painters in Water Colour in 1950.

Between 1950–60 he was a practising painter, etcher and illustrator, and in 1960 became a full-time tutor at Harrow College of Higher Education, and in time Director of Studies, Illustration.

Since 1950 Bill Ward has exhibited at the Leicester Galleries; Walker's Gallery, Bond Street; Kensington Galleries and Zwemmer Galleries in London; St John's College, York; Digby Gallery, Colchester; Suffolk College, Ipswich; Chappel Gallery, Essex; and the Art Galleries in Wakefield, Shipley and Middlesborough. In 1997 he exhibited at Woodgate Gallery, Suffolk. His work has also featured in Open Exhibitions at the Royal Academy, New English Art Club, London Group, Bradford Art Gallery, Royal Society of Marine Artists and the Royal Scottish Academy.

Important purchasers of his work include The National Gallery of New Zealand, Victoria & Albert Museum, Contemporary Art Society, and Oxford University. His works also hang in many private collections. He has produced design and illustrative work for Conway

Maritime Books, *Country Life*, Argus Press, Shell Petroleum and the Midland Bank Calendar. In the theatre, he has designed properties for Tom Arnold's Ice Show and *Camelot*. His book *Composition and Perspective* was published by Bloomsbury.

The Regimental Museum of the Royal Welch Fusiliers at Caernarfon Castle, in North Wales, houses a substantial collection of his wartime drawings and paintings. Bill Ward writes:

I was called up in Sheffield and sent to the local barracks, which was a decorative medieval-looking building. I wanted to join the Royal Navy as I had made a voyage as an apprentice on a Houlder Bros ship the *Dunster Grange*. I was patted on the shoulder and told I was in line for a commission in the RN. A colleague whose father had served in the Royal Artillery, who wished to go into the same unit, was treated with equal benevolence. There is something about Sheffield: Michael Palin has spent much of his life globe trotting as if a Sheffield dynamo was beneath his feet!

After a few weeks I received an official letter directing me to Wakefield with a 3rd class railway ticket, where I was to join the KOYLI. I could not imagine what those initials stood for, so I went out and met a neighbour on the main road, who had been a soldier during the last war. In asking what branch of the Navy it was he burst out laughing and told me it was not the Navy but the Army and a unit that ran, not marched, and carried its rifles like walking sticks: The King's Own Yorkshire Light Infantry. He advised me to go and get a hair cut, which I did. That was a bit of good advice I shall never regret.

The bright and cheeky Sheffield boys had no respect for the red-sashed sergeant who came to meet us at Wakefield train station, and gathered us all together. He took the teasing in good heart. When the bus ran into a modern barracks I got out and stood in amazement beside a huge flat parade ground, where we watched a very young bugler march out and play a call! It was Strensal Barracks near York. We had been transported there in a fleet of coaches from Wakefield Station. It had been a rowdy journey during which the staff sergeant took some ribbing.

Suddenly there was a loud bellow in my ear. A lance corporal wanted to know if I had fallen asleep. The crowd of recruits with whom I had travelled had marched off to the quartermaster's store in a corner of the parade ground and I was being urged to catch up. It

wasn't long before I was shuffling off in a pair of heavy leather ammunition boots trying to catch up with my companions, with the leather boot laces dangling from my hands. We arrived at a Militia Spider, a very new wooden and strong cuprinol-smelling group of huts. We were allocated beds on which I was glad to dump my armful of clothing and bedding and follow instructions to the dining hall with my mess tins.

Sunday came and we still had only one mess tin each, so after our first course, the remnants of that course was scraped out on to the centre of the table, to form a ridge of potatoes and gristly meat. My middle-class upbringing withheld me, but I soon saw the advantage of doing likewise, when down between the rows of seats came orderlies with big oval dixies and a large spoon. In the dixies was a rather blue rice pudding which went slap on the centre of our mess tin. During that week I acquired an enamel plate and mug, so mealtimes became more civilized. The long tables were not such a horror, and perhaps my more civilized eating equipment, or the vigorous thumping around the parade ground, improved my appetite.

Hoisting a barrage balloon, drawn by Bill Ward.
(*Reproduced with the permission of RWF Museum*)

Just before being called up I had applied for a place at the Royal College of Art in the Engraving School. I had attended the Sheffield College of Art four nights per week and realized, after seeing the full-time students, how weak my own drawing was, so I didn't hold too many expectations of being offered a place. When I was invited to take the entrance examination in South Kensington, I asked permission from the army to have leave to do this. My Company Commander was the Viscount Gorman. He was a wonderfully civilized man and told me his aunt, Lady Butler, was an artist. She had made splendid large paintings of military occasions. 'Charge of the Light Brigade' in Leeds Art Gallery, was one. So a very sympathetic company commander gave me a week's leave plus a few days to spend at home, due to the fact that we were going abroad almost immediately on my return. We had a few hectic weeks taking delivery of mortars, Bren gun carriers and equipment, and we looked like soldiers, even though we didn't feel like the real thing. I had been promoted to lance corporal and had a beautiful dark green stripe on a white stripe and had painted it hanging on my bed!!

My week in South Kensington was heaven and I met Malcolm Osborn, the professor, a man of great artistic stature and compassion. His assistant Robert Austin was a character full of fun. They both looked through all my sketch books and gave me the encouragement which carried me through the next six years. I saw London for the first time and looked forward to living there. It seemed an exciting place. A young lady from the Wakefield School of Art who had got a place on the Graphic Design Course lent me her digs in Limerston Street, Chelsea. I really was on Cloud 9.

The embarkation leave went brilliantly, then it was back to Wakefield and the hectic scramble to acquire all our kit. There was no anxiety as we were a 20-year-old militia unit, untrained, and the war had not properly started. We felt safe. Little did we know!

The railway station at Dewsbury was black that night. I had to get my section of seven men into a compartment, complete with their packs, to which were strapped steel helmets, and each carried a 9lb rifle. They were just seven black oval heads, amongst 800 other black oval heads. Miraculously, 800 men embarked. A few well-informed girls had appeared from somewhere and down the platform a small group of Scottish bagpipers played plaintively 'Will ye no come back again'. They had come from a unit stationed locally.

The compartment was hot and stuffy and every time the train pulled up sharply a pack and steel helmet fell off the rack with a thump and a sharp grunt from a militia boy. By morning we were in Southampton. Our Brigade No 138 was made up of one battalion of KOYLI, one of York and Lancaster Regiment and a third of the Duke of Wellington's. There we all were, being bundled out of the trains which had pulled up on the dockside and shuffling untidily over the dock to board three cross-channel steamers. Somehow we all managed to get on board our respective ships. It was fresh and clean in the morning sea air, after the stuffy hot journey. Down below decks, tables were lined up with tea and thick cheese sandwiches for us all.

The Channel Crossing with two destroyers escorting was tremendously exciting and our pals in the other ships were within waving distance all the way. We were fed again, this time on thick jam sandwiches as we got into Cherbourg. What a super little town is Cherbourg, and what a picturesque harbour. Trains came alongside the piers, but there were no passenger trucks like in England, just cattle trucks boldly labelled 'Huit chevals' and '40 hommes'. Not having any horses it was just a platoon to each waggon. We had no idea where we were going. I sat with my legs hanging out of the waggon door, and we cheered every French girl that passed by – and they cheered back! Motorcyclists came alongside when we stopped at crossings. Later, we were told they were Germans. Certainly our parents heard from Lord Haw Haw's broadcast that evening that the 46 Infantry Division had landed in France and that 138 Brigade were entrained. Well, it wasn't difficult for the enemy to discover who we were, as so many soldiers leaned out chatting to everyone who could talk in English. We came to halt about teatime just beyond a station called, I think, Caen, and disembarked. We marched off to a ready-made camp of Nissen huts. Here we were tasked with making a siding for an ammunition dump. There were big orchards to clear: it seemed such a shame. Our enthusiastic subalterns soon learned to use dynamite under the roots and we cleared the trees, burning them. I was drawing, of course, every spare minute and walking along the towpath of a little canal. We had left England in a very sparse and early spring but here it was high summer, warmer than what we were used to at home. We picked up a little English news on a radio; the Germans had attacked France and begun to

squeeze our armies back against the Channel coast. The MO came with an orderly and injected us where we stood, and left us wondering why. I lined my section up and made sure that each man received his injection, until I felt my head beginning to swim and I blacked out.

At lunchtime I walked to the nearest village where there was a little café. I took out my sketchbook and began to draw. A very characterful farmer looked over at me and to my horror strode across the room pushing chairs aside and slapped my face. I was not the only soldier present and all were ready to join in and break the place up. I tried to explain that I was an artist and nothing to do with 'espion' and the fellow ran off at the sight of so many aggrieved Brits lining up.

The next day we were squeezed into cattle trucks again with all our gear, trundling off to Paris at nothing more than a walking pace.

A delightful experience from this time happened one Saturday. Going into town for the day I came across what was a school of art. I went inside. It was as old-fashioned as the one I had attended before the war. I met Le Professeur, who was taking a life class. He asked me to join the other students on a donkey, gave me a piece of vine charcoal and an imperial sheet of cartridge paper. How I enjoyed that opportunity even though the model had to keep herself warm with a coke stove and a bucket of coke. Frequently she stopped to stoke up the stove, but it was fun. It even smelled of oil paint. I was very proud of that drawing, although I had to fold it up to fit it in my sketch book, even though mine was larger than most. In fact, when I had a one-man exhibition of my pictures some years later, in the Channel Islands, some students from the College of Arts of Caen, Evreux and Lisieux, who had heard of my wartime visit, turned up at my exhibition, making it a very enjoyable day.

Returning to my original story, and the slow pace of the train as it trundled northwards, one incident that had a profound influence on us all for the rest of the war was when a train crept slowly towards us in the opposite direction. It was a French hospital train. The weather was hot and the windows were wide open, and so we could all see everything that was going on in the train, which was full of casualties. The medics were patching up the soldiers who had been cruelly wounded in the last battle. There was blood-soaked cotton wool everywhere. As the last coach crept by, I found a pile of

cotton wool, thrown out of the ambulance train, which had landed by our wide open door. Kicking it to a less conspicuous position, three fingers rolled out! We all went silent as the olive green coaches slid by, while our train whistled in morse code and the I.O., it was said, walked up to the locomotive and shot the driver. The noise certainly stopped!!!

When we got to Arras and the long line of huge beech trees and the Somme Canal that runs alongside the railway line, the sound of bombs and machine-gun fire could be heard very close by. We jumped clear of the train and took cover under these beautiful tall trees. Looking up through the gaps in the branches and leaves we could see what looked like an air display as Stuka dive bombers swooped down over us. I was near a bridge that straddled the canal, over which, streams of people hurried in panic. I remember putting a towel tightly around someone's chin who had been hit in the face by a bullet.

We mustered a patrol together with Corporal Dransfield and crossed the bridge against the oncoming crowd, and went into Arras itself. There we encountered German soldiers riding motorbikes with sidecars. They were the advance parties from Rommel's 22nd Panzer Division. Only later did I hear of Rommel's surprise at the stiff resistance he met from us. We were amateurs at warfare and obeyed orders to withdraw westwards down the railway line and reform. I have to admit I hated pressing the trigger of our Bren Gun when real people were in the sights. On the other side of the train line was a deep ditch filled with water and one of my section, a mighty jumper, cleared the water but had to wade through it when scrambling back to the truck. He was soaked, so we fitted him out with a piece of his own blanket like a kilt and all the French called him *Ecossais*, much to our amusement.

That evening we regulated our stride to the width of a sleeper. The mortar crew found their weapon and bombs very heavy, so I offered to carry the case of bombs. I caught up with our company quarter-master sergeant who was well read in military history and as we walked we discussed all the great retreats of the past. The lines of fleeing people along the railway were endless, but I had particular sympathy for the little children, or mothers with babies.

Towards dawn I took my section into a wooden barn, climbed aloft and fell asleep in the straw. When digging into our packs for breakfast, German armoured cars ran across the field in front. We had a

council of war and decided to get on our way again – it was daylight. We went back to the railway line, where a train lay on its side hissing steam. Streams of young Belgian boys were on the move back. Two English guardsmen joined us; they had a very frightened Belgian civilian with them, who they claimed was a spy. They asked if we would escort him back. As they were only two and we eight, we agreed. How they knew he was a spy I have no idea. When we encountered some Belgian troops, I got them to take him off our hands, and we were able to set about our journey again. Some time later we came across an abandoned waggon, and when we looked inside, we saw his dead body.

The CQMS's feet were very sore and blistered. Ours were hardened with frequent route marches. Somewhere towards the coast we met some officers who directed us into a French Army barracks where we were reformed and became part of an emergency division. We were sent north again and had to hold back the German Army at Abbeville, while the last Canadian Division re-embarked with all its equipment and returned to England.

I remember fairly clearly that second rail journey north and we detrained somewhere near Pont de L'Arche. The remnants of our division were there. We had been ordered to hold the line of the Seine to the east of Pont de L'Arche and were split into companies. Our company was asked to hold the most eastern section. Whether the Germans were near or not we had no idea and so we set off marching in sections down the road. A steep hill rose on our right and to the left were fields of ripe corn. We reached a road and hamlet at the foot of the hill; at the junction a team of French artillery men had an anti-tank gun pointing uphill. A steady stream of black French colonial troops were making their way down the hill. It seemed a dangerous place to be but our new platoon commander, Peter Lambeth, who had been posted to us, told me a reverse slope was a classic position to hold and that was what we were going to do. So, in an amateur way, we dug our positions.

Late that afternoon there was a series of enormous explosions from the direction of the river. It was the French engineers destroying the bridges over the Seine. We settled down to wait. I remembered rather sadly my last enquiry about my transfer to the Navy. The adjutant was away and I went in to see the 2nd-in-command, a real military man. A major with a stiff moustache and a voice like a dog's bark.

Drawing made by Bill Ward in 1939 of the construction
of an air raid shelter.
(*Reproduced with the permission of RWF Museum*)

He got straight to the point: 'Who had been foolish enough to make me into a lance corporal? A poet!!! What would I do if I had to lead a bayonet attack, a mild-charactered artist? And what impertinence to think of a commission.' He then told me to get out and look to my platoon.

Later we heard the rattle of tracked vehicles on the far side of the hill, so at dawn our platoon commander decided to send a patrol to look. I was chosen with a fellow lance corporal and was sent up the hill and along the line of hedge, to get a view over the top of the hill. We could see numerous armoured vehicles and lorries. All of them looked black with white crosses and swastikas.

Standing up in the turret of an armoured vehicle which was coming along the road was a young man wearing a French steel helmet. It must have been a souvenir, but at the time I thought the man was French, so I stood up beside the road. On seeing me, he ordered his gunner to open fire. At the same time the French gunners at the bottom of the road opened up with ferocious explosions. My colleague put the Bren gun he was carrying on my shoulder and began to fire. We then went through the hedge and down the hill as fast as we could. I was deafened by the noise. A German motorcycle and side car was slewing off the road by the armoured vehicles, already firing at us before he stopped. The platoon commander ordered us to withdraw down the hill. The journey downhill was incredible; young Vallans was hit with a bullet which tore a strip out of his trousers and underpants. This we patched up as best we could with our first aid equipment.

Crossing the road we came under fierce and intense fire from the motorcyclist. Our platoon commander, Peter Lambeth, was hit by a bullet in his leg. Wally Arnold, his batman, and I dragged him to safety behind a cottage where we tried to patch him up. We could see the bullet but Peter wouldn't let me try and get it out with my knife – and I don't blame him. The machine gunner could see us, but we lay flat on our stomachs and he could not depress the gun sufficiently enough to hit us. The cottage wall was disintegrating behind us.

We found ourselves in some rose bushes and I picked a flower for each member of the section, who put them in the buttonholes of their battledress blouses. It brought a bit of hope to our somewhat depressed feelings. The bullets seemed very close now, so with Wally on one side of Peter and me on the other, we made a hasty but clumsy

115

dive for the bottom of the garden, through the wooden fence and into the field full with corn.

We set off through the corn after the others. Peter was wonderfully courageous, hopping on one leg, while hanging on to Wally and myself. It must have been painful, but he never complained. Further motorcyclists and armoured vehicles went down a track on our right leading to the River Seine. The armoured vehicles gave no quarter to those who surrendered to them. The Germans made them put their rifles on the road, which they ran over, and then opened fire on them. It was horrendous!

We lay flat in the corn, quiet and out of sight, when we heard a motorcycle and side car coming down the lane on our left. Once again the gunner couldn't depress his machine gun far enough, and although he took the tops off the corn above our heads, we remained safe. So there we decided to stay. Peter's leg was painful, so I had another go at bandaging it. The blood drying on my hands prickled sharply. We finished the water in our water-cans and listened to the German machine gunners talking nearby.

All day long, from somewhere to the north, heavy artillery bombarded the south bank of the Seine. As we lay in the corn we could watch the blur of each shell, as it went over the fields, followed by a dull thud and a cloud of smoke. I made drawings of these impacts in my sketch book. We dozed and afterwards, I made a foray to the road. It was narrow, metalled and raised, with a ditch on either side. Coloured French colonial troops were dodging along. One stopped and asked if I was *blessé*, I replied, 'No' and wished him well.

Eventually night fell and a great dark yellow moon appeared in a mauve sky. We could still hear the advanced German soldiers talking nearby, but we got on our feet, put our arms round Peter and shuffled to the road. I knew the 23rd Psalm by heart and quickly recited it to my friends. I went ahead: a milk van had rolled over into the field on the right, so I went to collect water from its engine in my steel helmet. The vehicle was smashed and there were bullet holes all over it. The driver was lying dead across his seat and there was no water or milk.

The banks on either side of the road were lined with wounded or dead people. One of them groaned and I could see he was a priest who had been shot. I gave him what was left of my water and he blessed me.

We carried on, but Peter kept getting cramp. He bravely continued until eventually we reached the river bank. It was thick with vegetation into which we scrambled and lay puffing. I went down to the water, filled my steel helmet and brought it back to Peter and Wally. The water stank like sewerage and tasted like it as well. Nonetheless, we all took a good, long drink.

We decided that I should go and look for a boat. First, I scoured the side of the river on which we were, but then decided I should swim across the river and look on the other side. It was starting to get light to the east. I stripped down to my vest and underpants. Peter gave me his .38 pistol which I hung by its lanyard around my neck. We shook hands and I waded in. There was a mist over the river as I set off. The Seine was wide at Pont de L'Arche and the pistol became heavy, so I wriggled out of the lanyard and let it go. As I swam a German sentry

Study of seated soldier by Bill Ward.
(*Reproduced with the permission of RWF Museum*)

117

watching the river heard me through the mist and opened fire. This didn't deter my stroke and the bullets plopped into the water beside me. It's funny how bullets seem to stop at once in the water.

I crawled over the slippery bank and started my search for a boat, attracting gunfire from the side of the river I had just left. I found a decayed boat, in a derelict state, which I couldn't move. Daylight was gaining and as I moved along the bank a machine gun opened up. The wire fence was cut and sprung apart and I made a dash up the bank. I scrambled through nettles and shoulder-high reeds, straight into the fire of a French sniper. I shouted, 'Ne tirez pas. Je suis Anglais,' as a great lump of bark flew off a tree by my head. To my amazement a sniper appeared from behind a bush in front of me. There was an anxious few moments as I looked down the barrel of his gun, and at his finger on the trigger. I must have been a comic sight in my under-pants and vest. He lowered his rifle and reached deep into the pocket of his overcoat, drawing out a bottle of wine, which he handed to me. I might have been a teetotaller, but I was extremely thirsty, and I more or less emptied the bottle at one gulp. He hurriedly snatched it back, but gave me his overcoat and beckoned me to follow him to his motor bike. I did so, and he took me into Pont de L'Arche. There I met a well-spoken French officer and was told that a small group of English tank men called Queen's Bays were a few miles downstream. I was also shown our Sgt Major suffering from shell shock, who was locked, raving, in a little outhouse. We then went hunting for clothes. I found a pair of trousers, which had come from a tailor's dummy, blown out of a shop by the bridge. They were fawn coloured and would pass for British army uniform, and they were comfortable. Soon a couple of French boys came back with a battledress blouse. There were no papers on it but it did for me.

This was a sad day, I had lost all the drawings I had done so far, but it wouldn't be too long before I was getting more done. I took the French lieutenant downstream and showed him where Peter and Wally were still hidden in the undergrowth on the other side of the river. He promised to get me a boat that night. However, the enemy were very active and Wally decided to swim across the river, just as I had done earlier. Peter Lambeth was taken prisoner and remained so for the rest of the war.

The 30cwt lorry from the Queen's Bays turned up and I crawled in the back and someone handed me a bottle of beer, which I thankfully

cleared. At the Queen's Bays, Lord Scott gave me a woollen light-weight blanket which some years later my mother made into a dressing gown. At their camp I managed to sleep. Then someone asked for volunteers to go and raid the nearby NAAFI. As a grate-fully rescued soldier I went in the lorry with the driver, Topper Brown, and a couple of lads from the KOYLI. We drove a few miles to the village square where there was a marquee full of NAAFI supplies – bacon, sausages, chocolate, beer, dry bread and blanco, which we gave to the French. They would find it inedible!

Then it was back to join the Queen's Bays and to our horror they had been attacked by a German armoured patrol. Their one remaining armoured car had been destroyed by close-range shellfire; one or two soldiers lay scattered on the ground. We quickly swung out on to the road, Topper putting his foot down to the floor, and headed south. We decided to go to Marseilles, but we didn't have a map. I then remembered seeing a wine advert on the walls of most cafés in the area, for 'du Byrhh'. The advert included a large-scale map of France. We stopped at the next café we came to. It was deserted but there was a map on the wall, which I carefully took down and folded, so we could read it from our current position. We continued at top speed, with two of our boys pointing their Bren gun over the tail board of the lorry and about three others armed with rifles in the back. We then noticed a line of dust going ahead of us in the road. Dawning on us what it might be, Topper turned the lorry at right angles into the trees on the roadside. It was a Stuka and we felt safe hidden by the foliage, and there we stayed until the aeroplane had disappeared.

As night was coming on, we looked for somewhere to camp. Then we saw a pair of splendid wrought iron gates at the entrance to a château. We tugged them half open just enough to get through, went in and closed them behind us. There was a good gravel drive slightly uphill to a fine château. We would be less obvious in the grounds than in the house. We pulled off under the trees, lit a fire and kept a good lookout. I had captured a chicken at a farm, wrung the poor creature's neck and hung it in the back of the van. On the way along it had started clucking, so someone had beheaded it, and now it was broiled for our supper. A bit crude, but we were hungry. A series of guards were chosen, two at a time, while the rest lay on the lorry tarpaulin. I was about the only one with a blanket.

In the very early hours of the morning while it was still pitch black a sentry shook me with a whispered warning. There was a light under one of the trees a few yards down the path, and when I looked, right enough, there was a dim light at the foot of the tree. I borrowed his rifle, fixed his bayonet and quietly (apart from my heart thumping) attacked the light. I gave a good thrust with the rifle and buried the bayonet into solid tree. It was moss growing round the foot of the tree that was luminous.

The next morning we were up and about early and fetched water from a stream that ran through the trees nearby. We then tucked into our last slice of bread. We also had a little sip of tea left. Then someone heard the gates we had come through being opened. We were staggered; it was a German motorcycle and side car out of which the gunner had climbed to open the gates. The likelihood of an armoured vehicle being close behind it dawned on us at once. We threw everything into the back of the lorry. I jumped into the cab with Topper, who was still crunching his slice of bread, and as soon as I was assured that everyone else was in the back we were off at top speed. Fortunately the drive carried on around the side and to the back of the château. We had no idea where we were going but happily there was another set of, less elaborate, gates. They were open and we went straight through them on to a narrow road lined with trees. Our Bren gun chattered away at the motorcycle which was now following us, and which was soon joined by an armoured car. We really got up speed. Topper had removed the governor on the engine and the lorry went like a sports car. We sped up a hill and the armoured car and motorcycle were left far behind.

Of all people, we met a guardsman, upright and marching 'left right'. He was carrying a Bren gun and decided to join us on our way. Then into the road dashed two or three soldiers. They were ack ack gunners with a Bofors gun and a truck to tow it, which had pulled in. We had a quick conference and decided they should leave the gun and join us. Before doing so, they unscrewed the barrel of the Bofors gun and tumbled it down a slope. They next unhitched the carriage, and we helped to push it out the way; then we were off again.

It was rumoured that the Germans were occupying several villages on the road but we roared through each of them at top speed, the gun truck doing its best to keep up. We were now on the road to St Malo

and I think we were told in Avranches that it was still in French hands. At last we saw the town and ran into an enormous queue of British Army vehicles. There was a fuel dump beside the road. Then, immediately behind us, drew up an American ambulance with five very confident young lady nurses. They had been captured by the Germans and then released.

We could see the harbour now and I noticed a beautiful salmon pink yacht, in which we could no doubt get across the Channel, or at least to the Channel Islands. But as we marched in file, myself leading and carrying – I think it was the guard's Bren gun – we were stopped by a staff officer, red tabs and all and directed to the racecourse. Little or nothing was going on there. I personally burgled the NAAFI and stuffed my jacket with Wills Gold Flake packets. I didn't smoke myself, but I thought the money would be useful if I could sell them. Our little army then marched to the harbour. A hospital ship was alongside the quay, but we were stopped at the gangway as

Wartime study of a soldier's personal equipment, including rifle, bayonet and webbing, by Bill Ward.
(*Reproduced with the permission of RWF Museum*)

we were armed. Unpatriotically we threw all our weapons in the water. An officer standing nearby said we could be court-martialled for this and I said, 'Provided it is in England we don't care,' and on board we marched, where we were ordered to remove our boots and go up on deck into the bows. The ship was the *St Andrew* and to our delight we sailed within minutes. There were Stukas circling overhead and dropping bombs into the sea, more to discourage us than hit us, but it was noisy and frightening. We got something to eat, a blanket each and got down to sleep under the anchor winches. It wasn't the end of our campaign but we sailed top speed to England and arrived in Dartmouth in the early morning. I tried to get some sleep on the quayside, when a well dressed man, seeing I was still awake, asked if my parents knew I was safe. I told him 'no', so he took my phone number and rang up father at the shop. It must have caused great rejoicing, as the beaches at Dunkirk had already been cleared. We went to Dartmouth, marching through the streets with a lone piper from a Scottish regiment in front. The town turned out and clapped us as if we were victors, not a defeated army. I felt proud though. At the marine barracks I sold my Gold Flake, had a bath with a crowd covered in oil from a torpedoed ship, got new uniform and was allotted to a train with others from my unit, who were despatched north. I couldn't believe it when we were bussed from Sheffield station to the army barracks to which I had first been called up. My family all came to see me in turn and how happy a reunion it was. There were many years of war ahead.

Later I was commissioned and was a staff officer for the invasion of Europe. Then to Burma where I served with the 1st Battalion Royal Welch Fusiliers in the jungle, coming home after six and three-quarter years' service. Most of the drawings I did at the time are now in the regimental museum at Caernarfon Castle.

DAVID LANGDON OBE

(Cartoonist)

David Langdon is a cartoonist, illustrator and caricaturist. He was a regular contributor to *Punch* between 1937-92, and *The New Yorker* since 1952. He is perhaps best known as the cartoonist for the *Sunday Mirror* between 1948-93, but he is also well-known for his caricatures of racing celebrities, responsible for the Ladbroke's Racing calendar from 1959-84.

Among David Langdon's other creations was 'Billy Brown of London Town' for London Transport. Bowler-hatted 'Billy' appeared in wartime cartoons with messages which, as well as being amusing, were designed to broaden people's awareness, such as 'Billy Brown's own highway Code for blackouts is "Stay off the Road" He'll never step out and begin to meet a bus that's pulling in. He doesn't wave his torch at night, but flags his bus with something white. He never jostles in a queue, but waits and take his turn. Do you?'

At the start of the Second World War David Langdon was working in the Architect's Department of London County Council and joined the Civil Defence Rescue and Demolition Depot. He was made Executive Officer of the London Rescue Service until 1941, when he joined the RAF. He attained the rank of Squadron Leader and, after working for some time on the *Royal Air Force Journal*, he eventually became its editor.

David Langdon has held exhibitions in such diverse places as Ottawa, Oxford, New York, Lille and London. He has written several books, including *All Buttoned Up, Slipstream* (with James Hadley Chase), *Langdon at Large, Punch with Wings, Punch in the Air* and *How to Play Golf and Stay Happy.*

Unlike a few of the people featured in this book, military service didn't put a temporary hold on David Langdon's artistry and he was in the enviable position of being able to continue developing his talent under the auspices of the RAF, as he now explains.

At the outbreak of the war, as part of my then employment, I was seconded, with the grandiose title of Executive Officer, to the Civil Defence Rescue & Demolition Depot in the borough of Finsbury, hard by the City of London.

Our job in the threatened event of bombing was to rescue people and demolish unsafe buildings. When the blitz started in earnest the Civil Defence services were stretched to the limit and for nights on end the City in the winter of 1940-1 was engulfed in the fire and general mayhem which were to afflict other parts of the country but which we then thought were aimed at us personally and in particular.

'Come along there! Put some bleeding life into it!'

Cartoon by David Langdon recalling a burial party he was leading when a sergeant shouted at the coffin bearers, 'Come along there! Put some bleeding life into it!' He sent the cartoon to *Punch*, but the editor decided to reject it – wisely.
(*Drawing courtesy of David Langdon*)

At a point when even the celebrated Cockney spirit began to flag, my thoughts turned to volunteering for the RAFVR as a safer haven. I chose the RAF because my favourite uncle had regaled me as a child with stories about his life in the Royal Flying Corps in World War I, and a book he bequeathed me, *Rovers of the Sky*, was the set-book of my early reading. I had, however, to get round the problem of being in a 'Reserved Occupation' and its implication that, young and fit as I then was, I was of more use at the R & D Depot than in the armed forces.

The recruiting requirements of the RAF seemed to vary with the fortunes or otherwise of the air war. At one stage the flavour-of-the-month was for air gunners, but I did not consider it was worth applying to my authorities to lift their ban, as I reckoned my chances of survival in the rear turret of a Lancaster were roughly equal to sitting behind the sandbags in bombed-out Finsbury.

Then came a call for trainee pilots. Our depot PT instructor knew a friend who knew a friend of the orderly room sergeant at the local RAF recruiting office. Encouraged by a non-committal reply for permission from my HQ office, I presented myself to the sergeant with a note, a nod and a wink. It was when I sat waiting my turn to be interviewed that I had my first chilling glimpse of Service life.

A young LAC had marched up to the table where the interviewing officer sat and, with a shattering thump of highly polished boots, pulled off an enormously exaggerated salute, handed over a chit, stepped back a pace, repeated the salute, turned about and thumped noisily away. My heart sank. I was to meet many stereotypes of that LAC in the months of training which followed my induction as AC2 1456437.

We all recall the traumatic days of initial training when callow youths like ourselves were transformed overnight into airmen, severing every last link with undisciplined civilian life, by dedicated NCOs who seemed all to have had identical training for the job in the same crack Guards' regiment. I recall a long line of raw recruits in the vast balloon hangar at Cardington, which had been converted into a mess hall, queuing for a midday meal. Each clutched his tin mug and 'irons' and proffered his mug in turn to an LAC standing behind a single large urn at a long trestle-table.

'Tea, coffee or cocoa?' he intoned, with that bored air of condescension all longer-serving airmen reserved for 'sprogs'. We each

pondered the alternatives, trying hard to revive taste-buds so recently atrophied.

'Tea, please,' one man would timidly suggest. 'Cocoa,' another. The spigot on the urn would be aimed at each mug. The unidentifiable liquid emerging was the same for all choices.

Another memory is of the regulation haircut procedure. Here the queue was for the camp barber-shop, with a civilian barber wielding an electric clipper. Those like myself who were reluctant to forego their last vestigial tie with civilian status made up the tail end of every intake.

'How would you like it, sir?' the barber asked, leaning conspiratorially towards my ear.

'Not too short, please,' I ventured. A pregnant pause, and I produced half-a-crown. The barber took a pair of scissors from a drawer and snipped away.

'How's that, sir?'

'Fine, thank you.'

I stepped out of the barber's shop and by some curious coincidence straight into the arms of our squad corporal.

'What do you call this then?' he thundered, poking a hard finger at the nape of my neck. 'Get back in there and tell 'im to take some 'air off!'

'Tck, tck,' said the barber, flourishing his soiled cloth over me for the second time. 'did 'e catch you then?' The sympathy was feigned, and out came the dreaded clippers. The mutual arrangements with the corporal must have gone on ever since the camp opened years before.

Some months later, as a newly commissioned acting pilot officer, resplendent in my Gieves & Co uniform, with the thin 'scraper' ring on my sleeves and greatcoat epaulettes, I was posted back to my original training unit. This posting, contrary I believe to all Air Ministry procedure, was due either to a simple clerical error or, as I prefer to think now, a quixotically devilish ploy on the part of someone in Postings paying off some old atavistic score. I therefore appeared on a station where I had so recently been an 'erk' AC2 and soon began to attract a series of smart salutes from the same NCOs who had spared neither word nor deed in the difficult task of transforming me into an airman.

I particularly cherished the salute of my old flight sergeant, a fiery

At a point when even the celebrated Cockney spirit began to flag, my thoughts turned to volunteering for the RAFVR as a safer haven. I chose the RAF because my favourite uncle had regaled me as a child with stories about his life in the Royal Flying Corps in World War I, and a book he bequeathed me, *Rovers of the Sky*, was the set-book of my early reading. I had, however, to get round the problem of being in a 'Reserved Occupation' and its implication that, young and fit as I then was, I was of more use at the R & D Depot than in the armed forces.

The recruiting requirements of the RAF seemed to vary with the fortunes or otherwise of the air war. At one stage the flavour-of-the-month was for air gunners, but I did not consider it was worth applying to my authorities to lift their ban, as I reckoned my chances of survival in the rear turret of a Lancaster were roughly equal to sitting behind the sandbags in bombed-out Finsbury.

Then came a call for trainee pilots. Our depot PT instructor knew a friend who knew a friend of the orderly room sergeant at the local RAF recruiting office. Encouraged by a non-committal reply for permission from my HQ office, I presented myself to the sergeant with a note, a nod and a wink. It was when I sat waiting my turn to be interviewed that I had my first chilling glimpse of Service life.

A young LAC had marched up to the table where the interviewing officer sat and, with a shattering thump of highly polished boots, pulled off an enormously exaggerated salute, handed over a chit, stepped back a pace, repeated the salute, turned about and thumped noisily away. My heart sank. I was to meet many stereotypes of that LAC in the months of training which followed my induction as AC2 1456437.

We all recall the traumatic days of initial training when callow youths like ourselves were transformed overnight into airmen, severing every last link with undisciplined civilian life, by dedicated NCOs who seemed all to have had identical training for the job in the same crack Guards' regiment. I recall a long line of raw recruits in the vast balloon hangar at Cardington, which had been converted into a mess hall, queuing for a midday meal. Each clutched his tin mug and 'irons' and proffered his mug in turn to an LAC standing behind a single large urn at a long trestle-table.

'Tea, coffee or cocoa?' he intoned, with that bored air of con-descension all longer-serving airmen reserved for 'sprogs'. We each

pondered the alternatives, trying hard to revive taste-buds so recently atrophied.

'Tea, please,' one man would timidly suggest. 'Cocoa,' another. The spigot on the urn would be aimed at each mug. The unidentifiable liquid emerging was the same for all choices.

Another memory is of the regulation haircut procedure. Here the queue was for the camp barber-shop, with a civilian barber wielding an electric clipper. Those like myself who were reluctant to forego their last vestigial tie with civilian status made up the tail end of every intake.

'How would you like it, sir?' the barber asked, leaning conspiratorially towards my ear.

'Not too short, please,' I ventured. A pregnant pause, and I produced half-a-crown. The barber took a pair of scissors from a drawer and snipped away.

'How's that, sir?'

'Fine, thank you.'

I stepped out of the barber's shop and by some curious coincidence straight into the arms of our squad corporal.

'What do you call this then?' he thundered, poking a hard finger at the nape of my neck. 'Get back in there and tell 'im to take some 'air off!'

'Tck, tck,' said the barber, flourishing his soiled cloth over me for the second time. 'did 'e catch you then?' The sympathy was feigned, and out came the dreaded clippers. The mutual arrangements with the corporal must have gone on ever since the camp opened years before.

Some months later, as a newly commissioned acting pilot officer, resplendent in my Gieves & Co uniform, with the thin 'scraper' ring on my sleeves and greatcoat epaulettes, I was posted back to my original training unit. This posting, contrary I believe to all Air Ministry procedure, was due either to a simple clerical error or, as I prefer to think now, a quixotically devilish ploy on the part of someone in Postings paying off some old atavistic score. I therefore appeared on a station where I had so recently been an 'erk' AC2 and soon began to attract a series of smart salutes from the same NCOs who had spared neither word nor deed in the difficult task of transforming me into an airman.

I particularly cherished the salute of my old flight sergeant, a fiery

tempered, ginger-haired type to whom I had once failed to endear myself when I asked him, with unusual temerity, why he had awarded 'A' Squad 100%, 'B' Squad 103% and 'C' Squad 106% at a passing-out parade. I was merely querying his grasp of elementary percentages. He dismissed this with a curt, 'Because 'C' Squad was a bloody sight better than you lot, that's why.' I was never able to verify whether he recognized me in my new guise.

That heady experience, the unfulfilled dream no doubt of countless aircraftmen over the years, was short-lived, and a correct posting soon followed. This was to RAF Hunsdon, an 11 Group night-fighter station in Hertfordshire.

This was the sharp end of Service life. Black-painted Hurricanes and Boston Havocs were being serviced by fitters and armourers at dispersals, or flying off at dusk on runways disappearing into the green countryside, over beacons and ack-ack sites and white-painted station bicycles, airmen-for-the-use-of. And overall the all-pervading smell of aviation fuel.

Numbers 3 and 85 night-fighter squadrons operated from Hunsdon, and with them such famed fighter pilots as Wing Commander Peter Townsend and John 'Cat's eyes' Cunningham, to name-drop just two. Lesser luminaries on the ground staff were Tim Molony, in civilian life Ladbroke's 'man-on-the-rails,' and now Adjutant of 85 Squadron, and the Station Adjutant Richard Watts-Jones, formerly managing director of Fenwick's, the ladies' fashion store in Bond Street.

The officers' mess was in a grand country house, Bonningtons. I have a poignant memory of having the job of bar officer tacked on to my duties in Intelligence. If someone thought the connecting link between the two jobs was a knowledge of fine wines they were sadly mistaken. The previous owner of Bonningtons had graciously left the contents of the well-stocked cellar to the new incumbents, and I found myself dispensing dusty bottles, long laid-down, at a shilling a time. My conscience still pricks me, although I feel the owner of Bonningtons might well have been happy to have given away his precious bottles free of charge to those fortunate enough to have returned safely from their nightly ops instead of my swelling the coffers of the PMC.

My final memory of Hunsdon is of No 1451 'Turbinlite' Flight. This was then a top-secret wheeze thought up by a senior scientific

boffin who had the ear and assent of the PM, Winston Churchill.

The flight was comprised of twin-engined Boston Havocs, into the nose cone of which was fitted an AI radar and a searchlight three times more powerful than the standard Army type, behind a flat disc of armoured glass three feet in diameter. The power unit was a ton of car batteries carried in the bomb bay.

The idea was for this airborne searchlight to illuminate and discommode the pilot of the enemy raider, and two accompanying Hurricanes would then go in for the kill. In practice the scheme was none too successful. Nose-heavy, the Turbinlites either crashed on take-off or proved difficult to manoeuvre in flight. Several fatalities resulted.

I recall leading one of the burial parties on its way to Hunsdon churchyard. The sergeant i/c the four aircraftmen bearing the coffin suddenly took umbrage at their slower than regulation pace.

'Come along there!' he barked at them. 'Put some bleeding life into it!'

I drew a cartoon of the incident and showed it to the assembled company in the briefing room at Control. In spite of its black humour it met with unreserved approval. I sent it off to *Punch* for publication. I should have added a note to the effect that it appeared to have gone down well with all concerned at the station. It was returned with an 'Editor regrets' slip. Wisely. But to be fair he made up for this thumbs-down by publishing many of my less controversial cartoons on Service life.

While on this subject I once received a request, by signal from Air Ministry, to illustrate a manual on 'Fighter Tactics'. Sitting on my bed and improvising a chest of drawers as a drawing board, I was busy trying to depict a type of air interception known as the 'Tizzy angle' when I became aware of heavy breathing over my shoulder. Our batman, AC2 Pedlingham (one batman per six officers), had paddled silently into the room in his regulation gym shoes and was taking a close interest in my small sketch.

'Coo, sir,' he said, 'I used to be a signwriter too!'

I felt proud to be included in the same company of artists such as Pedlingham, who had once been engaged on work of similar importance at Ford's of Dagenham, painting 'Ladies' and 'Gents' and such like on factory doors.

One fine summer's morning I was walking down the Strand, some-

what pre-occupied. I was on embarkation leave, with yet another posting, this time to the Middle East. Striding towards me was the tall, slim erect figure of a squadron leader, military moustached, brief-case under arm. We exchanged salutes. He turned.

'Langers!' he cried.

He was Rene Raymond, whom I had once met at the Air Ministry when we were both contributing to *The Royal Air Force Journal*. He had written a series of amusing stores of barrack-room life, which I had illustrated.

'You're just the man.'

'If it's more illustrations,' I said, 'I haven't much time. I'm on embarkation leave.'

'Hector's gone,' he countered, 'and I'm in charge of P9.'

Squadron Leader Hector Bolitho, a New Zealander and well-known as a royal biographer, had been editor of the official *Journal* since its inception. It was a lively magazine, putting across Air Ministry Orders to the troops in palatable form, and containing articles and stories by RAF personnel, including those by H. E. Bates, John Pudney, Richard Hillary and Basil Boothroyd. Unlike its larger counterpart in Whitehall, the Directorate of Public Relations, P9's remit was selling the Service to the Service.

I congratulated Raymond on his appointment and promotion.

'Coo, Sir! I used to be a signwriter too . . .'

'And I've a vacancy for a flying officer,' he said.

'Sorry, sir,' I replied, glumly. 'I'm posted abroad.'

I had long learned that in the Service if there was something you desperately needed from the powers-that-be there was scant chance of its being granted. On the other hand . . .

'I'll see about your posting,' Raymond said, and marched off.

Rene Raymond's pen name was 'James Hadley Chase'. He had become famous, and notorious, for his first novel, *No Orchids For Miss blandish*, which had sold in its thousands and was then in process of being turned into a West End musical. A question was raised in Parliament asking the then Air Minister about the desirability of a Squadron Leader Raymond to edit the official *Royal Air Force Journal*, following the publication of the scandalous *No Orchids*. The Air Minister stoutly defended the appointment in the glowing terms dictated by AVM Bertine Sutton, then Director of Personnel, and nominally in charge of P9 branch and Raymond.

In my view there was no finer choice of officer than Raymond. He seemed to have inherited the military bearing and attitudes of his father, who had been a colonel in the Indian Army, and I found it always a pleasure to work with him. His briefcase invariably carried a batch of typewritten sheets for a new novel, but he was a strict disciplinarian, tempered by an impish sense of humour.

'You may wish you'd taken that Middle East posting,' he said to me one day, waving a signal at me. 'SEAC want to drop us over Burma by parachute with a portable press to set up a Far East edition of the *Journal*.'

My cancelled posting suddenly did appear preferable.

Soon after this scare, which failed to materialize, we were taking a lunchtime walk, from Adastral House where P9 operated, and passing Bush House in the Aldwych. A V-Bomb exploded directly above us. Raymond and I were thrown to the ground. The carnage around us was frightful. Buses were ablaze, one was hurled into an emergency water supply tank. Buildings on either side of Kingsway were shattered and there were many dead and wounded littered around.

When we recovered from delayed shock some days later, the Middle East and Burma were forgotten. Instead my thoughts went back to my comparatively halcyon days at Finsbury Rescue & Demolition Depot. I had come full circle.

JAMES BOSTOCK RE ARCA
(WOOD ENGRAVER)

James Bostock studied at the Medway School of Art, Rochester, and the Royal College of Art, London. After the war he worked as a full-time teacher until 1978, during which time he had been vice-principal of the West of England College of Art and academic development officer for Bristol Polytechnic. He has exhibited water colours, etchings, wood engravings and drawings at the Royal Academy and venues around the world, in Poland, Czechoslovakia, South Africa, the Far East, New Zealand, USA, Russia and Sweden. He has held several one-man shows and his work has been bought by collections such as the Victoria and Albert Museum, the British Museum, and many education committees, libraries, museums and private collections.

James Bostock has written several books and articles including *Roman Lettering for Students,* and his work was reproduced in *The History of British Wood Engraving* and *British Wood Engraving of the Twentieth Century.* In 1988 he also produced the wood-engraved illustrations to the poems of Edward Thomas.

A member of several art societies, including the Society of Wood Engravers, James Bostock served with both the Durham Light Infantry and the Royal Corps of Signals during the Second World War, mainly in Iraq and Egypt.

In the following account he describes the daunting moment when he was ordered by his commanding officer to sketch his portrait, for which he was to receive in payment, a carton of Victory V cigarettes.

I completed my three years of study at the Royal College of Art in July, 1939, leaving with the ARCA (Associate of the Royal College of Art).

War was obviously looming. I did a few months' service in Civil Defence Camouflage and was then conscripted into the Army with the 22 age-group in February, 1940.

Nearly two years later I was a private in the Signals platoon of a battalion of the Durham Light Infantry. We were in Iraq (Note 1). The theory was that the Germans might come down from the Russian front on their way to the Middle East.

We had travelled in large heavy three-tonner trucks from the south, having passed through Tel Aviv and driven monotonously alongside the great oil pipeline between today's Israel and Bahrain.

We passed through Baghdad and finally reached Kirkuk. As far as we could see it was just another part of the endless wilderness, with perhaps rather more black pipes sticking up from the ground, permanently flaming at the top. 'Burning off gas,' I was told.

Our Commanding Officer was a tough old warrior, related to a famous Northumbrian family, and everyone was terrified of him, including the officers. At least, that was my impression.

He sent for me one day, much to my alarm, as apparently he had heard that I had some skill in drawing, and he commanded me to do a drawing of him to send home.

I had no decent drawing paper or pencils, charcoal, etc. I had to make do with typing paper and a pencil borrowed from the Orderly Room, which was a small tent acting as a movable office. I entered the great man's own tent with trepidation. He ordered me to sit down, offered me a briefcase to rest my paper on, and seated himself firmly in a chair and stared fixedly into the distance, having already warned me to 'get these in', indicating his epaulettes with star and crown, indicating his rank as Lieutenant Colonel. He seemed to be hewn from granite with a flourishing moustache and a fearsome frown.

It was hardly a situation in which great works of art are made. I did the best I could, and to be fair to him he sat rigidly still for a long time, while I did what I could to draw this awesome sight.

Eventually I indicated that I thought, perhaps . . .

He took the paper from me and scrutinized it from several angles.

'You've made me look very grim,' he said. I had nothing useful to say. He was the grimmest individual I had ever met, so far.

Then he said, unexpectedly, 'Do you smoke?'

'Oh yes, sir!' I said thankfully, waiting for him to offer me a cigarette. However, nothing happened except that he indicated the meeting was over . . . thank you. I think he said thank you. He took the drawing and I left, saluting once or twice on my way out.

A couple of days later his batman came over to me and gave me a carton of Victory V cigarettes, a gift from the CO. These cigarettes came up free with the rations, and were just about unsmokeable. If you tipped one up the contents spilled out on to the sand. You would really have to be in need of a smoke to use these!

About a year later I was a sergeant in the Royal Corps of Signals working at GHQ Cairo in High-Grade Ciphers.

Off duty we lived in a Sergeants' Mess in a small village just outside Cairo, a pleasant enough situation. I took the opportunity to paint a couple of murals on the white walls of the Mess. In the dining room I painted a long nostaligic view of an English country scene in summer, with a cornfield, sheaves stacked into stooks, a farmhouse, elm trees, soft cumulus clouds, etc.

On the wall behind the bar I painted a mural which looked at its best by artificial light, featuring a few semi-nude dancing girls in strong, dark colours. The chaps seemed to approve of both paintings.

It all added up, I'm afraid, to quite a small contribution to English art during the war.

NOTES:

(1) The campaign in Iraq is one of the lesser known military involvements of the Second World War. In May, 1941, Iraqi troops under the command of Rashid Ali, who was the prime minister of Iraq, attacked the British garrisons at Basra and Habbaniya. The oil reserves in the area were crucial to the Allied war effort and had to be defended at all costs. The Nazis were quick to appreciate this, so the Germans and Italians built a joint air base at Mosul and supplied the Iraqis with munitions. Shortly afterwards the RAF attacked and destroyed the air base. Meanwhile, British ground troops, quickly mustered from the local garrisons, reinforced by troops from India and General Wavell's garrison in Palestine, attacked Baghdad, the capital of Iraq. Rashid Ali fled the country and stability was returned to the area.

The events described by James Bostock took place a year after the campaign in Iraq had finished, but British troops garrisoned the area in case the Nazis should start a front there. The area remained essential to the war effort and James Bostock describes the oil pipes, which were the main reason that British troops remained in the country.

Chapter Eight

CAPTURED ON FILM

Film and television provides a platform for many areas of creativity, such as producers and directors, designers, scriptwriters and composers. In this chapter we shall be meeting people who have used their creative talents, either in the film or television industries, and who served in uniform during the Second World War.

There are three stories: the first is written by film producer, designer and dramatist John Hawkesworth, who served with the Grenadier Guards, the second by film and television producer Shaun Sutton, who served in the Royal Navy, and the third by scriptwriter and author George MacDonald Fraser, who served with the Gordon Highlanders.

Other film producers and directors who did war service include John Boulting and his twin brother Ray. John Boulting served in the RAF as a Flight Lieutenant, while Ray served in the Royal Armoured Corps finishing as a Captain. They often worked on films together and their credits include *Burma Victory, Private's Progress, I'm All Right, Jack* and *Crest of the Waves*. John Boulting also wrote the screenplays for several films.

Ralph Thomas, who served with the 9th Lancers and was an instructor at the Royal Military College, directed some of the best-known films in British cinema history, such as *Appointment with Venus, Above us the Waves, The Iron Petticoat, Campbell's Kingdom, A Tale of Two Cities, The 39 Steps, Hot Enough for June* and *A Nightingale Sang in Berkeley Square*. He also directed the Doctor series with titles like *Doctor in the House* and *Doctor at Sea*.

Lord Attenborough joined the RAF in 1943 and was seconded to the RAF Film Unit. Among the films he has directed is *A Bridge Too*

Far, a graphic re-enactment of the Battle of Arnhem in 1944. Other films as director or producer include *Young Winston, Oh! What a Lovely War* and *Gandhi*. As an actor Richard Attenborough has appeared in many films, including *In Which We Serve, Dunkirk, The Great Escape, Dr Dolittle* and *Jurassic Park*.

Film designer John Box served in the Royal Armoured Corps and the Royal Tank Regiment, and in 1944 was mentioned in despatches during the campaign in Normandy. Among his film credits are *Lawrence of Arabia, Doctor Zhivago, A Man For All Seasons* and *A Passage to India*. He also produced *The Looking Glass War*.

On the subject of television producers, another name worthy of mention is Arnold Ridley. Having served during the First World War, Arnold Ridley enlisted at the outbreak of the Second World War and was sent to France in 1939 with the British Expeditionary Force on the Public Relations Staff with the rank of acting Major. Although he made his name as a television producer and dramatic author, he will be best remembered for his acting role in the long running series *Dad's Army*, in which he played the part of Private Godfrey. *Dad's Army* is without question one of the most successful British television programmes ever made, which has seldom been off the small screen for thirty years. Children today are still as familiar with Captain Mainwaring, Sergeant Wilson, Corporal Jones and Privates Fraser, Godfrey, Walker and Pike, as their parents were in the nineteen seventies. The series was written by David Croft and Jimmy Perry from personal experiences of the time, and helps to keep alive for future generations that tremendous spirit of England against adversity, and why we need to remember the Second World War and those who fought and died between 1939–45 in the name of freedom.

Other war veterans who became scriptwriters for film or television include Eric Ambler who served with the Royal Artillery and became Assistant Director of Army Kinematography at the War Office. In 1944 he wrote the screenplay for a film called *The Way Ahead*, which starred David Niven. Set in North Africa at the time of El Alamein, the film was conceived by Niven himself, who was serving in the army at the rank of Lt Colonel, and was released for special duty to make it. After the war Eric Ambler wrote the screenplay for *The Cruel Sea*, which tells the story of the Battle of The Atlantic. Based on the novel by Nicholas Monsarrat, the film starred Jack Hawkins, Donald Sinden, Stanley Baker and Denholm Elliott. Eric Ambler also wrote

the scripts for *Yangtse Incident,* and *Wreck of the Mary Deare.* His many books include *To Catch a Spy, A Kind of Anger* and *Passage of Arms.*

Robert Bolt, who served in both the army and the RAF, wrote successful plays such as *A Man for All Seasons* and *The Thwarting of Baron Bolligrew.* He also wrote the screenplays for a string of historical epics, such as *Lawrence of Arabia, Dr Zhivago, Ryan's Daughter, Lady Caroline Lamb* and *The Bounty.*

Lionel Jeffries served with the Ox and Bucks Light Infantry and the Royal West African Frontier Force. He wrote and directed *The Railway Children* in 1970, which won the St Christopher Gold Medal in Hollywood for Best Film. His screenplays for film and television include *The Amazing Mr Blunden, Shillingbury Tales, Father Charlie, Tom Dick and Harriet* and *Rich Tea and Sympathy.* Also known as an actor, Lionel Jeffries appeared in *Colditz Story, Chitty Chitty Bang Bang* and *The Prisoner of Zenda,* among many others.

JOHN HAWKESWORTH
(FILM PRODUCER, DESIGNER AND DRAMATIST)

Film and television producer John Hawkesworth is also known as a dramatist, film designer and painter. He is best known for both writing or producing some of the most successful programmes in the history of British television. Programmes which have since become regarded as national treasures in the mind of the viewing public, such as 'Upstairs Downstairs,' 'The Duchess of Duke Street,' 'The Flame Trees of Thika' and 'By the Sword Divided'. He also produced programmes like 'The Tale of Beatrix Potter', 'Sherlock Holmes', 'The Return of Sherlock Holmes and the Sign of Four', 'Campion' and 'Danger UXB', which followed the exploits of a London-based bomb-disposal team.

After serving with the Grenadier Guards during the Second World War, John Hawkesworth entered the film industry as a designer and worked on titles like *The Third Man* in 1949, a memorable romantic thriller starring Joseph Cotten, Trevor Howard and Orson Welles. Written by Graham Greene and directed by Carol Reed, the film was a huge box office success, for which John Hawkesworth helped to design stunning backgrounds depicting a war-torn landscape.

Other films he designed include the delightful eccentric comedy *Father Brown*, starring Alec Guinness, Joan Greenwood and Sidney James; *The Man Who Never Was*, starring Clifton Webb and Robert Flemyng, which was based on the famous book by Ewen Montagu, and *The Prisoner*, with Alec Guinness and Jack Hawkins.

In 1959 he wrote and produced a film called *Tiger Bay*, which has since become regarded as a landmark in the history of British cinema, and which at the time was a considerable hit. The film, directed by J. Lee-Thompson, featured the father and daughter pairing of John

and Hayley Mills, and also starred Horst Buchholz as a Polish seaman who kills his faithless girlfriend during a trip to Cardiff and afterwards kidnaps a child, who proves to be more than a match for him.

As well as being a producer, dramatist and film designer, John Hawkesworth has written several screenplays, including *Mrs 'Arris Goes to Paris* in 1992, and is an accomplished painter who has held four one-man shows.

His many TV awards include the Peabody Award 1977, and his books include *Upstairs Downstairs, In My Lady's Chamber* and *The Making of Upstairs Downstairs*.

During the war John Hawkesworth was able to put his own talent as a producer and designer to very good use, helping to put on shows for the army, as he now explains.

Being too young to join up at the outbreak of the Second World War, I went up to Oxford, where I produced several plays. When I was old enough I was commissioned into the Grenadier Guards. As a troop leader in an armoured brigade I landed in Normandy and finished the war in front of Lübeck. (Note 1)

During that time I had little chance to draw or paint except during those brief breaks when we joined with our luggage. So much was always going on that there was little time for drawing but I now wish I had made more effort with my sketch book. I have given the Imperial War Museum a watercolour of a village called Kevelaer, which is between the Maas and the Rhine, but that is about all I have left of my wartime drawings, except for a few sketches.

In December, 1944, just when we had settled into comfortable billets near Eindhoven in Holland, we were suddenly dug out and rushed south over icy roads to support the American Army who had been attacked in the Ardennes, in what was to be known as 'The Battle of the Bulge'. By Christmas Day I found myself a few miles from Maastricht. Hans Roeterihk, our very bright Dutch liaison officer, said he'd like to show me something that might interest me. We drove to Maastricht where a small hill in a curve of the Maas had been excavated and made into a huge shelter with great security and the latest technology, by the Germans, to house all the great paintings from the public collections in Holland. All was air-conditioned and heat-controlled. The big paintings such as Rembrandt's 'Night Watch' had been rolled up in wax, like a carpet, and gently revolved. The majority

of the paintings were hung on wire mesh steel screens and could be turned over like pages in a book. It was an amazing sight. The Director showed me a letter from Goering saying that when Germany had won the war he would get directions about where to send each painting. There were several gates at the entrance which closed behind a visitor and the Director told me that only one German general had dared visit the repository.

During the occupation of Germany I designed and had made the scenery for many plays and reviews put on for the Guards Armoured Division. Future colleagues in civilian life were Sandy Faris, who composed the music for *Upstairs, Downstairs* and *The Duchess of Duke Street* and Freddy Shaughnessy, the story editor of *Upstairs, Downstairs*.

When I was demobilized I was quite unqualified for any job in civilian life, and, being married, had to get on with earning a living quickly. Things looked bad until suddenly, out of the blue, Vincent Korda asked me to come to see him and, having seen some of my paintings in a mixed exhibition in London, offered me a job in the Art Department at London Films. I became a designer in films, then a producer and dramatist in both films and television.

The only time in my career I can honestly say that my wartime experiences actually helped my subsequent career was in a television series I produced and created called *Danger UXB*. This was based on the exploits of the gallant bomb disposal units in the war; it was centred on a Royal Engineers section based in London and all the characters in the section were in some way portraits of my own troop during the war. I also incorporated some of my own memories of wartime London into the stories.

For millions of people like myself the war was made up of long periods of boredom and short periods of frantic activity. I can still remember the endless hours of guard duty as a recruit and the drudgery of having to stay awake and sober as an officer to turn out the guard at midnight.

My generation grew not to think or plan more than a few weeks ahead; I suppose it was a protective mechanism. When peace came it was quite an effort to have to plan ahead.

People often ask me if I was very frightened – I don't think I know of anyone who wasn't. In the battle, because fighting in a tank and having to control people in other tanks was so difficult and confusing, there was simply not time for anything else. When I was very fright-

ened was lying in bed in London during the Blitz or crouching very flat under a tank waiting for the long-drawn-out scream of a 'Moaning Minnie' to finish in its explosion.

For some reason I was never upset by the sight of dead people though the smell was utterly nauseating. What made me very angry was the sight of so many dead and dying animals, especially in Normandy. The most uncomfortable thing was having to live out of doors in the winter.

Though we didn't think about it at the time, for most of us the war years were a big waste of our youthful years. I had the consolation of finding a wonderful girl and getting married at a much younger age than would have been usual in peacetime. We have just celebrated our fifty-fifth wedding anniversary.

NOTES:

(1) Lübeck, across the North German plain, fell into the hands of the Allies on 2 May, 1945, after Montgomery's 21st Army Group, spearheaded by VIII Corps, had fought its way across the Elbe, supported by the newly operational British jets, the Gloster Meteor. The capture of Lübeck cut off the German armies in Denmark and Norway and secured the entrance to the Baltic, as much from the advancing Soviet armies as the Germans themselves.

SHAUN SUTTON OBE
(AUTHOR AND TELEVISION PRODUCER)

Shaun Sutton was head of the BBC Television's Drama Group between 1969-81 and has been a consultant director and associate of Prime Time Television since 1987.

He attended the Embassy School of Acting in London and before the war he worked as an actor and stage manager in theatres such as the Aldwych, Adelphi and Criterion.

After the war Shaun Sutton was the stage director for Embassy and Provincial theatres until 1948, and producer for the Embassy, Buxton and Croydon theatres until 1950, when he toured South Africa as a producer. He entered service with the BBC in 1952 and wrote and produced many plays and serials for children's television and directed programmes like *Z Cars, Softly Softly, Sherlock Holmes* and *Kipling*. He produced the BBC TV Shakespeare series in 1982–84, and dramatised *Rogue Herries* and *Judith Paris* for BBC Radio.

Shaun Sutton is a Fellow of the Royal Television Society and a member of BAFTA. His own books include *A Christmas Carol* (the stage adaptation), *Queen's Champion* (a children's novel), and *The Largest Theatre in the World*.

During the Second World War Shaun Sutton served in the Royal Navy, although he was seconded to the Greek Navy for much of the time, serving in the Mediterranean with Admiral Cunningham's fleet, as he now describes.

My family background was theatrical and literary. I had been a Stage Manager for several years before the War and was working at the Criterion Theatre, London, when I was called into the Navy. This was in the late summer of 1940. I was sent, as an Ordinary Seaman,

to HMS *Raleigh* in Plymouth, a 'stone frigate' where, to my surprise, I spent the next three months 'square bashing'. No learning how to tie knots or recognize signal flags, not even one trip out to sea.

This came soon enough. I was sent to HMS *Cardiff*, based on the Clyde. She was an old light cruiser from World War One, which had actually led in the surrendered German Fleet at the close of hostilities. The ship was mainly used for gunnery training down the Clyde, but we had our ventures out to sea. On one of them, Captain Enright, one of the rare Naval Captains to rise from the lower deck, announced that the huge German battle cruisers *Scharnhorst* and *Gneisenau* were reported at sea, and that if he met one of them, he intended to ram her.

From *Cardiff* I was sent to HMS *King Alfred* (Hove, in Sussex) for Officer Training. That done, I was a Sub-Lieutenant RNVR and I was sent on a series of lightning courses – to the Clyde for ASDIC (Anti Submarine) Training, back to Portsmouth for Torpedo and Gunnery courses. All this, of necessity, was very rushed, cramming into a few weeks what would have taken a regular peacetime officer years to assimilate.

Towards the end of 1941 I suddenly received an order to report to John Brown's shipyard on the Clyde, to join HMS *Airedale* with the utmost dispatch. The train journey to Glasgow took twenty-four hours. I was very concerned that I might miss my ship, a serious offence in the Navy. I need not have worried. When I arrived they had only just got round to putting on the funnel!

Airedale was a small destroyer of the new Hunt Class, built for convoy and escort work. Her main armament was two twin HA/LA four inch guns, a few torpedos, and a lot of depth charges. After a number of 'working up' exercises – one of which was firing at a target towed by a tug, during which I am sure we nearly hit the tug – *Airedale* went on general patrol duties on the West Coast of Scotland. Then up to Scapa Flow and, in February, 1942, we went on a Russian convoy. We had not the fuel to reach Murmansk, so we had to turn back about half-way. Unlike so many Russian convoys, which experienced terrible losses, this one was trouble-free. But on our way back to Scapa we ran into the most appalling storm, with waves towering above our small ship, and the sea 'shipping it green' over our open bridge.

From there, via the Cape of Good Hope, to the Mediterranean.

With the Germans in France, Italy, Sicily, Crete, Greece and much of North Africa, it was considered too risky to send us alone across the two thousand miles of the Med to Alexandria. So instead, the long voyage round Africa, towed down the West African Coast for part of the way by one of *Cardiff*'s sister ships, the *Dauntless* – to make the fuel last!

Then through the Suez Canal to join the small Mediterranean fleet. No capital ships – the daring Italian midget-submarine raid on Alexandria had put *Queen Elizabeth* and *Valiant* out of action. Our largest warships were cruisers.

At first it was convoy duties between Alexandria and the small port of Tobruk in Libya, still held by a British garrison, but beleaguered by Rommel's Army. The harbour was an extraordinary sight – rows and rows of wrecked ships, including a large italian cruiser. I was told that there were over a hundred of them.

We were then sent as part of the escort to a large convoy of twelve merchant ships to carry desperately needed supplies and arms to Malta. Admiral Vian collected every warship he could lay hands on – light cruisers, destroyers of every class, and a dummy battleship. This was the old *Centurion*, which had been at the Battle of Jutland, and had been, between the wars, a target ship for gunnery practice; her sides were a mass of patches. She was now rigged with false gun turrets and funnels to look like one of the new *King George V* class of battleships – if you didn't look too close. The idea of this, of course, was to fool the Italians, and perhaps to draw their own capital ships away from the other Malta convoy, approaching from the West. We never made it to Malta. We sailed hundreds of miles down the Med, then deliberately turned back, presumably to draw the Italian Fleet out. That night *Airedale* was left behind to cope with some German or Italian E-Boats (fast torpedo gun boats). That done, we set off at full speed to rejoin the convoy.

Suddenly we were in the middle of them, hurtling through at a combined speed of about forty knots. In our absence, they had turned back through one hundred and eighty degrees. We scraped down the side of a huge merchant ship, missing her by inches. Our Captain looked up at the white-faced skipper of the merchantman and said, very politely, 'Sorry'.

The next day – this was in June – we were sunk. German Ju 88s and Ju 87s made a huge attack on the convoy, and we received a direct

hit aft. I read later that fourteen Ju 87s had singled *Airedale* out. A third of our crew was killed, the rest of us went over the side, to be picked up fairly soon by our sister ship *Aldenham*. I remember, when I was swimming away from *Airedale*, a box of matches floated out of my shirt pocket. Absurdly, I swam back to retrieve it.

I was soon sent to a new ship – the large fleet-class destroyer *Javelin*, which had once been commanded in Home waters by Mountbatten. When I was a seaman, at Portsmouth, I had been sent for by my cousin Lieutenant Commander Burnett, who was First Lieutenant of the famous destroyer *Kelly*. He asked if I would like to join the ship. I thought it might be embarrassing for him to have a cousin in the crew, so I politely refused. Later, of course, the *Kelly* was sunk during the evacuation of Greece. Fortunately, my cousin had left her some time before to take charge of ASDIC operations in the Clyde. From *Javelin* a shift to *Jervis*, a destroyer with a very distinguished record.

Then, for some reason, I was sent to await a new posting in one of those dreary camps in the desert outside Alexandria. A signal came to me to join HHMS *Katsonis*. HHMS? What was that? The Greek Navy, I was told, and *Katsonis* is an old submarine. My heart sank, for I am very tall, and not built for submarines. However, when I got to Port Said I was told that *Katsonis* was lying at the bottom of the harbour. Some unexplained accident. So I went instead as Liaison Officer to the Greek destroyer *Kondouriotis*, named after a Greek Admiral who had beaten the Turks many years before (Note 1).

I got on famously with the Greeks. It was mostly routine work, but we took part in one very odd operation. With out sister ship *Spetsai*, we were ordered to Haifa to pick up a captured Italian merchant ship, renamed *Empire Patrol*, and according to the orders, about which the Greeks were inclined to be part-secretive, we were to proceed North of Cyprus and then, unbelievably, speed through the Bosphorus, pretending to be Italian ships, to the Black Sea port of Odessa, with vital supplies for the Russians. Why the Turks should let an Italian force, let alone a Greek one, through the Bosphorus was not explained. Fortunately, the whole operation was cancelled half-way. The Greeks longed to take part in major operations, but I soon learned that our ship was suspect in the engine department. Moreover, we could not do more than twenty-seven knots.

However, no doubt by some political persuasion behind the scenes, we were attached to a fleet of warships sent on a fast operation

(I forget now what it was). A force of fast cruisers and fleet destroyers. I noticed something in the orders about 'Increase speed to thirty knots' and knew it would be impossible for us. But the Greeks were adamant. The fleet sailed at dusk, the *Kondouriotis* a flank destroyer. The signal came: 'At 21.20 commence Zigzag Number 18'. Zigzags were a way of thwarting attacks by U-Boats. At stated intervals the convoy or fleet would turn, say, fifteen degrees to starboard. Ten minutes later, fifteen degrees to port.

The Greeks argued about the signal. I maintained that we must start at 21.10 position in the chart; they said we must go from the top of the page.

The result was comic disaster. At 21.20 the entire fleet turned fifteen degrees to starboard, we turned the same to port. Within minutes, the fleet was a dot on the horizon. 'Back to Alex', I thought. But the Captain refused to give up. He shouted instructions for full speed and more, and soon the whole ship began to shake. On the bridge the vibrations made blurs of us all.

I made my way down to the main deck, where I found the Engineer Officer sitting near the funnel. To my horror, I saw that the base of the funnel was slowly beginning to glow red hot, something that was surely impossible. I pointed it out to the Engineer Officer, but he seemed unperturbed. Then there was an appalling crash from below, a great hissing of steam, and we limped back to Alex on one propellor.

Nevertheless, it was with the Greeks that I finally got to Malta with a convoy, and then on to the newly captured Tripoli – I think we were one of the first ships in there.

This was 1943, and the War in the Mediterranean was calming down. Convoys could now move with relative safety; soon Sicily would be invaded and Italy knocked out of the War.

My time with the Greeks was up and I was sent to Naval Control at Suez. The Greeks gave me a solid silver cigarette case, with an inscription thanking me for my 'collaboration', an unfortunate word in wartime.

The job of Naval Control is to route merchant ships on to their next destinations, to see them refuelled and generally looked after. I had a fast motor boat and my job was to lay it alongside the ships as they came out of the Canal, rush up the accommodation ladder, and contact the Captain. That done, back to my boat and the next ship. I would do as many as thirty ships in a day, hot work in the Suez heat.

In autumn 1945 I was sent home in the battered old battleship *Queen Elizabeth*. In the Bay of Biscay we heard news of a bomb being dropped on Japan that had wiped out an entire city. We discounted the report.

I finished the war off Ramsgate, in Kent, now routing ships to the newly opened ports of Europe. After the Mediterranean, I found Kent bitterly cold. But the war was soon over, and in 1946 I was able to return to the same theatre company I had left, five and a half years before, to join the Royal Navy.

NOTES:

(1) Greece had originally been invaded by the Italians in October, 1940, when General Sebastiano Visconti-Prasca with 162,000 men crossed the border from Albania. The Greek army of 150,000 men, under the command of General Alexander Papagos, put up fierce resistance and repelled their attack. Supported by elements of the Royal Air Force, sent by General Wavell from Egypt, the Greeks advanced into Albania.

In April, 1941, the Germans turned their attentions to Greece and the Twelfth Army of Marshal Wilhelm List smashed through the fortified Metaxas Line to face British troops newly arrived from North Africa. The Germans had surprised everyone by using armoured divisions in a terrain thought to be impassable by tanks, and the Royal Navy had to evacuate British and Greek soldiers from the beaches along the east coast. By 27 April, 1941, Greece had been completely conquered, but much of her Navy had escaped and worked with Cunningham's Mediterranean Fleet until liberation in 1945.

GEORGE MACDONALD FRASER

(AUTHOR AND SCRIPTWRITER)

A prolific writer of numerous adventure books and film screenplays, George MacDonald Fraser served during the Second World War with the Gordon Highlanders.

His books include *Royal Flash* which follows the fortunes of Harry Flashman, the character immortalized in *Tom Brown's School Days* by Thomas Hughes. Having left Rugby School, Flashman is commissioned into the 11th Hussars. The book was turned into an amusing film, with Malcolm McDowell in the title role and featuring an all-star supporting cast, which included Alan Bates, Oliver Reed, Lionel Jeffries, Michael Hordern, Alastair Sim and Britt Ekland. Directed by Richard Lester, George MacDonald Fraser wrote the screenplay himself. In some places military tradition and heroics are made light of. However, in his writing for us he illustrates only too well how horrific the war in the Far East was and captures something of the pride and camaraderie of the men who, today, still wear the Burma Star. The character of Harry Flashman has also featured in many more of George MacDonald Fraser's books, including *Flashman at the Charge, Flashman in the Great Game* and *Flashman's Lady*. His other books include *The Sheikh and the Dustbin* and *The Hollywood History of the World*.

George MacDonald Fraser's screenplays have included the James Bond film *Octopussy*, Arnold Schwarzenegger's *Red Sonja* and Richard Fleischer's 1977 version of *The Prince and The Pauper*, starring Mark Lester, Oliver Reed and Raquel Welch.

He also wrote the screenplay for Richard Lester's hugely successful and sparkling adaptation of *The Three Musketeers*, and its two sequels, starring Michael York, Oliver Reed, Richard Chamberlain

148

and Frank Finlay. More recently his television credits include the highly acclaimed *Casanova*.

Before becoming a successful novelist and writer of screenplays, George MacDonald Fraser had worked in newspapers and had been deputy editor of *The Glasgow Herald* until 1969. So often he has written about the comic book antics of super heroes, but for us, however, with the customary modesty of this rare breed, he now writes about a true life hero – himself.

When you have a million memories, you must choose at random. Standing guard in the snow at Durham in a great coat miles too big for me. Being told by an irate sergeant-major, 'It's dopey buggers like you what turn my hair grey!' after I'd let the company boiler go out. The stifling discomfort of sleeping on a table on G Deck of the rusty old trooper that took us from the Clyde to Bombay, and the technicolor wonder of Africa seen for the first time on a Mediterranean morning. The homesickness of Deolali at Hogmanay, with the raucous voices of the Cameronians singing 'We're no' awa' tae bide awa''. That terrible slow-motion moment when Jap caught us in the open at Kinde Wood and more than half the section went down in a matter of seconds. The mad scramble of the bunker-clearing fight that followed, when we killed 136 Japs for the loss of seven dead and 43 wounded. The artillery exploding among us as we advanced at Pyawbwe and a wounded corporal sang 'John Peel' (Note 1). Sitting in a Burmese basha, hearing the news of Hiroshima, and someone growling, 'High bloody time'. The discomfort of prickly heat as we stood sweating but immaculate in the blazing heat of the passing-out parade at Bangalore, and the heart-singing pride of knowing that beneath my cadet's white shoulder tabs there nestled the stars of a second lieutenant. The wonder of being a Gordon Highlander and sitting on mess night deafened by the pibroch and staring at the silver-mounted snuff box made from the hoof of the drum horse of the Scots Greys at Waterloo, where our Gordon forerunners broke Napoleon's heart in the Stirrup Charge. The pipes and drums beating retreat at Tripoli with 'Cock o' the North'. The shapeless apology for a suit, the ridiculous pork-pie hat, and the brown cardboard boxes in the demob centre at York.

Memories that are linked inevitably with peacetime thoughts over the past fifty years. The tanned remembered faces of young men

whose graves lie between the Irrawaddy and Rangoon. Walking through a car park and seeing all the Japanese models. Listening to the babblings of rejoicing pundits and politicians as television showed the Berlin Wall coming down, and thinking how delighted Hitler would have been if he could have seen it. Cold rage at the betrayal which railroaded my country into Europe, surrendering its sovereignty so that its very laws could be set at naught by the whims of foreigners who include the children of those wonderful people who gave us Dachau and Belsen. Wondering what Churchill and Attlee, to say nothing of Wellington and Drake, would have thought of our leaders in the last quarter of the twentieth century.

Looking at my grandchildren, and thanking God I was spared to be their grandfather. Meeting my old Burma mates once a year for prayers at the Cathedral and beer at the Castle, and wondering how many of us will be here next year. And if there is regret for the dead, and anger at the spoiling of their sacrifice by unworthy inheritors who cannot begin to understand what they and long centuries of Britons fought and died for . . . still there is thankfulness and comfort in the million memories of a time when we felt proud and strong and free.

NOTES:

(1) The advance on Pyawbwe and the other incidents recorded by George MacDonald Fraser took place during the final Allied thrust in Burma, ending in Rangoon itself. Following the capture of Mandalay on 20 March, 1945, Admiral Lord Louis Mountbatten, Allied Supreme Commander, South East Asia Command, was anxious to clear the Japanese out of Burma before the start of the monsoon. The Allied armies took several routes towards Rangoon. George MacDonald Fraser was with General Messervy and IV Corps, fighting its way along a route which took them through Pyawbwe (11 April), Pyinmana (21 April), Toungoo (22 April), Pegu (1 May) and Rangoon (2 May). At Pyawbwe itself the Japanese put up strong resistance, but, after being surrounded by tanks and infantry, they hastened to retreat, and Pyawbwe was considered to be a significant victory, leaving over 1,000 Japanese killed. It completed the Japanese disorganization that had begun at Meiktila on 3 March, and from that point Messervy's advance was largely a pursuit.

Chapter Nine

WRITING ON THE MARCH

Many contributors to this book have produced some form of creative writing at some point in their career, particularly in the last chapter. In fact, all the people involved in the creative side of film and television who told their stories could also be described as authors. In this chapter we shall be hearing from people who are predominantly writers of fiction, either for adults or children.

You will be reading the stories of the novelists Michael Gilbert, Ralph Hammond Innes, Richard Hough, John Prebble and Nigel Tranter. Some of these have also written for television or film, but they are principally regarded as writers of fiction.

Ralph Hammond Innes and John Prebble were both fortunate enough to use their literary skills as service reporters during the war. Another author who had also been a service reporter is Sir Ludovic Kennedy. He was still at Christ Church, Oxford, when the Second World War broke out and followed his father's footsteps into the Royal Navy, where his talents as a writer were duly recognized when he was asked to join the staff of the Admiralty Press Division. Indeed, his very first book, *Sub-Lieutenant*, was published during the war. Before joining the Press Division, as a young Naval officer he had already experienced forays against the German battleships *Bismarck* and *Tirpitz*, and sailed with convoys to Russia. Later, he was to take part in the Normandy Invasion.

Since the war Ludovic Kennedy has pursued a hugely successful career in literature and broadcasting. He became widely known as a television newscaster, before presenting programmes such as *Panorama* and *Did You See?* and making documentaries like *Battleship Bismarck* and *Great Railway Journeys of the World*. His

books on crime include *A Presumption of Innocence, 10 Rillington Place, Wicked Beyond Belief* and *The Airman and the Carpenter*. He has also written murder plays, anthologies on Rail, Sea and Air Journeys and several highly respected books about the Royal Navy. His appointment to the Admiralty Press Division came as a result of the publication of his book *Sub-Lieutenant*, where he was to work with several other established authors focusing their creativity on the war effort. These included Nicholas Monsarrat, author of *The Cruel Sea*, west country novelist John Moore, and playwright Anthony Kimmins.

Another famous author who served as a Gunner was Spike Milligan, who is best remembered as one of the Goons and as a radio and television personality. Serving with the Royal Artillery in North Africa and Italy, he wrote an amusing series of books about his experiences, *Adolf Hitler – My Part in his Downfall, Rommel 'Gunner Who' – A Confrontation in the Desert, Monty – His Part in my Victory* and *Mussolini – His Part in my Downfall*. Spike Milligan's other books include *The Bald Twit Lion, Puckoon, Milligan's Ark, Badjelly the Witch* and *Sir Nobonk and the Terrible, Awful, Dreadful, Naughty, Nasty Dragon*.

Other notable novelists and writers of fiction for adults or children who served in the Army during the Second World War include Sir Kingsley Amis, Dick King-Smith, and Chapman Pincher.

Kinglsey Amis did war service in the Army between 1942-45. His novels include *Lucky Jim*, which was filmed in 1957, *The Green Man, One Fat Englishman, The Anti-Death League* and *Russian Hide and Seek*. His novel *The Old Devils* won the Booker prize in 1986 and was adapted for the stage in 1989. He has also written verse, belles-lettres and works of non-fiction.

Dick King-Smith served with the Grenadier Guards. He has written over 90 books including *The Toby Man, Dodos are Forever, Dragon boy* and *The Schoolmouse*. In 1995 his book *The Sheep Pig* was filmed under the title *Babe*, and *The Queen's Nose* was turned into a popular television series for children.

Chapman Pincher served in the Royal Armoured Corps. His novels include *Not with a Bang, The Giantkiller, The Penthouse Conspirators, Dirty Tricks* and *One Dog and Her Man*.

Richard Hough, who writes a passage shortly, is only one from an impressive list of post-war authors who served in the Royal Air Force.

It includes the science fiction supremo Arthur C. Clarke, who co-wrote with Stanley Kubrick the novel and screenplay for *2001: A Space Odyssey*. His other books include *The Sands of Mars, Earthlight, A Fall of Moondust* and *Rendezvous with Rama.*

Children's author Roald Dahl was a pilot with No 80 Fighter Squadron, serving in the Western Desert, Greece and Syria, until he was wounded. Afterwards he worked as Assistant Air Attaché in Washington and with British Security Co-ordination for North America. His books include *The Gremlins, James and the Giant Peach, Charlie and the Chocolate Factory, George's Marvellous Medicine, The BFG, The Witches* and *Matilda*. Several of Roald Dahl's books have been adapted for film. He also wrote the screenplays for several movies: *You Only Live Twice, Chitty Chitty Bang Bang* and *Willy Wonka and the Chocolate Factory.*

Crime, adventure and thriller writer Dick Francis flew as a pilot. His books include *Blood Sport, Rat Race, In the Frame, Smoke Screen* and *To the Hilt.*

James Herriot practised as a vet after the war and didn't begin writing until he was 50 years old. His books include *It Shouldn't Happen to a Vet, All Creatures Great and Small* and *Vet in Harness*. His books have featured in several films and a long-running television series.

Other famous authors who served in the RAF include James Hadley Chase, Frank Muir, Robin Skynner, H.E. Bates, Basil Boothroyd and Richard Hillary, who served as a fighter pilot during the Battle of Britain and was later killed. Hillary's book *The Last Enemy* is considered a classic.

MICHAEL GILBERT CBE
(AUTHOR)

Crime writer Michael Gilbert was educated at Blundell's School and London University. He served with the Honourable Artillery Company in his spare time and was mobilized at the outbreak of war, going on to serve with the 12th Regiment Royal Horse Artillery in North Africa and Italy. He spent part of the war as a prisoner, and, after removing himself from captivity, was mentioned in despatches in 1943.

After the war Michael Gilbert became a solicitor with the firm of Trower, Still & Keeling, becoming a partner in 1952. In 1960 he was appointed Legal Adviser to the Government of Bahrain.

His first novel *Close Quarters* was published in 1947, and since then he has published dozens more, with titles like *Smallbone Deceased, Death in Captivity, Sky High, The Tichborne Claimant, Blood and Judgement, The Crack in the Tea Cup, The Dust and the Heat, Flash Point, The Black Seraphim, Roller Coaster* and *Ring of Terror*.

Michael Gilbert has also written several murder and mystery plays such as *A Clean Kill, The Bargain, Windfall* and *The Shot in Question*, as well as several scripts for Radio and Television dramas.

During his career Michael Gilbert has been a member of the Arts Council Committee on Public Lending Rights, the Royal Literary Fund, and the Council of the Society of Authors. He also founded the Crime Writers' Association and in 1987 he was appointed Grand Master of the Mystery Writers of America.

One tiny speck of light in the darkness of nearly sixty years gone by. From it I rescue a single moment of remembered pleasure.

154

In the autumn of 1938 – what came to be called 'Munich-time' – I had joined, in the ranks of that great-grandfather of all territorial regiments, the Honourable Artillery Company, widely known and always referred to as the HAC. I say 'in the ranks', for this was the only way in. No one, whatever the colour of his old school tie or the importance of his position in the City, could attempt to join with a pip on his shoulder or a stripe on his arm. If you served well, and successfully, for some years as a gunner you might attain the dizzy height of becoming a bombardier, or even, exceptionally, a sergeant. Until then you were one of the four hundred gunners who made up 'A' and 'B' Batteries, and a very happy family it was.

So, on the night of 31 August, 1939, there I was, on guard at Armoury House. The sergeant in charge of the guard – whose name I have forgotten – was a Scotsman and a chartered accountant in an important City firm. I was at headquarters because I had volunteered to be a member of the advance party that was sending out notices to all members of the Regiment that they were called up for active service and were to report immediately. I could easily be spared by my firm for this job since I was an unpaid and unimportant articled clerk in a solicitor's office.

I see myself standing, an unmilitary figure, at the City Road gate at one o'clock in the morning of September 1st when a taxi drew up and a young man descended. It seems that he had received his call-up papers and had been married that same day. His wife was in the taxi. What he wanted to know was whether he could go with her to the Great Central Hotel, where he had booked a room, or whether he must send his wife there and report in at once.

After all, the notice had said 'immediately'. What did I think?

I said, quite firmly, that he should go with his wife to the hotel and report in the morning. We discussed the pro's and con's of this at some length and finally he drove off delighted with my decision. He asked my name, and said that his first son should be called Michael.

All this had taken some time, and when I returned to the guard-room the sergeant was less than delighted. He said that a message had been received that I was to report to the Adjutant at nine hundred hours. This would scarcely give me time to buff up my boots and equipment to a condition suitable for the Adjutant's eye. I must do the best I could. Also he stipulated that when the Adjutant had

finished with me I was to report straight back. No sliding off to get a cup of coffee, he said.

The next scene in the drama was played when I got back to the guardroom at 11.30. The sergeant was, by that time, almost speechless with fury. What the hell had I been playing at? Impossible that my business with the Adjutant could have taken two hours.

'Well,' I said, 'it had been rather complicated.'

'In what way complicated?'

I said that the Adjutant (that excellent soldier, Richard Goodbody, who rose later to the top of the military tree) had explained to me that the HAC, like some other established territorial units, preserved the right to appoint to commissions without the rigmarole of pre-selection and OCTU training, but that this privilege ceased on the outbreak of war. Seeing that war was inevitable they had accordingly selected ten men for immediate commissions.

Whilst I was explaining this the sergeant's jaw was dropping.

'And the fact is,' I concluded, 'that, although the paperwork will take some time to finalize, actually since ten o'clock this morning I've been an officer.' If we had both been ten years younger, I should have added, 'And snubs to you'.

The memory of the look on his face proved, somehow, a comfort to me in my sometimes uncomfortable first weeks as a very inexperienced second-lieutenant, nominally in charge of men both older and, in most respects, more important than I was.

Why, out of four hundred, I should have been one of those ten was inexplicable to me at the time and, since most of the people concerned are now dead, will remain unexplained until the Day of Judgement when all books are opened and the Adjutant will be called upon to justify his choice.

The rest of my war in the 12th RHA (HAC) was only different in one respect from the experiences of many men called up at that time .

I trained with the regiment in England and Canada for two years and finally went abroad to North Africa in October, 1941. Here, owing to bad map reading when out one night, I fell into the hands of the Germans and was taken off by them to Italy, ending up in a prisoner of war camp on the River Po, from where I removed myself at the time of the Italian armistice in August, 1943. After making my way back to our own lines, I continued with the 12th RHA through

the Battle of Cassino and the subsequent advance through Italy, rising eventually to the rank of major.

I can only suppose that my 'mention in despatches' was accorded to me for my evasion which, although it took two months, was not unduly difficult, with the Italian population almost 100% on our side.

RALPH HAMMOND INNES CBE
(AUTHOR)

Ralph Hammond Innes is unquestionably one of the most respected British literary talents of the twentieth century. Before the Second World War he was working on the staff of the *Financial News*. It was therefore inevitable that his talents would be put to good use, and, although he began his military career with the Royal Artillery, he soon found suitable employment as a reporter for British Army Newspapers. It was in this capacity that he found himself going in with the first wave on the invasion of southern France. His experience of that time has left him with a profound and lasting admiration for the price France paid for its eventual freedom from Nazi occupation, which he reflects upon in the following article.

His books include *The Trojan Horse, The Angry Mountain, Maddon's Rock* and *The Land God Gave to Cain*. The 1954 film *Hell Below Zero*, starring Alan Ladd, was based on his novel *The White South*. The 1957 film *Campbell's Kingdom* was adapted from his novel of the same name, and starred Dirk Bogarde and Stanley Baker. In 1959 his book *The Mary Deare* was turned into a star-studded amalgam of seafaring action and courtroom melodrama, with Charlton Heston, Gary Cooper, Michael Redgrave, Cecil Parker and Richard Harris, among others, and was released under the title *The Wreck of the Mary Deare*. Since then he has produced a consistent flow of impressive novels.

In the following passage Ralph Hammond Innes describes the moment he approached the southern coast of France and the effect it had on him.

Dawn just breaking and the start of the assault only minutes away (Note 1). I was a gunner captain who had switched to British Army

Newspapers. I ran a syndication office feeding articles to our nine editions spread over four countries and was now on a Landing Craft (G) approaching the French coast. The (G) stood for GUN, an ancient naval three-inch mounted in the tank hold.

Away on our starb'd beam the mighty *Richelieu*, flagship of the French fleet, was a dark silhouette, her guns swinging towards the northern horizon where the villas of the Cote d'Azur drew a sharp white line. I had talked my way on to this venture via the C-in-C Med and now I was rather wishing I had not, for we had opened our orders. These were to give close support to the first wave of assault craft and silence any opposition.

As soon as we read that we all of us grabbed for the wardroom first aid book! The words Close Support meant we would be a sitting duck when it was daylight. One 88 . . .

Oh to be on the *Richelieu*. The Free French were going home. They were flying a tricolor half a block long and they were cheering as the first wave of assault craft creamed past them. Moments later the whole fleet opened up, pounding the shore as the light grew.

But there were no 88s, no opposition – the Germans had backed off, and I was left thinking what it must be like for the Free French, their homeland at last, and no opposition.

Some years later, driving south in search of spring sunshine, in that year when the Bouche de Rhone froze over, we stopped at Châteauneuf-du-Pape. Waiting for our meal Chez la Mere Germaine, relaxed and passing the time drinking the red stuff warmly steaming in brandy glasses, Dorothy found the Visitor's Book. She turned automatically to the period just after the fall of France and called me over to read page after page of heartbreaking, poignant scribbling, a record so unexpected – signature after signature, most with their rank and their regiment – all the famous ones, and some we had never heard of. *Vive la France*. Those words again and again.

It was the bravest, most pathetic document I have ever read, cream of a great nation fleeing south to the Mediterranean to fight again from Africa. The desperate hopes, messages to loved ones, to comrades feared dead – messages to friends who might just possibly pass this way.

Reading these brief, sad, sometimes violent epistles was a glimpse into the heart of men in defeat, some wounded, most near to despair, yet still determined to fight on.

We sat over our meal, sad and silent, except for the occasional comment on what it must have been like hiding and running and starving, families and friends abandoned – and all in order to fight again.

Vive la France.

I told Dorothy then about the *Richelieu* and that enormous great tricolor and the cheer that went up as the barrage started and the assault craft roared away.

This is a glimpse of another country's travail. The Cenotaph and all those village war memorials throughout Britain bear testimony in the name of our dead to what it cost to keep our country free. But France was occupied and the roll of the dead contains many who kept faith with their comrades and died under torture.

Pause then at France's memorials, the long string of names, particularly in the area of the Massif Central where the Resistance was most active.

Oh God, may our children be taught to understand what it costs to have the freedom they possess, the freedom to speak their minds without fear. Freedom seems such a simple matter when you have it, but when it is taken from you . . . !

NOTES:

(1) 'Operation Anvil-Dragoon' the invasion of southern France began on 15 August, 1944, when the U.S. Seventh Army and French II Corps made an amphibious landing on the Cote d'Azur. Ralph Hammond Innes found himself with the French fleet employed as an army reporter. German resistance, compared to that in Normandy, was very light, and during the assault on the beaches the Allied forces lost a total of 183 men killed and wounded, with 49 non-battle casualties.

RICHARD HOUGH
(AUTHOR)

Our next contributor is the author Richard Hough, whose novels include *Angels One Five, The Fight of The Few, Buller's Guns, Razor Eyes, Buller's Dreadnought* and *The Raging Sky*. His 1972 publication *Captain Bligh and Mr Christian* won the *Daily Express* best book of the sea award, and in 1984 was turned into a major Hollywood movie, *The Bounty*, starring Mel Gibson as Fletcher Christian and Sir Anthony Hopkins as Captain Bligh.

Educated at Frensham Heights, he worked in publishing from 1947-1970, first with Bodley Head and then with Hamish Hamilton, where he became Managing Director of Children's Books in 1955.

As well as novels he has written many books about naval history, having been the vice-president of the Navy Records Society. He also wrote the Battle of Britain Jubilee History in 1989 with Denis Richards. Using the pseudonym of Bruce Carter he has written many books for children. He has also written under the names of Elizabeth Churchill and Pat Strong.

During the Second World War Richard Hough served as a fighter pilot with the RAF and the following story is the account of what happened on a routine patrol during the closing days of the hostilities in Europe. At the time he was serving with 197 Squadron of the 2nd TAF, flying Typhoons.

> During the last days of the war, with resistance crumbling, there were three groups of the enemy who never let up – the Waffen SS, the Hitler Jugend and the flak gunners, our hated foe for so long. Three of our squadron were shot down in the last weeks of fighting.

Meanwhile, we remained as busy as ever, precision dive-bombing targets the army wanted destroyed and patrolling for targets of opportunity, which meant strafing anything that moved – on the roads, railways and canals. In late April, 1945, three of us took off with long-range tanks and headed for the flat country of northern Germany. The routine was for one of us to go down on any likely target while the other two gave top cover against unlikely German fighter intervention. Visibility was perfect but the country looked dead – no sign of action, nothing moving. It looked like a dud op.

Then I spotted a car going at great speed along a straight stretch of road.

'That's mine,' I claimed, and immediately went down, dropping my tanks and slipping off the safety catch. I took the car from the rear. I remember thinking, 'The damn fools should be keeping a lookout!' Only the military had cars and they ought to know better.

I opened up with my four cannon, the first shells dancing along the road, racing towards the rear of my target. The car appeared to be packed with officers who disappeared into a ball of flames as the shells found their target. I pulled up sharply over it, at the same time experiencing a shock from a heavy blow which threw my plane on its side at about fifty feet. I just managed to avoid going upside down by hauling on the stick, at the same time jettisoning my hood as a crash seemed inevitable.

Curiously, I faced death feeling I deserved it after roasting alive five or six men. I had killed many men in this war but none with such cold-blooded ruthlessness when they must have thought they were going to survive.

My two mates came down and flew low either side of me.

'What the hell have you been up to?' they asked. 'One of your wheels is down and wobbling about and your tail is in a terrible mess.'

Encouraged by their presence, I managed to climb to a safe height and flew back to our airstrip, half-frozen without my canopy, and wondering once more about the ubiquity of German flak. Or maybe – for once – it was not flak? Perhaps the undercarriage lock had broken under the stress of the pull-out and the jettisoned canopy had smashed up my tail. I would never know. What I now faced was

a landing with one insecure wheel and the other one locked up or down, and probably no rudder or elevator.

(In the event, it was a rough landing but nothing caught fire as perhaps I deserved, and the crash crew offered me a quadruple brandy.)

JOHN PREBBLE FRSL
(AUTHOR AND SCRIPTWRITER)

John Prebble entered journalism in 1934 and towards the end of the war was able to use his talents as a sergeant-reporter with the No 1 British Army Newspaper Unit, based in Hamburg. He had initially served with the Royal Artillery.

After the war he became a reporter, columnist and feature writer for British newspapers and magazines, until he was able to make his name as a novelist, historian, film-writer and author of many plays and dramatized documentaries for radio and television. His books include *Where the Sea Breaks*, *The Edge of Darkness*, *Age Without Pity*, *The Mather Story*, *The Brute Streets* and *The Buffalo Soldiers*. He is a Fellow of the Royal Society of Authors.

John Prebble's film credits include *Zulu*, starring Michael Caine and Stanley Baker. The film tells the epic story of the defence of Rorke's Drift in 1879, when a handful of British soldiers beat off the repeated attacks of four thousand Zulu warriors. Eleven defenders of the mission were awarded the Victoria Cross. Having written the original story, he co-wrote the screenplay with Cy Endfield.

John Prebble's television credits include episodes of *The Six Wives of Henry VIII* and *Elizabeth R*.

The article which John Prebble has provided, 'Along the Maas', is in fact part of a letter he wrote home in November, 1944, of which he says:

'It does, I hope, attempt to give some feeling of life in the ranks at that time. It has also, perhaps, the small merit of being written at the time.'

The Maas is a river which passes through Holland and was one

of the last major obstacles facing the Allies before the final crossing of the Rhine in March, 1945.

John Prebble had accompanied the Allied thrust all the way from the Normandy beaches and was about to take part in the action which would ultimately bring about the collapse of Nazi Germany.

A hand grasps you by the shoulder and you start into consciousness. You have been dreaming that you were standing by Marble Arch waiting for a 30 bus and you could see it as it turned into Oxford Street by Selfridges. Then a hand grasps your shoulder and shakes you. It is only a gentle shake but you feel as if your body were subjected to great torture. It is agony to open your eyes. You keep them closed, hoping that nothing will happen. But the sentry is anxious to be relieved. He shakes you again and you open your eyes and look at him blankly. You push down the collar of your top-coat and pretend you do not know what he wants. Ten minutes, he says, All right, Johnnie? All right, you say, light the lamp. Black-out, he says. But you turn up the lantern a fraction. You can see him now, the light glows warmly on his face, framed in a balaclava beneath his helmet. He bangs his hands together and looks at you anxiously. He is afraid you will go to sleep again and he lights a cigarette and pushes it between your lips.

Cold? you say. Cold enough for a walking-stick, he says. I've got an extra pair of bootlaces, you say. They'll do, he says. All right, Johnnie? All right now, and you sit up and cough to clear throat and lungs thick with foul air and smoke. The sentry is gone now. You dress quickly. That is you put on top-coat and equipment and soon you are enclosed in a tight chrysalis of overcoat, leather jerkin, webbing equipment, two pairs of woollen gloves and a balaclava. You slip out the magazine of your rifle to see if it is full and you thrust the short bayonet on to the barrel. You are ready and you move slowly into the open. The cold strikes cruelly on your eyes, your breath already frosting on the balaclava. The sentry is waiting. All right, Johnnie? O.K. you say. Anything doing? Not much, he says. There was some machine-gunning about ten minutes ago, and they slung some dirt over too. Got your extra bootlaces? Yes, very comfortable. Goodnight, Slash. Good morning, he says. Christ it's cold.

You are alone. It is cold, and you feel sick as a pig. Then you begin to walk up and down, walking faster and faster to get a reserve of warmth, sliding in the slush. The noise of the shelling comes suddenly and you swing round in alarm. It is ours, and for a few minutes or so the shells pass overhead like a hurrying train. When they explode across the river the noise seems to fill the sky with flame. It is quiet again and now you are truly awake and you stand with feet astride waiting for the gun-flashes. You see them away to the rear and you count the seconds until you hear the noise of the discharge and the fluttering whistling passage of the shells.

Then it is quiet again. Behind the front, forward of the rear, you are waiting for a response, and yet it comes unexpectedly almost. A far distant discharge in the east and the great rustling overhead like a cane passed through the air. The shells explode so far to the rear that they are scarcely heard. Oh yes? you say, as if it were a wise observation.

A machine gun, a Bren you think, stutters along the river where the beams of the detachments are motionless in the sky. It is answered by a Spandau and then the thud of mortars. The noise of the orchestrated action dies away slowly, one machine gun firing to the last with careful precision and ending with one single round. It is silent. You are alone. You feel as if the whole war depends upon your vigilance at this moment, but it is almost impossible to keep your eyes open, and the edge of the balaclava on your cheeks is now hard with ice. You think of daylight, of yesterday, a week, a life ago. The town by the Maas, one road leading in to it and none leading out of it. They are all closed. 'Roads heavily mined!' Another that says 'Stop! Enemy ahead'. An infantryman sits on a felled tree with a Sten across his knee, chewing gum and reading the *Daily Mirror*. The streets of the little town are full of civilians, all afraid and waiting for evacuation. A shire-horse pulls a little sports car full of furniture. You grin at the memory of it and the lift of your cheeks is a sharp pain in the cold.

A Bren-carrier comes up the road towards you and you stand before it stupidly, rifle lifted. The driver sees you in time but swears at you amiably. He wants to know where 'A' Infantry Echelon is. On the back of the carrier is a large Winchester of rum, and in the light of your torch you see the spirit lifting and turning in response to the throb the engine. You tell the driver where to go, or

166

where you think he should go. Thanks, Charlie, he says and rocks away.

You are alone once more. You have not noticed that the Bren is firing again down by the river, long irritable bursts. You no longer feel lonely. The hour, the hour and a half is almost over. You look into the operations room. The wireless operator is making tea in a biscuit tin. Time, Frank? you say. Zero one, one fiver. In English, please Frank. Quarter past one. Want some tea? Of course. It is strong and sweet. You are glad your stag-duty is almost over, and with the mug in your hand you go to find your relief. He looks at you with hate across his blankets and coat. Ten minutes, Ginger. O.K., he says, closes his eyes and pulls up his blankets. He has sewn them into a sleeping bag and it will take him a long time to emerge. You shake him again, take a mouthful of the tea, and press the mug against his face. Ginger? He sits up. O.K. Thanks. What's doing? Nothing, you say. There's something over there. Machine-gunning. And they slung some dirt over now and then. O.K., Ginger? O.K. he says and sits up grinning. He looks like a caterpillar in all that bedding.

You go outside and wait for him in the light of the beams, watching silent gunfire far, far to the south. The relief comes at last, swearing at the cold and pulling his rifle by the sling. You're a slovenly soldier, Ginge, you say. He nods and bids you an obscene goodnight.

NOTES:

After the withdrawal of what remained of Major General Urquhart's 1st Airborne Division from Arnhem in September, 1944, the Allies had faced a major setback. The River Maas had featured in Operation Market Garden, and the US 82nd Airborne Division under General Gavin had been tasked with capturing the bridge over the Maas at Grave near Nijmegen. The capture of the bridges over the Maas and Waal to the north was vital to the success of the operation, as without them the likes of architect and painter Sir Martyn Beckett with the Guards Armoured Division and XXX Corps, under General Horrocks, wouldn't be able to relieve Urquhart's depleted paratroops. Unfortunately, although the bridge over the Maas was captured intact, the bridge over the Albert Canal wasn't and a crossing had to be provided by Bailey Bridge, which caused yet another hold up to XXX Corps in their mission to relieve Arnhem.

Although the Allies were defeated at Arnhem in September, 1944, in the beginning of October a new offensive began and by the time John Prebble wrote his letter home in November a fierce campaign was being fought in the Netherlands.

In February, 1945, Montgomery launched a pincer attack, with the Canadian First Army and the British Second Army, attacking the German lines between the Maas and the Rhine. The weather was terrible and the terrain boggy, so progress was very slow. The Allies also faced formidable resistance and floods, but by 10 March the last German bridgehead at Wesel had been defeated and Montgomery stood on the west bank of the Rhine.

NIGEL TRANTER OBE KCLJ D.Litt Hon.MA
(AUTHOR)

Nigel Tranter has been a full-time writer since 1946. He is known mainly as a writer of historical, romantic and Gothic novels, but he has also written a few westerns under the pseudonym of Nye Tredgold.

Having written a staggering 85 adult novels, 12 children's novels and around 20 works of non-fiction, particularly concerned with the history of Scotland, it would be tedious to list all his titles, but a few include *The Bruce Trilogy, The Wallace, The Montrose Omnibus, The Master of Gray, The Courtesan, Chain of Destiny, The Wisest Fool, The Captive Crown, Lord of the Isles, Unicorn Rampant, Children of the Mist, Druid Sacrifice, Tapestry of the Boar, Price of a Princess* and the latest *High Kings and Vikings.*

Before the Second World War he trained to be an accountant with a small family insurance company, until he was able to support himself as a full-time writer of fiction. When the war started, although his ambition was to join the RAF, he was called up by the Army and posted to the Durham Light Infantry. He went on to serve in both the Royal Army Service Corps and the Royal Artillery.

Actively involved in Scottish public affairs, Nigel Tranter has held numerous appointments, including President of the East Lothian Liberal Association, Chairman of the National Forth Road Bridge Committee, chairman of the Society of Authors in Scotland, Chairman of the National Book League in Scotland, and Honorary President of the Scottish Association of Teachers of History.

Nigel Tranter was voted Scot of the Year in 1989 by BBC Radio Scotland, and in 1986 he was made Chancellor of the Order of St Lazarus of Jerusalem in Scotland.

169

For most of the war years he was employed by the Royal Artillery on anti-aircraft duty around the coast of Britain, trying to shoot down German aircraft and flying bombs. However, towards the end of the war he found himself posted to a prisoner-of-war camp, looking after German prisoners, which kept him in uniform until 1947.

Although he remained in uniform until 1947, he was in a position to carry on writing and during the war he continued to produce a string of novels, as he now explains.

My war was full of contradictions, the unexpected, the ridiculous, the oddities – but I survived it. First of all, when war was declared, I was summoned by the RAF to be a Squadron Leader – myself, who had never been in an aeroplane – this, as an author, to interview pilots on their flight reports (who presumably could not be trusted to write their own) as a kind of Intelligence Officer. I awaited the call. But suddenly 'reserved occupations' were dreamed up by the authorities and, as a one-time junior insurance inspector in my uncle's company, the Scottish National, I found myself to be reserved, although I had given up insurance inspecting years before, to become a full-time novelist. However, the said authorities did not have the profession of novelist in their books, so I was, to them, still in insurance, a reserved occupation (do not ask me why). The RAF kept getting in touch with me, to join it – but no that was not allowed. So I joined the Special Constables and the Home Guard.

As a Special Constable one of my duties, having my own car, was to go out to meet convoys of army vehicles and lead them to local destinations. On one occasion, at night, in the blackout, I met one quite large line of trucks at the west side of Edinburgh, to lead them to a point in my own East Lothian. I did this via Princes Street, Edinburgh's principal thoroughfare, in pitch dark and of course without headlights. It was only after perceiving people jumping out of my way at the last moment and at the east end noticing a pillar box on my right, when it should have been on my left, that I realized I had driven the half-mile street along the pavement, not the roadway, with all the trucks laden with troops following behind.

Then, without warning, I was de-reserved, called up and, despite my protests about the RAF, hurled straight into the Durham Light Infantry, as a full private – why this, I had no idea, the only Scot in the outfit. There, at Brancepeth Castle, Durham, I learned to write while walking, as the only way to gain any privacy to continue to produce novels – this because King George thought that, as a private soldier, I was worth 19 shillings per week, and I had a wife and two children to support. So I went on writing, and produced five novels during my army career. Incidentally, I found writing while walking suited me very well, and I still do it that way – and type it up while I can still read my own writing. I got into some trouble with this odd way of making a living to keep the family, for my sister, a hospital matron, gave me an electric-torch pencil, so that I could write in the dark, and in the blackout the air-raid wardens assumed that I must be signalling to enemy aircraft.

I was soon summoned to a War Office Selection Board, of retired brigadiers, to decide how best I could serve His Majesty further. The profession of novelist left them bemused, so they posted me to a Mobile Printing Unit of the Royal Army Service Corps, to turn the handle of a mobile printing machine – very logical. I remained so doing, and writing novels, until casualties began to multiply and the War Office decided that it needed more officers to replace these. So, as comparatively educated, I was sent to an Officer Cadet Training Unit in Wales, where I spent nine months doing nothing very much, and quite enjoying it. Then, commissioned as a Second Lieutenant, I was posted to a Royal Artillery regiment, anti-aircraft division. There it became discovered that I was hopeless at mathematics, always had been, and could not efficiently calculate the necessary aim-offs for shooting at high-flying planes and fast-moving objects. So I was transferred to light anti-aircraft guns, Bofors, which were shot by sight at low-flying planes. I was quite good at this, being a seasoned duck-shooter. I became a full lieutenant, and spent the rest of the war shooting down, or trying to, German planes and flying bombs, mainly on the Suffolk coast and marshlands. Five times my various batteries were ordered overseas, and five times this was cancelled as the flying bomb menace grew worse, and I got what was called embarkation leave, brief spells at home with my wife and bairns, but never left the country. My kit on one occasion did go overseas and I never saw it again.

When the German war was over, it seemed to be decided that light anti-aircraft guns were not needed against the Japs, so I was given a change of direction. I was sent to the Lake District to become second-in-charge of a German prisoner-of-war camp, as an acting captain. Very pleasant. I lived in Greystoke Castle, this with seventy-five rooms, and was the only man to stay the night therein, this because it was reputed to be haunted. I gained my only one piece of wartime booty there, a Hepplewhite armchair, which still graces my sitting room, and which was being thrown out.

Unfortunately or otherwise I did not get demobbed at the end of the Japanese campaign, for we still had a lot of German prisoners, who did not want to go back to Germany because the Russians had occupied East Germany and they were killing off the Germans or turning them into slaves. So it was late 1947 before I finally got out of khaki and returned to civil life, still writing novels of course. At least this part of my military career did allow me to send home valuable supplies of butter, cream, cheese and eggs, then strictly rationed, this because my prisoners were now working on the surrounding farms and I had to supervise them and see that they did their work effectively and did not get too many of the farmers' daughters pregnant.

Such is regimentation.

NOTES:

Conditions for German and Italian prisoners of war held in England were decidedly more comfortable than those which Allied troops faced in Germany or Japan. In many camps the prisoners were given a quota of bread and meat each day and meals were often prepared by their own cooks. The prisoners were able to maintain their rank structure, and captive NCOs and officers were responsible for discipline. As long as the camps ran smoothly, the British guards didn't interfere. The prisoners were also provided with essential services such as a doctor, dentist and tailor. If such professionals existed within the camp itself, they could opt to employ their own. In fact, in many camps, the British guards were no better or worse off than the men under their charge. Naturally, prisoners often broke the rules and offenders had to be punished.

Italian prisoners stuck here after their Fascist government had surrendered found life particularly pleasant. They couldn't return home as Italy was occupied by the Germans. So they were able to remain and work in England, usually on farms or in factories, and, although they lived at the camps, they were permitted to come and go as they pleased.

Chapter Ten

MILITARY LIFE AND MUSIC

Military life and music are inseparable partners, and through the ages countless composers have been inspired by their service in the armed forces. For this chapter I have only managed to track down one composer who served during the Second World War. George Lloyd served in the Royal Marines but his story is particularly relevant for two reasons: first, because he was able to utilize his talent, to a certain degree, as a Royal Marine Bandsman, and secondly, because the war itself had a devastating effect on his subsequent life and musical career.

Before reading Mr Lloyd's story it is worth mentioning a few other composers who served during the war: Humphrey Searle was educated at The Royal College of Music and the New Vienna Conservatory. In 1938 he joined the music staff of the BBC as a programme producer. During the war he served with the Gloucestershire Regiment and the Intelligence Service, where he helped in the training of paratroopers. After the war, but while he was still serving in Germany, he assisted Hugh Trevor Roper in his research for the book *The Last Days of Hitler*. On returning to England he rejoined the BBC, but in 1951 he became music advisor to Sadler's Wells, Ballet. His compositions have been varied and wide-ranging, including a full-length opera of *Hamlet* in a romantic, burlesque style. His other operas include *The Diary of a Madman* and *The Photo of the Colonel*. He has also written full-length ballets, notably *Noctambules* and *The Great Peacock*. As well as orchestral, chamber and choral music, he has also composed incidental scores for radio.

John Gardner CBE, who served in the RAF during the war, is a

prolific composer. Before the war he was Chief Music Master at Repton School and afterwards worked for Covent Garden Opera. He also became a Professor at the Royal Academy of Music. His operas include *The Moon & Sixpence, Bel and the Dragon, The Entertainment of the Senses* and *Tobermory*. He also wrote the musical *Vile Bodies*, as well as symphonies, string quartets, brass chamber music, and a number of major cantatas for chorus and orchestra, including *The Ballad of the White Horse*. His many honours and awards include being chairman of the Composer's Guild, director of the Performing Right Society, and being awarded the Bax Society Gold Medal. During a varied career he has also composed music for films, for the Old Vic, the Royal Shakespeare Theatre and the BBC.

Sir Anthony Lewis was also working for the BBC music department before the war, where he organized a series of broadcasts entitled 'Foundations of Music'. He was later to become responsible for all broadcast chamber music and recitals. In 1938 he planned a highly successful series under the title 'Handel in Rome'. During the war he joined the army and served with the Mediterranean Expeditionary Force. He returned to the BBC in 1945 and between 1963–1969 was president of the Royal Musical Association. In 1968 he was appointed principal of the Royal Academy of Music, where he himself had studied piano and composition in 1928. His compositions include *Choral Overture, Elegy and Capriccio for Trumpet and Orchestra, A Tribute of Praise* and a Horn Concerto.

Composer Donald Peart served in the Gloucestershire Regiment during the war, mainly in Africa and India. He went to Australia in 1947 where he was appointed Chair of Music at the University of Sydney. In the nineteen-thirties he had studied composition under the great Vaughan Williams.

William (Harry) Gabb CVO, who served in the Royal Armoured Corps, became Composer at HM Chapels Royal, and had the honour of playing the organ at the Coronation of Her Majesty Queen Elizabeth II, and at many Royal weddings and baptisms.

Finally, although writing music on a less grand scale than the above-mentioned composers, certainly worth remembering in this context is Ralph Reader CBE, famous for producing the 'Gang Shows'. In fact, during the war, while serving with the RAF he put on Gang Shows with Official RAF Entertainment Units and had a

particularly strong connection with the war in the Far East, which became evident in later life when he wrote and produced several reviews to commemorate Burma reunions. As a theatrical producer, author and composer, he wrote many musical plays and reviews and was responsible for providing British troops in Malaya with their first entertainment during the emergency.

GEORGE LLOYD
(COMPOSER)

George Lloyd began playing the violin at the age of five and writing music at ten. Later he studied the violin with Albert Sammons, counterpoint with C.H. Kitson and composition with Harry Farjeon. In 1932 he wrote his First Symphony, which was later played by the Bournemouth Municipal Orchestra. Two more symphonies quickly followed, the Third being played by the BBC Symphony Orchestra.

His first opera *Iernin*, with a libretto by his father, was produced at Penzance, Cornwall, in 1934; it was so successful that the following year a special season was arranged for it at the Lyceum Theatre, London; *The Times* commented that 'George Lloyd showed that rarest of all qualities in a British composer, an almost inerring perception of what the stage requires'.

During the summer of 1936 he was in Switzerland and met a Swiss girl, Nancy Juvet; they were married the following year.

In 1938 a second opera, *The Serf*, conducted by Albert Coates, was produced at The Royal Opera House, Covent Garden, and subsequently in Liverpool and Glasgow.

These early successes were brought to an abrupt end in 1939 by the Second World War, during which George Lloyd served in the Royal Marines. Most of his service was spent in the Arctic on convoy duty, where, after several engagements his ship was sunk and he was severely shell-shocked. Invalided out in 1942 he was unable to do any work of any kind for over three years but in 1945 he recovered sufficiently to leave England for his wife's home in Switzerland, where he lived until 1948 and wrote his Fourth and Fifth Symphonies.

Returning to England, he and his father were commissioned by the Arts Council to write a new opera for the Festival of Britain, to

177

be played throughout the country by the Carl Rosa Opera Company. This opera, *John Socman*, was given a series of performances in 1951, but problems with the production, combined with the pressure of having completed the opera within two years and with continued bad health, drove George Lloyd into abandoning the musical world and withdrawing to the country.

During the next two decades he and his wife built up a carnation and mushroom growing business and composition was only intermittent. Eventually his health improved and more works were written so that by 1973, when he sold his business, he had four more symphonies and four concertos to his credit.

In 1977 George Lloyd's musical fortunes took on a new lease of life when his Eighth Symphony was premiered by the BBC Northern Orchestra under Edward Downes. It made an immediate impact on the listening public. Since then the BBC have performed seven more symphonies, meanwhile three were recorded for the Lyrita label by the Philharmonia Orchestra, London, conducted by Edward Downes.

In 1984 George Lloyd made his re-appearance as a conductor, performing his Fourth Piano Concerto at the Royal Festival Hall, London, with the London Symphony Orchestra and Kathryn Stott as soloist. He has now recorded all four of his piano concertos and eleven of his symphonies for the Albany label; the Eleventh and Twelfth Symphonies were commissioned by the Albany Symphony Orchestra, New York, and during the '89–'90 seasons George Lloyd acted as Principal Guest Conductor of that orchestra. In 1993 he was commissioned by the Brighton International Festival to write his *Symphonic Mass*, which was recorded by Albany Records shortly after the première. Recent recordings include the complete opera *Iernin* and highlights from *John Socman*. In 1996 he conducted the first performance of *A Litany* at the Royal Festival Hall, and recorded the work for commercial release shortly afterwards.

A week before the declaration of war I joined the London Fire Service. Nothing happened during the phoney war and I left at Christmas.

The Navy would not have me because of my heart, so in March, 1940, I became a Royal Marine Bandsman at the Naval School of Music at Deal, which was the centre for providing small bands for all capital ships. Eventually I was assigned to a band for a new cruiser, HMS *Trinidad*. She was at Plymouth waiting to be commissioned but

she was bombed twice, once during the blitz on Plymouth. Finally in October, 1941, she became seaworthy.

The band had two distinct jobs – in harbour we played ceremonial music on the quarterdeck, entertained the crew and played with a string band for the wardroom. At sea we computed the gunnery and were stationed at the bottom of the ship alongside the magazine and oil tanks.

During the winter of '41–'42 we patrolled the seas between the Orkneys and Iceland and did Arctic Convoys to Murmansk. At the end of March we were engaged by German destroyers trying to attack a convoy. Although we blew one destroyer out of the water with our first salvo, our ship was hit by a torpedo and the oil tanks were damaged.

There were nineteen of us, marines and sailors, manning the position; cold black oil started to come down the hatchway; the warrant officer in charge shouted 'Shut the hatch' and my friend the principal cornet (we called him Lou because he could play like Louis Armstrong) attempted to climb the ladder but was knocked back by the force of the oil. I went to help him and pushed him up. I lost consciousness and the next thing I knew I was with great difficulty endeavouring to haul myself out of a hatchway two decks up. A sailor who tried to follow me was killed as the hatch fell on him and broke his back. I was the last of three but I had been burnt out making the effort; all the others were drowned in oil.

In due course I was hospitalized, but the doctors could do nothing for me and finally they told my wife that I would have to live in an institution for the rest of my life. She replied that if they could do nothing for my shell-shock they had better let her try, so I was discharged.

It took many years to regain some sort of health; by late 1945 I started with difficulty to write my Fourth Symphony. As a musician the best years of my life were taken from me but I have been more fortunate than some. In old age I am able to write music and conduct orchestras which are the only things I enjoy doing.

Chapter Eleven

VERSED IN THE ART OF WAR

In this chapter we feature the stories of four poets, two of whom, Paul Griffin and Randle Manwaring, both served in Burma, Griffin with the Gurkhas and Manwaring with the RAF Regiment. The other two poets, Gavin Ewart and John Press, both served in the Royal Artillery, Ewart in North Africa and Italy and Press in East Africa.

I have strategically placed Randle Manwaring's story at the end of the chapter because he was instrumental in setting up the reception of the Japanese delegates when they surrendered to the Allies in September 1945, thus bringing the war to its conclusion – poetic justice indeed!

We have already mentioned other poets like Ivor Roberts-Jones who served in the Royal Artillery, but who was first and foremost a sculptor, and Laurence Whistler, brother of Rex Whistler, who served in the Rifle Brigade.

One of the most respected poets of the twentieth century was Roy Fuller CBE, who served in the Royal Navy from 1941–1946, attaining the rank of Lieutenant. A solicitor in professional life, Roy Fuller was a Governor of the BBC between 1972–1979. His verse includes *The Middle of a War, Epitaphs and Occasions, Tiny Tears* and *The World through the Window* collected poems for children.

Poet and playwright Patric (Thomas) Dickinson served in the Artist's Rifles, after which he worked in the Feature and Drama Department of the BBC and was Acting Poetry Editor until 1948. As well as writing poetry such as *Soldier's Verse* and *Theseus and the Minotaur*, he wrote the libretto for Malcolm Arnold's *The Return of Odysseus* and Alan Ridout's *Creation* and *Good King Wenceslas*. Some of his work has been illustrated by John Ward RA.

Poet and broadcaster Charles Causley CBE served on the lower-deck in the Royal Navy's Communication Branch from 1940–1946. After the war he became literary editor of the BBC's West Region radio magazines. His poetry books include *Survivor's Leave, Dawn and Dusk, A Field of Vision* and several volumes of collected poems for Penguin Books. Charles Causley has also written several books for children, as well as verse plays and the libretto for William Mathias's *Jonah* and Phyllis Tate's *St Martha and the Dragon*.

Another poet who served in the Royal Navy was Alan Ross CBE, who spent much of the war in the Arctic and North Sea. During a distinguished naval career he was Assistant Staff Officer (Intelligence) with the 16th Destroyer Flotilla, and on the staff of the Flag Officer, Western Germany. In 1946 he was appointed Interpreter to the British Naval Commander-in-Chief in Germany. Poems include *Mess Deck Casualty, Radar* and *Off Brighton Pier*.

George Buchanan, who wrote *Conversation with Strangers* and *Bodily Responses*, was an operations officer with RAF Coastal Command. He also wrote several prose works and a number of plays, including *War Song* in 1965.

David Holbrook was Intelligence, Mines and Explosives Officer with the ER Yorks Yeomanry, Armoured Corps, between 1942–1945. His work includes *Imaginings, Against the Cruel Frost* and *Moments in Italy*.

Author of *Even For An Hour*, John Raymond Godley DSC, Lord Kilbracken, was an RNVR pilot who served with Fleet Air Arm. Commissioned in 1941, he attained the rank of Lieutenant-Commander and commanded Nos 835 and 714 Naval Air Squadrons.

Leonard Clark OBE, author of *Drums and Trumpets: Poetry for the Youngest*, and *The Hearing Heart*, served in both the Home Guard and the Devonshire Regiment.

The writer of *Six Reasons for Drinking, Walking Wounded* and *Act of Love*, Vernon Scannell served with the Gordon Highlanders as part of the 51st Highland Division and was present during the invasion of Normandy.

Harry Reed, who wrote *Lessons of the War, Sailor's Harbour* and *Unarmed Combat*, joined the army in 1941, but was transferred to Naval Intelligence in 1942. After release from service following VJ Day in 1945, he was promptly recalled by the Army. However, he refused to go and the matter was conveniently forgotten. During the

war he continued to write and publish verse and began to write and broadcast radio plays.

Welsh poet Keidrych Rhys initially served with the London Welsh AA, before joining the Ministry of Information and going to Europe as a war correspondent. In 1942 he published *Poems from the Forces*, followed by *More Poems from the Forces* in 1943.

Finally, poet and novelist Bryan Guinness, the 2nd Lord Moyne, served as a captain in the Royal Sussex Regiment. His verse includes *The Summer Is Coming* and *What Are They Thinking?*

PAUL GRIFFIN MBE
(POET)

Poet and author Paul Griffin has been a school teacher for most of his professional life, studying before the war at St Catharine's College, Cambridge. He served on the North-West Frontier of India as a Gurkha officer and followed the war into Burma and Malaya with the Chindits, working on Orde Wingate's operations staff.

In 1949 he began teaching at Uppingham School where he became the Senior English Master. Between 1956-1960 he was Principal of the English School in Cyprus, before being appointed Headmaster of Aldenham School in 1962. Finally, from 1976–1982 he was Principal of the Anglo-World Language Centre in Cambridge.

His first volume of poems, *Sing Jubilee*, was published in 1966. He is also known as one of the authors of the 'How to Be' series, with titles like *How to Become Ridiculously Well-Read in One Evening, How to Become Absurdly Well-Informed about the Famous and Infamous, How to Be Tremendously Tuned-in to Opera, How to Be Well-Versed in Poetry* and *How to be European.*

Here Paul Griffin explains how he volunteered to join the Army at the same time as his brother-in-law. The brother-in-law in question went on to become General Sir Patrick Howard-Dobson, whose military career culminated as Vice-Chief of the Defence Staff.

After Orde Wingate's death Paul Griffin, and others, carried on with his essential work, and his experiences during the war in general have provided his article with a more philosophical approach than the majority of our contributors:

> Writers and artists must be among the most selfish of creatures. I took
> the outbreak of the Second World War as a personal insult: just when

I was looking forward to leaving school, being free, writing a bit, meeting girls, I was bound for five years to a life more disciplined than school, where there were no girls to speak of.

I was in the position, not of a stockbroker or teacher whose life had suffered a five-year hiccup, the commoner pattern of wartime officer: more that of a young man making the Army his first career. My brother-in-law, in the same position, stayed on and became a General. He and I had volunteered together for the Indian Army. He, the real soldier, was rejected on some trivial pretext; I, the phoney one, was accepted.

I was commissioned in 1942 into the 6th Gurkhas, and soon discovered that my intellectual pretensions were of little interest to anyone, except that my indulgent CO mistook them for military competence. I was never a real soldier, if only because I thought and talked too much about death. Soldiers tend not to talk about death, except lightheartedly. Serious consideration of the subject dents their essential and in many ways admirable gung-ho image. But Hubert Skone, my CO, was an exception to most rules, and would take on any topic from the psychology of sheep to the Twelve Tribes of Israel.

'If you survive this war,' he said one day in 1943, as he unwrapped his lunch, 'you can stop worrying. People'll be living for ever by the time you're old. I'll be gone by then, thank God!' he added, tucking into a sandwich.

I wondered at the time why he said 'Thank God!', though I never asked him. In those strange days we asked a different sort of question. Otherwise we might have asked how we were helping by playing dangerous games, miles from any real theatre of war. I suppose a few Pathan tribesmen could have become an awful nuisance to Northern India; anyway, day after day, we marched out under their gaze, seized their hilltops, and made the road safe for traffic, which was, as far as I could see, only there to supply us and others like us.

Meanwhile, over to the east there was a real war going on. A Japanese army, numerically inferior to ours, had invaded Burma and was pressing on the Indian frontier. Thousands of our men had been killed and captured, and I must admit many questions were being asked about that, but they were not the sort of questions late twentieth century man would ask. They concerned how we could fight better, and how we could protect India. Late twentieth century man would have asked, What am I doing here, so far from home?

How can I justify to mothers the death of their sons for a country which does not want them? How much is this costing?

In a few weeks our battalion was moving to join that real war, and to my surprise I had found that at the age of twenty-one I had been made its Adjutant. Meanwhile, I sat on a high pass among brown hills under clear skies with the Colonel, waiting for the lorry convoy to come through. The sun was hot but tolerable, and the air was fresh and exhilarating. Below us we could see our permanent platoon picket, a grey blockhouse on a raised mound, which just had room also for a basketball pitch. The sight of the pitch reminded me that a Gurkha NCO we will call Durgabahadur was in hospital with a shattered leg.

'How's Durgabahadur?' I asked the Colonel.

He shrugged. 'They've plastered his leg,' he said.

'It ought to be all right. But Gurkhas are funny chaps. Sometimes, they decide they're going to die. Go and visit him, and see if you can cheer him up. Blowed if I can!'

I looked down at the basketball pitch where the Pathans had thoughtfully left a mine for Durgabahadur to step on. He was always stepping on something. Tomorrow I would hitch a lift into Bannu and do some cheering up.

'Isn't it unusual for the tribesmen to use mines, sir?' I asked.

The CO nodded. 'Bit offside, really. I think we annoyed them by turning the artillery on them the other day. They haven't got any that works.'

That was what the game was like – a sort of Ludo that had gone on for decades, with the use of a mine persuading everyone to shout 'Cheat!' and look up the rules.

I went to see Durgabahadur. He was lying in bed with sweat standing out on his forehead and with unnaturally dull eyes. Normally cheerful and as broad as he was long, he seemed badly out of place.

'We'll be off soon,' I reminded him, patting his vast plaster. 'To fight the Japani log. You'll be well enough to come with us.'

But he only shook his head and mumbled.

I was still partly living a romantic dream of war at that time, where the enemy was always inferior to myself. When I was certain that we were all to join General Wingate's Chindits (Note 1), with a 50/50 chance of survival, I emerged abruptly into reality and was terrified.

We moved over to Central India for training. Perhaps my CO was beginning to rumble me. Anyway, just after we had completed our training and were due to fly in behind the Japanese lines, I was transferred to being one of Orde Wingate's forward operations staff. It was fantastically exciting. Then, on duty one long night at our Advanced HQ in Assam, I discovered that his aircraft had flown into a hill.

After his death we tried to complete his task. I found myself flying round our strongholds in Burma, carrying messages and organizing airlifts. Slightly less terrified now, I was beginning to find real life romantic, and had the curious experience of helping to fly out Hubert Skone from inside Burma. He had earned his DSO and no doubt several more, but a groggy foot had forced him out. The battalion went on to win two VCs, but the price was appalling. Out of 800 men, only 200 marched out.

Why did I enjoy this bit of the war? My own lucky situation and the fact that we were winning clearly played a large part. In the Chindits I also began to meet men of a pattern I could aspire to – visionaries, writers, originals. Wingate himself was one such, so were Peter Fleming, Bernard Fergusson, the Perownes and lesser-known men like Peter Mead and Eric Kyte, both to make a mark in the Army after the War.

The Third Battalion of the Sixth Gurkhas, and the Chindits of whom they formed a part, paid a heavy price, but the Army had saved India from the Japanese. The British finally handed the country over to its inhabitants four years after that time, sitting on the Waziristan pass. Another few hundred thousand people were killed in the process and six million lost their homes.

Durgabahadur had died a few days after I last saw him. I cannot remember his parents ever asking us how we could justify his death. Nobody asked that sort of question. He lost his life, not in modern war, but in an old game that was just beginning to use modern weapons. Decades later, in Afghanistan, the reality of mines came home to the Pathans, poor devils. Just as we had come to India, and left, so Russia came to Afghanistan, and left. I am sure we achieved more. Hubert Skone died as a Brigadier, helping to stem the Communist tide in post-war Malaysia. It was that sort of a century.

All these deaths and battles have been a strain on all of us, whether or not we are poets and artists. Perhaps the biggest strain has been changing from early twentieth century man to late twentieth century

man. A youth in the Thirties held all sorts of sincere beliefs that are supposed to be anathema to a man in the Nineties; yet both men were, and in a way still are, me. One of me would still defend what we were doing then, but it means an awful internal struggle to do so, so I mostly keep quiet. We both do.

Living for ever would apparently mean turning oneself into a terrible battlefield every fifty years. There have been battlefields enough already.

My CO had said Thank God! that he would not be here to see the future. I now understand what he meant. Also I am truly grateful to him and the men I met in the Chindits for teaching me to be less selfish. I still think a lot about the battalion I left, with half its officers, my friends, still lying in Burma. I wrote this poem about them:-

THE LOST BATTALION

I thought I saw, in living truth,
The lost battalion of my youth;
I told them all the news since they
Shouldered their arms and marched away,
Until with puzzled smiles they said:
'Who is the living? Who the dead?'

I hear the lost battalion still
Deep in the Burma of my will,
Dying to save me from defeat,
Fighting to cover my retreat,
Till I, without a deal of pain,
Stand in the line with them again.

NOTES:

(1) Prior to the creation of the Chindit force there had been unsuccessful attempts in 1943 to recapture Akyab and its airfield by an overland advance down the Arakan coast and a seaborne assault, which had failed at great cost, particularly the frontal assaults against the terrifying Japanese bunkers. Orde Wingate's first Chindit operation was supposed to have been supported

by a Chinese-American advance from Ledo and a British-Indian advance from Imphal, neither of which materialized because of supply problems. However, Wingate went ahead with his own expedition and, after crossing the Irrawaddy with 3,000 men, operated behind enemy lines, disrupting Japanese communications and attacking enemy railways and other supply routes. The Chindits were supplied by air drops in jungle clearings, which were made on radio demand. They often carried their equipment on mules, which sometimes had to be left behind at the close of an expedition. They learned to live and operate in the thick Burmese jungle, deep behind enemy lines, and became effective guerrilla marauders. They were a highly trained and very fit force, who became masters in this type of warfare. The Chindits were the first units to rival the Japanese themselves, who until that point had been considered almost invincible.

Four months after setting out on the original Chindit expedition, just over 2,000 men arrived back in India, having covered an estimated 1,500 miles. A lot had been learned through the exploits of these men and, more importantly, British morale in the area, which had been low because of earlier defeats on the Arakan peninsula, began to rise again.

The second Chindit operation in March, 1944, consisted of guerrillas going 161 kilometres behind the Japanese lines to Indaw, where they carved out airstrips in the jungle ready for the Allied penetration of the area. Shortly afterwards, Orde Wingate, now a Major-General and only 41 years old, was killed in an air crash in Burma.

JOHN PRESS
(POET)

Poet and author John Press served with the Royal Artillery during the Second World War, after which he served with the British Council in Greece, India, Ceylon, Paris, Birmingham, Cambridge, London and Oxford.

His publications include *The Fire and the Fountain, Uncertainties, The Chequer'd Shade, Guy Fawkes Night, Herrick, Rule and Energy, The Lengthening Shadows, Spring at St Clair, Aspects of Paris* – (illustrated by Gordon Bradshaw), *A Girl with Beehive Hair* and *Troika*, with Edward Lowbury and Michael Rivière.

John Press has also written volumes about the poets of both World Wars and the libretto for *Bluebeard's Castle*, Michael Powell's television film of Bartok's opera.

With the Royal Artillery John Press served in East Africa, where he remained for the duration of the war. Soldiers who were posted to East Africa Command, often reinforced other theatres when the necessity arose: notably Burma.

Arriving in East Africa in 1942, John Press had missed the campaign against the Italians and Kenya had become a garrison for supplying other war fronts. He writes:

I became a gunner on 30 September, 1940, was commissioned just before Christmas, 1941, and sailed for East Africa in June, 1942 (Note 1). The physical impact of the country was overwhelming. As we reached the dockside the blast of the Mombasa sun assailed us like a furnace. We handed in our grotesque pith helmets to the military hospital in exchange for the excellent Australian bush hats, to the friendly jeers of the orderlies, who asked, 'Who do you think you are?

189

Kitchener's army?' Despite warnings that we must never go out without a hat, even in the sea, and never swim at noon, we all swam bareheaded like mad dogs and Englishmen out in the midday sun.

The magnificence of the coast between Mombasa and Malindi was beyond my experience or my imagination, while the grandeur of the White Highlands, where big game still wandered freely, moved even the most stolid to wonder.

Twice I took one of the finest rail journeys in the world – from Mombasa to Kampala. Near Jinja a guard walked along the corridor closing the windows. Ten minutes later a sound like gunfire reverberated through the train as spray from the Ripon Falls four miles away drummed against the windows. Nobody will ever again thrill to that ferocious sound: a dam has tamed the majesty of the Falls.

I experienced what we now call culture shock: the impact of Africans stripped to the waist carrying heavy loads on their heads, who were mostly illiterate and who ate a repulsive sludge of white millet called posho. Indians and Goans worked as clerks or served in (and sometimes owned) shops and hotels.

In East Africa the colour bar was as rigidly enforced as in South Africa. It filled me with shame that I was part of such a mean and loathsome system. In 1944, thanks to the encouragement of the Fortress Commander, Brigadier Barkas, I became a founder of the Mombasa Arts Club, the first all-racial club in the country.

There were weeks on end when I was the only officer on an isolated gunsite in charge of seventy men and six Bofors guns. But at other times I was free to devote myself to a strenuous round of pleasure. I played cricket, tennis, football and hockey; I dined and danced with WRNS, FANYS, ATS and a variety of civilian women; I read widely in English poetry and fiction. Like most soldiers in E.A. Command, I knew that we might at any moment be posted to Burma, where there awaited the possibility of death or capture and torture by the Japanese.

When I was on an army course up country at Molo, I met a young woman named Lavender Lloyd, who was attending a teacher-training college. A few weeks later I ran into her and her mother at an auction in Nairobi and was invited to have lunch with them the next day. After retiring from the Indian Army, Colonel Lloyd had bought a house at the foot of the Ngong Hills, about ten miles from Nairobi. It had formerly been the home of Karen Blixen, the most gifted writer ever to have lived in East Africa.

Colonel Lloyd was the kindest and most delightful of men, whose books about a Hindu army clerk had enjoyed widespread popularity in the ICS and the Indian Army. Mrs Lloyd, a member of the Jameson family who sold Irish whisky, welcomed with gentle affection a great variety of visitors to Karen House. The one I knew best was Ivor Keys, with whom I used to share a log cabin built by Colonel Lloyd with his own hands. When Ivor married Anne Layzell, the daughter of a settler, they were given a bedroom in the house.

Ivor had become an FRCO at the incredibly early age of thirteen and his gift as a pianist was scarcely less than his ability as an organist. At Karen House he often played the music of his favourite composers: Scarlatti, Bach, Mozart, Beethoven, Schubert, Chopin, Brahms, Debussy and Ravel. His enjoyment of music was in no way narrow or hidebound. When he gave recitals at army camps he would play, as an encore, any requests from the audience – jazz, dance music, popular songs, film music – drawing the line only at the Warsaw Concerto, which he regarded as a debasement of Rachmaninov.

On one or two occasions at Karen House he accompanied a young tenor in a programme of German lieder. The unusual thing about this was that the singer was a German who had been studying music in Nairobi at the outbreak of war. He was speedily released from internment and allowed to continue his studies, being required only to report to the police once a month.

I chanced to make a slight contact with other enemy aliens. In mid-1943, when my battery became Africanized, we trained our newly recruited Ugandan askaris in a camp at Athi River, some twenty miles from Nairobi. One of my duties when I was Camp Orderly Officer was to inspect the section of the camp where Italian POWs were interred. What astonished me was the standard of living the officers had achieved: colourful rugs and curtains, bookcases, gramophones, a background of comfort and elegance that compared very favourably with the mess and living quarters of British officers in the main camp.

There were many other highly civilized Italian POWs elsewhere in East Africa. Some of them formed a symphony orchestra, making most of their instruments – strings and woodwind – but receiving help from the British army in providing metal for brass and percussion. The orchestra gave in Nairobi the first symphony concert ever heard in East Africa, in the presence of the Governor of Kenya, Sir Philip Mitchell, and Lady Mitchell.

Because of the colour bar I was denied any contact with the Indian community, nor, apart from a splendid evening on a dhow in Mombasa Old harbour, did I learn anything about the Arab civilization that flourished on the coast between Mombasa and Dar-es-Salaam. I discovered something about Africans because my anti-aircraft battery was composed of Ugandans, apart from a handful of British officers and NCOs. When I was seconded to Fortress Mombasa I became responsible for 150 African education Instructors who gave one hour's instruction in English every week to all askaris.

At one unit that I inspected I was impressed by the intelligence of the AEI and by the quality of his teaching. After the lesson he assured me that his colonel gave him every facility to carry out his educational duties.

The CO welcomed me most hospitably for a drink in the mess. 'As you may have gathered,' he said, 'I obey East Africa Command's instructions about the teaching of English. Perhaps I should tell you that I forbid any AEI to address any British officer or NCO in English. Are you going to order me to countermand my directive?' I replied that I had no authority to do any such thing, but I should make a report to the Fortress Commander. I also said that I should like to know the reason for his attitude. He answered, with a smile, 'If an African speaks to you in English he is making an implicit claim that he is your equal. Before long he'll be wanting to marry your daughter.' Perhaps he was right, insofar as the growing literacy in English of young Africans was a contributory factor in their progress towards political independence.

I was exceptionally lucky in getting at least a glimpse of the races and the communities that existed side by side in East Africa – the Italian POWs, the coastal Arabs, the African tribes of Kenya, Tanganyika and Uganda, the British settlers, most of whom worked hard and were untouched by the antics of the few men and women who cultivated hedonism in the 'Happy Valley'.

In East Africa between 1942 and 1945 I wrote about twenty-five poems. I can discern in some of them traces of the experiences and influences that I have described in this article. But the main legacy of these years has been diffuse and pervasive. The shadow of East Africa has fallen continually over the pages that I have written during the past half-century.

NOTES:

(1) The Second World War didn't greatly affect East Africa, although the Italians maintained an army in Ethiopia and Italian Somaliland to the north. The main concern for the Italians was the capture of the Suez Canal and the campaign against the Eighth Army in the western desert. The presence of British and Commonwealth forces in Kenya and the Sudan to the south, although a thorn in their side, was of little military significance as far as they were concerned.

In 1940, when the Italians entered the war, Britain fielded 9,000 troops in the Sudan, 5,500 in Kenya, and 1,475 in British Somaliland. By comparison, the Italians had roughly 110,000 troops in Ethiopia, Eritrea and Italian Somaliland. They also had naval ports on the Ethiopian and Italian Somaliland coasts. However, it wasn't long before troops from South Africa and other parts of the Commonwealth began to redress the balance.

The Italians certainly intended to invade Kenya and the Sudan while opposition was so light, but only after they had secured Egypt and the Suez Canal. In September, 1940, Marshal Rodolfo Graziani attacked Egypt with five divisions and drove the British forces of General Wavell back to Mersa Matruh. The Italians dug in and built a line of fortified camps. Then, on 9 December, the British, under the command of Major General Richard O'Connor, ripped through the Italian defences so comprehensively that the Italians in turmoil retreated out of Egypt in confusion, leaving 38,000 prisoners to be mopped up. The British continued to assault the Italians, taking the war into territory which they had previously held.

In January, 1941, General Wavell launched a two-pronged offensive against Ethiopia and Italian Somaliland from the Sudan and Kenya. From Khartoum in the Sudan General William Platt with two divisions of South African troops headed east, while from Kenya Lieutenant General Sir Alan Cunningham moved north with one South African division, two African divisions and other Commonwealth and Free French Forces, an estimated 70,000 troops. By 4 April, 1941, Addis Ababa had been captured and Emperor Haile Selassie reinstated in Ethiopia. Cunningham had captured 50,000 prisoners and 360,000 square miles of enemy territory, all for the cost of 135 Commonwealth lives. Effectively, the war in East Africa was over and so was any further threat the Italians posed to the Suez Canal from that area. With the capture of Italian ports on the African coast, it also meant that the Red Sea was now under the control of the Allies.

GAVIN EWART FRSC
(POET)

Gavin Ewart served in the Royal Artillery from 1940–1946. During a remarkable career he published over twenty books and several volumes of children's poems.

Sadly, he died in October, 1995. His wife Margo, who served in the WRAF herself during the Second World War, has selected one or two poems which illustrate both his army service and some of the imagery that influenced his work. Reflecting on his military service, 50 years before his death, the poems of Gavin Ewart, like the drawings and paintings reproduced in this book, give a practical illustration of his particular art.

Gavin Ewart began his army career with various batteries employed in the air defence of airfields and industrial centres in Great Britain. Posted to North Africa, and later Italy, his unit was employed mainly on port and airfield defence, until it was disbanded in order to strengthen infantry battalions and armoured divisions. Ewart then found himself posted to a mobile Operations Room and, on a motorbike, travelled up the west coast of Italy from Torre Annunziata to La Spezia, until the German surrender, after which he returned to Rear Headquarters by the Torre al Gallo, overlooking Florence.

Gavin Ewart, unlike most war veterans, openly admitted that he didn't enjoy life in the Army at all and maintained that the period he spent in Great Britain as an officer with a Light Anti-Aircraft Regiment, providing air defence for airfields, factories and other crucial establishments, was one of the most boring episodes in his life. However, when he was eventually sent overseas on port defence duties, he began to enjoy the experience a lot more. He particularly enjoyed his tour in Italy, visiting places like Naples, Gragnano and

194

Castellammare. During his stay in the area, Mount Vesuvius provided some entertaining fireworks and he was able to see some of the great Italian masterpieces which were beginning to re-emerge from their hiding places, having escaped the Nazis. Many of these masterpieces were exhibited in Rome, below and behind Mussolini's famous balcony, where Allied soldiers were able to view them. He was greatly affected by his tour in Italy and by the time he returned home to England in May, 1946, he could both speak and read Italian, though not very well.

His books include *Poems and Songs, Londoners, The Young Pobble's Guide to His Toes, Late Pickings, The Learned Hippopotamus, Pleasures of the Flesh, Be my Guest, No Fool like an Old Fool, Caterpillar Stew, Like it or Not* and various editions of collected verse.

Gavin Ewart had been a fellow of the Royal Society of Literature and chairman of the Poetry Society.

The following poems, 'War Death in a Low Key,' 'A Murder and a Suicide in Wartime,' 'A Piece of Cake,' 'War-time' and 'Only the Long Bones' were either written during the Second World War itself, or were inspired by events that took place during it.

WAR DEATH IN A LOW KEY

This all happened in 1943, near Algiers.
I was at a base camp, waiting to be posted,
a Second Lieutenant in a Light Anti-Aircraft Regiment –
but my unit had dumped me (for a more efficient officer),
following an exercise where my map reading had been faulty
(the maps were fairly old).
I had to start the whole thing. I had to lead the Troop off
and the road I was on wasn't even on the map;
consequently I took the wrong turning at the wrong crossroads.
'Understandable, but inexcusable,' the Assessor said later.
It was hot as hell. There was a donkey in the camp that
 brayed all day long,
a depressing sound. I was depressed, and felt like a reject.
There was a Captain with alopecia from the Eighth Army,

who wore his black beret all the time and made a very big
 thing
about being a Desert Rat (we, of course, were First Army) –
the war in North Africa was very nearly over
and the Germans and Italians were about to be pushed off
 Cape Bon
into the sea. This captain was by way of being
a hand grenade instructor. Some of these junior officers
obviously worshipped him because of his daring,
and they would lob grenades about among each other.
One subaltern, one day, lobbed (or held) one once too often.
The top of his head was blown off, though his rimless glasses
stayed on his nose. Panic on the range.
I was told all this at lunchtime.
Later (because I'd known him? But I
hadn't really. I just knew which he was)
I was detailed to be part of the Guard of Honour at his
 funeral.
How many were there? Three or four of us? And the driver.
His body lay on a stretcher on the floor
of an open 15 cwt. We collected it from the Hospital.
There was no coffin. He was wrapped tight in a
grey army blanket (as I remember). Blood still oozed through
at the top, where his head was.
Over-awed, I think, we sat in the truck with our rifles.

There was another burial, I remember.
A woman, a nursing sister. No coffin either.
She was wrapped from head to toe in bandages
like a rather plump, short mummy.
Somehow it was pathetic to see the mound of her breasts
and realize it was a woman. Young men's reactions
to such things are usually quite other.

The prayers were said, the red soil scattered on.
We fired, together, our valedictory volley.

We were quiet, but relieved, as we drove home empty.
His name began with an A? It's hard, now, to remember.
Someone that night slightly shocked me by saying:
'I knew him – but I'm afraid I didn't like him.'

A MURDER AND A SUICIDE IN WARTIME

You'd think neither was necessary,
with so many soldiers being killed –
the German, the Italian, the Russian brother –
but I came across the one
and then the other.

In 1942 the Troop was in billets,
not long before we went overseas,
Fernhurst or Fleet (I think the latter),
the memory blurs, and finally
that's no great matter . . .

There was one Welsh gunner
always being picked on by a Bombardier
for Welshness and stupidity;
this irked him like pre-thunder
pressured humidity,

so one night he took an axe
(part of the standard Fire Precautions)
as everyone lay peacefully sleeping.
Heavy strokes, blood splashing,
running and seeping.

he bashed the Lance-Bombardier's
handsome unconscious head in . . .
was he paranoid or persecuted?
At least authoritarian niggling
was more than muted.

The suicide happened in North Africa –
a big, apparently happy, gunner
shot himself with his own rifle.
What triggered that, what depression
or magnified trifle?

They said he was happily married.
Would the separation cause it?
The MO's death certificate hit one nail
on the head: in perfect health,
the body of a young male . . .

A PIECE OF CAKE
(In Memoriam Dieppe, 19 August 1942)
Dieppe, August 1984

No, the murders left no traces on the shore,
no, the murders left no traces
on the bright and murdered places
where the murderers were active once before.,

and the sun shines bright on that bright promenade
where the slayers crouched to slay them,
there was massacre and mayhem –
because, to tell the truth, it isn't hard

(though there are hundreds in the landing craft)
if you know you'll be invaded
and you have them enfiladed,
to mow them down at leisure, fore and aft.

Just the accidental skirmish out at sea
and they went to Action Stations.
All they needed then was patience,
like the spider in his web – you must agree

it wasn't hard, with strong points on the cliffs,
you could do it sitting, standing,
even though the tanks were landing
you could knock them out without the 'buts' and 'ifs'.

No, the murders left no traces on this scene;
where there once were blown-up bodies
kids with eyes like silly Noddy's
run in joy as though that war had never been.

NOTE:
The Dieppe Raid of 1942 had as its centrepiece a frontal attack on the
town by Canadian troops, towed across the Channel in landing craft.
The operation was compromised, not by any security leaks, but because
a German E-boat patrol sighted the left flank of the convoy and opened
fire. If communications had been better, the raid might have been called
off, even at this late stage. The whole operation depended on very exact
timing (waves of fighters attacking the town) and the timing went
wrong. One battleship shelling the defences would have made a lot of
difference, but the Royal Navy reserved its battleships for the Atlantic
War. As a result, the Canadians lost fifty-six officers and 851 other
ranks. One Army officer at the briefing is supposed to have told the
regimental commanders that the raid would be 'a piece of cake'.

WAR-TIME

A smooth bald head, a large white body.
No trace of pubic hair.
Raw, fretted and frayed by that rocky coast,
The flesh where the nipples were.

A woman drowned in war-time
On the Ligurian shore.
An Italian shouted 'E Una femmina!'
There seemed to be nothing more.

A suicide! A Resistance girl
From La Spezia floated down,
A murderee from Genoa?
The coast road into the town

Led me back to Livorno
And a British Army tea.
The war got hold of the women,
As it got hold of me.

Twenty years later, in the offices,
The typists tread out the wine,
Pounding with sharp stiletto heels,
Working a money mine.

It's a milder war, but it is one;
It's death by other means.
And I'm in the battle with them,
The soft recruits in their teens.

ONLY THE LONG BONES

NOTE:
'Only the Long Bones' was inspired by Gweno Lewis, wife of the poet
Alun Lewis, who died in Burma in 1944. After her husband's remains
had been moved at least four times, from different War Graves
Commission cemeteries, she asked the gardener how much of him
remained, to which he replied, 'Only the long bones, Madam, only the
long bones.'

Only the long bones, Madam, only the very long bones,
we skip the fingers and toes – but we do remember the ribs -
of Lewis and Morgan and Jones.
Knuckle-bones, useful for dibs,
are given to prep school boys.
They're not much use to his nibs!

Only the long bones, Madam, only the very long bones.
Necklaces (fingers and toes) – you could sell them in a
 bazaar –
anguish I hear in your tones . . .
does it matter where they are?
Since most of him is here,
and you have come so far!

Only the long bones, Madam, only the very long bones,
all of them labelled and packed – and the backbone counts
 as long
(I thought you'd like to know that).
Move and bury. It isn't wrong.
It's the way the War Graves work.
It's a game, like Bezique or Mah-Jongg!

RANDLE MANWARING MA

(Poet and Author)

Throughout a literary career which has seen the publication of thirteen volumes of poetry and several other works, often reflecting his deep Christian faith, Randle Manwaring has followed an equally successful career in commerce. He has been a director of several companies in the field of insurance and banking and was a managing director of C.E. Heath, Lloyds Brokers, also the first managing director of Midland Bank Insurance Services. He has also been the President of the Society of Pensions Consultants, Chairman of the Governors of Luckley-Oakfield and Northease Manor Schools, Diocesan Reader (Chichester), and churchwarden of St Peter-upon-Cornhill, London.

His books of poetry include *Satires and Salvation, Under the Magnolia Tree, The Swifts of Maggiore, In a Time of Change* and *A Late Lark Singing*. Prose works include *The Heart of this People* and *A Christian Guide to Daily Work*. He has also contributed many poems and articles to various journals in Great Britain and Canada.

During the Second World War Randle Manwaring had the honour to participate in the birth of the Royal Air Force Regiment, eventually commanding its strength in Burma.

Randle Manwaring writes:

There have been several much more distinguished literary people who combined writing with a commercial life e.g. T.S. Eliot, who worked for Lloyds Bank, Walter de la Mare, who worked in an office in the City of London and, more recently, Roy Fuller, a leading poet of this century, who was a full-time solicitor in one of the largest building societies. I must say I never found it easy to be a writer when working in the City whether as a junior pre-war, or post-war, helping to run

a public company and when it came to the war years, I seemed to have little inclination to write verse, although some was written under the stress of events.

I was a member of the Royal Air Force Volunteer Reserve from 1939 but was not called up until the following year, when there was a threat to our airfields and a defence unit was hurriedly put together. In 1942 this became the RAF Regiment and, as I was already commissioned, I became one of the 'founding fathers' of the regiment, being engaged (1941/43) in airfield defence in perhaps fifty different UK places. (Note 1) Not until 1943 were we put together in a force of about ten squadrons and shipped in a convoy to the Far East. I sailed in the *Queen of Bermuda* (we called this luxury liner the *Queen of Blue Murder*). It was a memorable journey with protecting destroyers abeam and circling Liberator bombers overhead, but we reached Bombay unscathed before a week's train journey across India to a jungle training unit in Bengal. There one of the hazards was tigers and I was encouraged to spend my nights in a jeep. From there, with all our equipment, we were flown into forward airstrips in Burma with the Japs more or less on the run but still fierce in combat and when left behind by their forces. They even threw grenades into our camp on V.J. Day!

Often units were called forward to a new airstrip which the sappers had carved out of the jungle and the Wing Commander flying and I nipped into a two-seater Piper Cub aircraft to test out the metal-stripped runways before the combat aircraft were allowed in. Once, after a rather hazardous flight, we shook hands and he mistook my handshake for that of a Masonic custom. 'No,' I said, 'It's an old cricket injury, Sutton v Wimbledon, 1936.'

I did a brief period on staff duty in Kandy but was eventually given responsibility for all the Regiment Squadrons in Burma. When I reported to my Air Vice-Marshal he said, 'Oh yes, I must put your name forward for an honour.' He never did. By now the war was coming to an end, but before this happened I was asked to visit all our units in India and Burma to raise the first airborne squadron of volunteers (no problem). In September, 1945, I had to set up the reception in Rangoon of a Japanese surrender delegation headed by a Lieut General Numata. They flew into Mingaladon airfield in a white Dakota aircraft identified by a green cross and, in token, we relieved the generals of their swords. (Note 2)

Ordered down to Singapore, we drove through cheering crowds,

but I decided to come home when my release group came up. The Wing Commander who took my place, going further south, an Australian, was promptly thrown into jail by the Javanese whom he was to sort out. They didn't like whites whether they were Dutch (their prime enemy) Australian or British!

When I went overseas I deliberately took with me a pocket bible and a couple of hundred hymn sheets, the kind used on special occasions like harvest and Christmas, and when I was a squadron commander, with no padre for hundreds of miles, I led a little service on a voluntary basis in the heart of the jungle, with appropriate guards overseeing, and my successor was forced by the unit to maintain this function. When I met him later he said it had been the most difficult part of his job!

Fifty years later, prompted by memories of V.J. Day, a member of the squadron wrote to me:

'I still talk about how you used to have a Sunday morning service. All of us sat around and you read the Scriptures to us and a Corporal Halliday who was a Salvationist led the hymns, and how L.A.C. Jackson, Chef, used to bake little cookies in his field oven and we all had tea and cookies after you gave us the news from the European front.'

So, with many memories, a number of them later inspiring poems, late in 1945 I returned to my wife and two little children. Early in 1946 I went back to my humble job in St James's Square, London, to work for a man who had not been called up. He told me that the war had turned me from a clerk into a wing commander but his job was to turn me from a wing commander into a clerk. 'See,' he said emphatically.

My first slim volume of poetry (or verse) appeared in 1951 (rather late by poetic standards) but since then there have been twelve further volumes, plus about half a dozen prose works, only one of which being of any significance.

If it does not sound too pompous, I consider myself a 'polymath', for, apart from my wartime career, I became a Fellow of both the Corporation of Insurance Brokers and of the Statistical Society, (neither at all difficult). Later, when I left the City, I did a Master's University degree in history and now, as I write, I am working for a higher degree in poetry. Incidentally but in my view significantly, in 1968 I became a Reader in the Anglican Church.

NOTES:

(1) When it was originally formed, many recruits for the RAF Regiment volunteered from the army and to begin with they wore khaki battledress with RAF insignia, but in due course RAF uniforms were issued as 'best blue'.

Although the RAF Regiment was formed originally to protect airfields against both ground and low-level air attack, its function was later widened to include attacking roles, such as capturing enemy airfields and other installations. For this purpose the Regiment was equipped with armoured fighting vehicles and was airborne when necessary.

In the India/Burma theatre the RAF Regiment served with distinction and, as well as defending airfields, they often had to occupy air strips hacked out of the jungle, in the same way that the Chindits did. They also had to camouflage the Hurricanes, Spitfires, Thunderbolts and other fighter aircraft used on the Arakan. Dakotas and Liberators were a bit more difficult to hide and had to operate from larger bases with properly surfaced runways, all of which had to be protected by regiment personnel.

(2) Randle Manwaring mentions the Japanese surrender at Rangoon in September, 1945. He had been given the task of setting up the reception of the Japanese delegates.

The race for Rangoon had really begun in April, 1945, when General Sir William Slim decided to beat the monsoon. Any later and his tanks would have become bogged down. Spearheaded by the 17th Indian Division, the British slashed through the Japanese lines and Rangoon was captured on 2 May. The British continued to pursue the Japanese through Thailand, but time was running out. The Japanese were now fighting on several fronts against the British, Americans, and even the Russians, who had opened a front in Mongolia.

On 6 August, 1945, the first atomic bomb was dropped on the Japanese city of Hiroshima, killing 78,150 people outright. Three days later, on 9 August, a second bomb at Nagasaki killed a further 40,000 people. Many thousands more would die of their injuries in the years to come. The Japanese had no alternative but to surrender.

The surrender at Rangoon set up by Randle Manwaring was a kind of preliminary occasion before the final defeat of all Japanese forces in Southeast Asia, which took place in Singapore on 12 September, 1945.

Chapter Twelve

ART IN THE AFTERMATH

In an earlier chapter, and in connection with the painter William Gear, we saw how servicemen remained in Germany after the war. William Gear found himself doing useful and very relevant work for the Monuments, Fine Art and Archives Section of the Control Commission, sometimes helping to re-introduce art exhibitions to bomb-damaged cities. Of course he was not unique and many thousands of soldiers remained in Europe or the Far East after the end of hostilities performing a wide range of duties. For many of these soldiers the war didn't end for several more years. Claude Harrison, for instance, was posted to Hong Kong after the war, where he established and ran an art department at St Joseph's College for service personnel from all three services who had been posted to the city. Similarly, painter and sculptor Eric Taylor established and ran an art school in Lübeck in Germany.

In this chapter we will be looking at the military career of one such individual, whose story doesn't really come into its own until the final surrender of Japanese forces in South-East Asia.

The story of painter Robert Strand is a particularly good place to end our research, because immediately after the war he was involved with guarding Japanese war criminals and was even commandant of a prison camp for a short time. It was during this period that he made a unique record of Japanese prisoners, sketching individuals and incidents at Bangkwang Jail in Siam and the notorious Changi Prison in Singapore.

ROBERT A. STRAND OBE
(Painter)

Robert Strand attended the Royal College of Art (School of Painting), in January, 1947, and was awarded the ARCA in 1949. He had already done three years at Croydon School of Art before the war.

Although commissioned in the Royal West Kents, on arrival at Kohima in Burma he was posted to the 1st Battalion of the Queen's Royal (West Surrey) Regiment and served with them as Adjutant and then as a Major for the rest of the fighting in Burma.

Between 1949–51 Robert Strand taught at Horsham School of Art; 1951–61 he was Deputy Principal of Stoke-on-Trent College of Art; 1961–70 Principal of Epsom School of Art; 1971–74 Deputy Chief Officer, National Council for Diplomas in Art; from 1974–82 he was Registrar for Art and Design, with the Council for National Academic Awards. He was appointed OBE on his retirement in 1983.

Throughout a successful career in education he continued his own professional practice as a painter and wood engraver. He has exhibited at the New English Art Club, the Suffolk Group and Suffolk Craft Society, and has held several one-man shows. His work hangs in private collections in countries around the world.

Immediately after the war Robert Strand was posted to Siam (as it was then) where his regiment came into contact with Japanese prisoners being detained as war criminals, as he now explains.

The war, for me, ended at Shwedaung on the Irrawaddy in June, 1945. The 1st Battalion of the Queen's Royal Regiment had been engaged in the scrappy business of cutting off as many as possible of the retreating Japs as they straggled back over the river and out of Burma for ever. We caught a few Japs at Shwedaung, and my most

207

vivid memory is of the sonorous nightly chorus of millions of frogs in the marshes along the river – enough to make anyone's throat sore. In fact I did contract a sore throat, though not from emulating the mating calls of the frogs. After a week or two of acute discomfort it became plain that I had something more than tonsillitis. I have vague memories of a bumpy jeep ride down the road to Rangoon, recently liberated following the roof-top display of the immortal words: 'Japs gone. Remove digit'. A British military hospital was already installed there, and I became the first British soldier in Burma to be treated for diphtheria with penicillin. They told me later that they had given me what turned out to be four times the requisite dose. I didn't mind being a human pincushion: I was simply thankful that they had saved my life.

It was delightful to find myself lying between clean white sheets and to hear the cheerful voices of English nurses. I heard other cheerful voices, too: Arthur Davies and Hugh Harris called in to see me on their way to catch the boat home. My own subsequent journeyings involved moves by sea and rail from Rangoon to Chittagong, from there to Dhaka (where I shared a six-bedded ward with five RAMC doctors, surely the most petulant patients in the world) and finally to the Officers' Convalescent Depot at Lebong, near Darjeeling. I arrived there, in the cloud-enshrouded Himalayan foothills, on the evening of V.J. Day, to witness an astonishing spectacle of attempts at celebration. I think we were all too enfeebled by our spells in hospital to be able to do as full justice as we thought we could to the amount of festive liquor available. Most of us, I fancy, awoke next morning feeling considerably worse than when we had arrived at Lebong. In retrospect, the universal rejoicing at the sudden end to a war which had seemed destined to continue for much longer was entirely understandable. None of us at that time could have foreseen the ominous consequences of the means employed to induce the enemy to surrender.

My month's stay at Lebong passed all to slowly. The company of fellow convalescents is not the most congenial. Besides, whereas earlier in the year, on leave in Darjeeling with Tom Raven and Arthur Davies, I had daily enjoyed the sublime sight of Kanchenjunga towering crystal-clear forty miles away, now one could see no more than a few yards through the mist that enveloped the depot. I was very anxious to rejoin the battalion and return to real life.

1st Queen's meanwhile had had a tough two or three months in the Sittang River area north-east of Rangoon, where the Japanese had fought a stubborn rearguard action to cover the retreat of the remnants of their armies. Had their Emperor not surrendered to the Allies in August it would have been the lot of the Queen's with other units, to march and fight their way over the mountains from Burma into what was then Siam. In the event they were saved from this daunting prospect and instead were sent by air to garrison Bangkok, the capital of Siam, and to assist in rounding up the very large Japanese forces which had been occupying the country.

I was fortunate enough to return from Lebong to Rangoon just in time to catch up with the Battalion's rearguard, which was about to board a shaky old Dakota at Mingaladon aerodrome. Morale had been shattered by the news, just received, that the plane immediately preceding ours had crashed somewhere in the jungle-covered mountains on the Burma–Siam border. All the passengers – men of the Queen's – and crew had perished. Our pilot himself showed signs of apprehension, but we took off and after an hour or two we were passing over the lush paddy fields of Siam, dotted with peasants and fat buffaloes, before landing in sunshine at Dom Muang airport, fifteen miles north of Bangkok. The Dakota's doors opened and I experienced a kind of double-take: two Jap soldiers ran forward and propelled me and my kit down to the tarmac. For a split second I thought it was a bad dream. In fact, so completely had the Japanese fulfilled the spirit and letter of the surrender that they were almost overnight transformed from our enemies to our obedient and even obsequious servants. It was a change of role that took some getting used to, at least for us.

The Battalion was accommodated in the buildings of the Chulalongkorn University, an attractive white complex bordering a green campus near the centre of Bangkok. The officers' mess was a couple of miles away, in a solid, timber house in a largely residential area where there had been homes for senior staff of trading companies and legations. The city itself bore little obvious evidence of its previous occupation by the Japanese – an indication of the agility with which its citizens had adapted themselves to the new order. In parts it was an attractive city, and its famous temple complex very beautiful. But mostly it was a warren of streets along which, for good or ill, the whole tide of human activity flowed. In the more affluent

districts shops and other premises started to advertise their wares in English for the benefit of the new arrivals. Through a blend of Thai sensuality and Chinese entrepreneurial skills (half of Bangkok's two million inhabitants were Chinese and they owned most of the businesses), new restaurants, nightclubs and other more dubious establishments mushroomed almost overnight. Every conceivable pleasure was available to all and proved the downfall of some.

It was perhaps fortunate that the Queen's had many and various duties to keep them busy for most of the time. Although still part of an Indian Army formation, they were the only British Infantry unit in Thailand (as we had better now call it) and they had substantial responsibilities. No one quite knew how things would go after the Japanese surrender, in respect of either the defeated enemy or the local population. The Queen's carried out security exercises, including a practice defence of Dom Muang airport. Corruption of all kinds, endemic in the Far East, was rife in the months after the end of the war. An expanding black market flourished. The Thai police, themselves riddled with graft and corruption, were induced to carry out raids on civilian premises to recover stolen and looted property of all kinds. On a number of these raids detachments of the Queen's accompanied the police, not to protect them but rather to protect the luckless victims from their depredations. Other detachments spent periods of guard duty at the Klongtoi docks on the Menam River at the southern end of the city. This was, as we supposed, in the general interests of security and crime prevention, for the docks were the main seaward gateway to Bangkok and the canals or 'klongs' extending through the city from the river were as great a hive of activity as the network of paved streets. I cannot recall any episode that stands out as having relieved the tedium of duties at Klongtoi.

Other much more interesting work, however, came our way. Thailand had been the main Japanese base area for their operations in Burma and Assam. Many thousands of troops had been stationed there or had passed through to and from the battle areas. There were still very large numbers all over the country when hostilities came to an end. One division at least had only recently marched south from China and had never confronted the British and Indian forces. Proud and self-confident, they must have found it hard to come to terms with the fact of surrender. Other troops had been employed as engineers, notably for the infamous Burma–Siam railway, while yet others had

been guards over Allied prisoners of war, either on the railway or in the numerous other POW camps scattered throughout the country. All now were to be sorted out and the sheep, as it were, separated from the goats. For many would be required to stand trial on war crimes charges and would not be allowed to slip through the net.

Special welfare agencies had acted quickly to release and repatriate British and Indian POWs. For the Queen's and other units in the Bangkok area the first major event was a formal ceremony having great symbolic significance for both sides: a surrender parade at which senior Japanese officers were required to hand their swords to – was it to our Corps Commander or to Geoffrey Evans, our Divisional Commander? At this interval of time I forget which. For a Japanese officer thus to part with what in every sense was an emblem of his honour, both personal and national, was the ultimate act of capitulation.

I should mention at this point that on my rejoining the battalion I had found that in my absence Victor Mosnicka had been appointed Adjutant in my place. I was now given a 'crown' and the command of a company. I found myself one of the group of officers responsible for escorting the Japanese generals at the surrender ceremony, which took place on a maidan in the city. My charge was no less a personage than Lieutenant-General Sato, who had held a very senior command. He was unusually tall for a Japanese, aloof and taciturn. With British, Gurkha and Indian soldiers paraded around the perimeter of the maidan, and our General standing at a table in the middle, I followed a pace or two behind Sato as he walked stiffly the fifty yards to the table, bowed low, placed his sword and scabbard in our General's hands, bowed again and returned to his place. All this was done in complete silence. Not a word was exchanged. Sato's face remained impassive throughout, but as he turned, having regained his place, I saw tears trickling down his cheeks. It was weirdly incongruous, yet oddly moving. I realized the completeness of the Allied Victory. For years afterwards I kept a small photograph of the pair of us strutting across the grass that day. Not long ago I passed it to a friend in the Imperial War Museum, in whose archives no doubt it records a tiny fragment of history.

There now began in earnest the business of rounding up, identifying and arranging the disposal of thousands of Japanese surrendered personnel. The Queen's rifle companies took turn and

turn about in this duty. I for one shall never forget the month or so which my Company and I spent at a large camp and collecting centre at Nakon Nayauk, which if I remember rightly was about seventy miles north-east of the capital, at a point where the flat plains and paddy fields met a range of jungle-covered hills. There was a railway nearby, along which those Japanese against whom no charges were laid could be sent to the coast for repatriation. The camp itself consisted of lines of bamboo and palm 'bashas' constructed by the Japs for their own use. These were set around several parade areas of hard earth, each about the size of a football pitch. Indeed one of them served just such a purpose for my Company. We had our own 'bashas' and there was even a group of smaller huts which served as Company office, officers' quarters, cookhouse and officers' mess. The whole camp contained at any one time during our tour of duty there as many as seven or eight thousand Japanese – and a hundred and thirty of the Queen's. Despite this huge disparity in numbers, so meticulously did the Japs comply with the terms of surrender that we felt totally secure and were able to sleep peacefully in our bedrolls at night until the last week of our stint, when our slumbers were broken for reasons I shall mention later in this narrative.

The procedure we followed daily during those weeks at Nakon Nayauk was as extraordinary as it was simple. The Japanese had to be identified, searched and sorted into three categories: 'white', which embraced those innocent of any war crimes; 'grey', those under suspicion and not yet cleared; and 'black', those against whom definite charges had been or were about to be laid. The 'whites' were despatched to the railhead for repatriation, but the 'greys' and 'blacks' were taken under escort to Bangkwang Jail, near Bangkok, whence those 'greys' who were found to have been laundered 'white' by our Intelligence staff departed for their homeland, while the 'blacks' and the 'greys' who turned out after all to be 'black' ended up in Changi Prison, Singapore, to stand trial.

The Queen's day began around six o'clock, and by seven I had gone out to one of the largest compounds to find myself confronting a solid phalanx of Jap soldiery lined up in columns, each man carrying his full kit. At the front of this mass of submissive humanity, which numbered anything up to five or six thousand on a normal day, stood half a dozen generals and colonels, also with their kit. The senior of these would on my appearance utter a word of command, whereupon

212

the whole assembly would bow in silent obeisance. At my word Japanese columns filed forward and the real business began. Behind me stretched a long row of little bamboo and palm-covered gates, such as might be found in a cattle market or a football ground (except that there were no turnstiles). At each gate stood a group of NCOs and men of the Company, and with them at a side table a member of the Allies' War Crimes Investigation or Intelligence staff who had arrived from wherever they had their own quarters in or near the camp.

Through the gates, at the double and led by their senior officers, came the Japs. They declared their name, rank and unit, had their kitbags and packs emptied and searched for any items considered to be loot, and were briefly interrogated and checked against the investigator's lists. Then, hastily gathering up their possessions (less what had been confiscated), they were sent in whatever direction their designated 'colour' required. The whole operation was conducted with as little ceremony and as much speed as possible, for by mid-morning the sun was hot and the searchers and scrutineers soaked in sweat, even though for us bare tops were the order of the day.

The Japanese for their part were totally co-operative and on the whole a fairly fit bunch of men. There were, however, some who limped and stumbled, a few syphilitics and other invalids from their sick bay, and some who carried around their necks pathetic cardboard notices bearing such words as 'The deaf person' or 'Hearing a little' or perhaps 'No am seeing'. Most were docile, a few were sullen, all were submissive. It was a tribute to the power of the word of the Emperor of a once proud and now vanquished people.

The day's work was usually finished well before noon. Any delusions of grandeur that the salutation of so many surrendered soldiers and their generals might have engendered in the mind of a twenty-three-year-old Company Commander were quickly dissipated by the heat of the day, the scale and strenuous nature of the proceedings and admiration for the cheerfulness and competence of the men who had really done the job. Morale in the company was high. There was the sense of freedom that comes from being on detachment, and with it an awareness of responsibility for carrying out an important if bizarre task, a task which it must be admitted was made all the sweeter for being undertaken in respect of our erstwhile enemies.

The rest of the day was given over to rest, recreation and general

company duties. I myself and the platoon commanders usually received a group of Japanese commanders during the afternoon, when we were presented with details of the units to be screened the following day. This was a brief, formal but courteous meeting, with no words wasted on either side. The platoons meanwhile played each other at football on the hard earth pitch marked out for the purpose. At the end of the game there occurred something which has remained in my mind as typifying the attitude of the Japanese surrendered personnel. As the final whistle blew and the two teams left the field a shout would go up from a Jap sentry, whereupon every single hut within sight of the pitch would disgorge its occupants who would then stand, row upon row, sometimes hundreds of men, with heads bowed as a couple of dozen Queen's men, sweat-stained and wearing only shorts and plimsolls, straggled up through the lines to their own quarters. Then and only then did the Japanese relax again.

Living was simple though hardly spartan compared with conditions in the field during hostilities. My predecessor whose company we had replaced had initiated a routine in the officers' quarters, as I soon discovered. At about five in the afternoon I would receive a summons from one of the Japanese orderlies – he was in effect my batman's own batman – to take my bath. At first I had some difficulty in persuading him that I preferred to bathe in rather less than scalding hot water. When I was comfortably ensconced in the longitudinally halved oil-drum there was a polite knock on the bath-house door and Laughing Jimmy, as he came to be known, announced 'Whiskisodasah,' pronouncing it as one word. As I had not at that time acquired a taste for the life-blood of my ancestors, I declined the proffered tin mug, but despite this he continued to offer it until the end of our stay.

Gradually the numbers of Japanese personnel passing through the camp decreased, until no more than a rearguard party remained, comparable in number to our own company strength. Most of the log huts were empty. Word of this must have got to local bandits, groups of whom roamed the hinterland of Thailand rather as the dacoits did in Burma. One morning our men awoke in the company lines to discover that everyone's spare battledress, newly laundered for us by the Japanese, had been stolen from beside the sleeping owners, and despite the presence of a sentry. This was worrying, though I consoled myself with the fact that no rifles had been taken. For several nights

we posted extra sentries. There was an eerie quiet over the empty huts now that so few Japs remained. Our men were jittery and slept badly. I consulted the remaining Japanese officer, a captain who had been some time in the camp. 'They will return,' he said. 'They will come for rifles.' In order to take some of the strain from our men, I reinforced our sentries with Japanese, fully armed with some of our rifles. We waited. The next night I awoke in my own hut, which was several hundred yards from the men's lines, to the sound of firing and much yelling. By the time I reached the scene the intruders had fled, empty-handed and pursued by combined British and Japanese patrols which presently returned having chased off the bandits. No one on our side had been wounded, nor had we lost any arms or equipment. In the morning we found trails of blood leading from the camp into the long grass beyond. We were not molested again. I asked my new Japanese ally what he and his colleagues had done when similarly visited. 'We went out and burned all the villages within a radius of five miles. That stopped it.' Whether he expected me to follow that example I fortunately never found out, for a few days later we received orders to return to headquarters in Bangkok, since our task at Nakon Nayauk had been accomplished. I managed to obtain a new set of battledress for each member of the Company without questions being asked.

Shortly after this an even more curious assignment came our way. We were ordered to relieve the company which during our time up country had been stationed at Bangkwang Jail, where 'grey' and 'black' Japs were confined pending either their clearance and release or their trial in Singapore. For the first and only time in my life I found myself a jail commandant. I was of course ultimately responsible to the CO of the Battalion, that lovable man and brave soldier John Terry. Once the Company had entered Bangkwang and we had heard the gates slam behind us we were virtually as isolated from the outside world as the prisoners in our charge. I had in effect total on-the-spot responsibility.

The jail itself consisted of a forbidding group of buildings occupying an area a few hundred yards square, set in a dreary swampland, dotted with palm trees, a dozen miles from the centre of Bangkok. I believe it had been built for the Thai government by the French before the war, to serve as a civil prison. It was surrounded by a high whitewashed wall. At each of the four corners rose a watch-tower from

which our sentries could look down upon the roofs and compounds within. The whole place certainly had a Devil's Island atmosphere about it.

The main entrance was through a tall archway barred by heavy iron gates. On each side of the archway were guard rooms and the quarters occupied by the men of my Company. Above it was the Company office, from which one had a view of the main compound, on each side of which were housed the 'grey' prisoners who accounted for about two-thirds of the total number. Beyond the compound were the sombre buildings containing the 'black' prisoners who were kept in close confinement. The 'greys' by contrast were paraded under their new officers, drilled, inspected and given various fatigues to carry out. There was no contact between them and ourselves beyond what was necessary to convey and acknowledge orders. Behaviour on both sides was at all times strictly formal and correct. We carried out our own guard and sentry duties meticulously; all parts of the jail, including the small hospital, were under constant surveillance. In retrospect, I do not think we need have had any fears of an attempt by the Japs to break out, either singly or en masse. Their Emperor had ordered all his forces to submit and, even in the grim circumstances in which the Japanese at Bangkwang found themselves, submit they did. There was, however, another and, for them, more honourable means of escape open, as I was soon to discover.

Meanwhile, on the first Sunday afternoon after our arrival I received a formal request through my Japanese interpreter for the 'greys' to be allowed to continue the previously agreed practice of holding contests and displays of the martial arts in the main compound. I gave my permission, and as if by magic a matting square was laid on the ground in the centre of the compound and improvised seating arranged about it. At the appointed time three or four hundred Japanese took their places, some sitting, others standing and yet others standing on the tiers behind. Their senior officers sat in the centre of one side. From my vantage point above the compound I could see that one seat was vacant. A Japanese officer knocked on my door and, through the interpreter, stiffly invited me to take my place below. I went down with him and on entering the compound I heard a shout and all the assembled audience and contestants rose to their feet as one man, bowed in silence and, when I had taken my seat, resumed their places.

As I recall, there were two principal activities: swordstick fighting and judo. Each bout of the first began with both contestants bowing to me, then to each other in a good deal of ceremonial before, with gutteral shouts and grunts and clashing of wood on wood, they joined battle. Bout succeeded bout. I was largely ignorant of the rules and the obvious finesse underlying the animal energy of the participants. The generals sitting on either side of me remained silent, and so did I. I could feel the tension and excitement mounting around me, though I do not recall applause, only a murmur of approval or otherwise according to the course of each contest. I watched, fascinated by the spectacle and somewhat awed by the occasion, trying to remain as impassive as those who sat beside me.

Next came the judo, and I quickly realised that I was witnessing something exceptional. After a few opening bouts between opponents of moderate ability, there entered the ring a sergeant, as I later discovered, of the Kempei Tai (the Japanese military police). He was short and slight, as thin as a rake, small-boned and sinewy. He had eyes more deeply set and a nose more aquiline than most of his compatriots. He wore only thin black cotton trousers. After the usual silent bow to me, he proceeded to take on a succession of opponents, some of at least twice his size and weight. It was a contest for real, not merely a display. One by one they came at him, pitting all their strength and skill against this little wiry figure. One by one he threw them, neatly and without apparent effort. He must have dealt with ten or more. At last, showing no obvious signs of exhaustion, he bowed again and modestly left the ring. I had never seen a judo contest before, but I now realized I had witnessed a master in action. It was a spellbinding experience. At the conclusion of the proceedings the same ceremonies as before were enacted and after I had left the arena the gathering dispersed. In a few minutes the compound was empty.

I have mentioned the interpreter assigned to me; his name was Tadashi Kato. He must have been about twenty-five and was a Private First Class. His English was very good; he had been a teacher of the subject in his homeland. In appearance he was the archetypal army misfit and almost a caricature Jap – cropped head, thick spectacles, protruding teeth and ears, and splayed feet. The movements of his legs and arms were unco-ordinated, but he was genuinely anxious to please, and when I had broken through his diffidence and deference of manner I found him to be a person of great charm and intelligence.

He was a creature totally at odds with the forces that had propelled him all unwillingly into the war. We had many conversations, the details of which I have forgotten, but he told me of his family and of his hope of resuming his schoolmastering when he was free to go home. It was inconceivable that this gentle creature could have been guilty of any war crime, and indeed just before I myself left Bangkwang Jail he was included in a large draft for repatriation. I do not recall where his home was; I have since prayed that it was neither Hiroshima nor Nagasaki.

I had completed three years at Croydon School of Art before my call-up for the army and had gained a place at the Royal College of Art which was being kept warm for me on my return. I had done a certain amount of desultory drawing during my time in the Far East whenever the military life permitted. My sketches had been mainly of people and landscapes. While I was in hospital the Battalion's rapid transfer by air to Thailand had involved the jettisoning of all superfluous gear and equipment. Among the ammunition boxes full of files in the Orderly Room had been one containing my sketchbooks. Supposing these to be of no importance (save to myself), I regret to record that the staff there threw them out. Now, however, despite the strict routine of guard duties and inspections in the jail, I had time to resume my craft. Indeed life in that dismal atmosphere had become boring.

Kato came to my rescue. I arranged for him to provide me with portrait and figure models from among the 'grey' Japanese. I did not select (as the tutors in our art schools were wont to do) but took all comers, from generals to private soldiers. I suspect that the artist in Japan has always enjoyed a somewhat higher prestige than his opposite number in Britain. In any case, the Japanese must have been as bored with the jail routine as I was. So as models they came, considering it partly an honour, no doubt, and partly a relief from the general tedium of life.

While on leave earlier in Calcutta I had stocked up with materials which had somehow escaped the fate of my previous work, and now in addition I got from some source or other a quantity of Japanese paper. I must have made thirty or forty drawings and sketches from life during odd hours of leisure. I was surprised at the variety of form and character to be found in the faces I studied. Moreover, when told to keep still, each man would stand or sit as motionless as a statue until told otherwise.

Very few of those sketches remain in my possession. Most of them I sold at different times after the war, no doubt as much on account of the relative novelty of their subject matter as for any artistic merit they may have had.

My slumbers were broken one night when one of my platoon commanders, serving as Orderly Officer, rushed into my room and in a state of panic (he was a fairly recent reinforcement in the unit) told me that a Japanese officer had committed suicide in his cell. This, if true, would spell trouble for me. It was a grievous misdemeanour to permit a Japanese accused of war crimes to escape the normal processes of justice by committing hara kiri and thus, incidentally, preserving his honour according to the code of Bushido.

I dressed quickly and hurried to the scene. I should explain that the 'black' Japanese prisoners were kept in close confinement in cells holding ten or so, and only left their cells for sanitary and exercise purposes during daylight hours. Our sentries were on guard at the end of each long corridor where at night the only electric bulb burned. They patrolled at intervals during the night watch but it was difficult to see into the darkness and silence of each cell.

What confronted me was the sight of a grey haired man, wearing only his customary G-string, lying in a large pool of blood and with his throat cut. He was emitting a gurgling snoring sound. Beside him was a crudely written note in Japanese. The other occupants of the cell, all of them officers, were awake and sat silently around the walls observing their comrade taking his honourable exit. No hand was raised to restrain him.

From his snores it was clear to me that we had arrived before he had achieved his aim. I summoned the Japanese medical officer, an incommunicative but efficient captain named Kubo, and with the help of orderlies we got the recumbent victim to the sick bay. I retired to bed again, not very confident of his chances (or of mine for that matter) of survival.

Next morning my first action was to visit the sick bay. There I found an elderly, grizzled colonel (as he turned out to be) lying propped up on one elbow, a thick bandage around his neck, shovelling in rice with chopsticks held in his free hand. The note of the night before had been addressed to me and was to the effect that he wished to apologize for any inconvenience he might have caused but that he wished to take the honourable way out. Now he gave a thin, rather

sheepish smile and through the medium of Kato told me he was sorry for having been such a very foolish old man. I made no comment, but took this to be a confession of failure and incompetence on his part. In fact, he had cut his own throat with a broken razor blade, but had missed a vital artery. Nonetheless, had we not discovered him in time, he would have bled slowly to death. Afterwards I looked up his charge sheet. He was accused of a series of atrocities, including the torture and murder of civilians, in Indo-China. Well might he have tried to effect his own solution to his predicament.

All weapons or other implements by means of which prisoners might attempt to make an end of themselves were of course strictly forbidden in the jail. The existence of so much as a piece of razor blade alarmed me. After breakfast I got the whole Company on parade and, armed with wicker laundry baskets, we descended on the cells in the 'black' block. In the course of an exhausting and distasteful morning we stripped all the Japanese occupants regardless of rank, searched every item of kit and clothing and carried out what I think has now come to be known as a body search. By the end of the morning we had filled several baskets with all manner of small implements: scissors or parts of scissors, nails and screws, broken knife and razor blades and in short anything by means of which the owner might in honour make his quietus. Every single man had one or more of these objects secreted about him. I was astonished at the haul but at the same time relieved that no one other than the old colonel had so far had recourse to his secret weapon.

Despite their rising gorges and tempers, my men used no force or brutality in their unpleasant task. The Japanese for their part were sullen, silent and unresistant. They had been rumbled and no further attempts at suicide were made while my Company was at Bangkwang. Years later, when visiting a handmade paper mill in the south of England, I found an incipient strike among the ladies responsible for sorting the rags which were the raw material for the fine watercolour paper made by the firm. They had been accused of the unforgivable sin of allowing small pieces of metal to enter the trays of pulp, which resulted in tiny brown rust spots sullying the finished sheets. I enquired the source of the rags they used. They mostly came from the Far East, I was told. I took a closer look. Some of the cotton fragments seemed familiar. They were Japanese army shirts and tunics. With a knife I slit open the seams of collars, sleeves and

pockets. Out fell little rusty pieces of razor blade and similar objects. Peace and harmony were restored, so perhaps that morning's work years ago had been useful in more ways than one.

Towards the end of our tour of duty at Bangkwang those among the 'grey' Japanese who had been cleared of suspicion were formed up ready for their departure by ship for home. The general leading them asked to see me and reported to my office where he handed me a cylindrical brass container from which I drew two rolls, one of paper, the other of silk. Each bore a painting in colour of a Japanese girl in traditional ceremonial dress. That on silk in particular was exquisitely drawn and tinted. Both, as I learned, had been done in the jail by a Japanese artist and now presented to me as a token of appreciation and, I like to think, perhaps of reconciliation. There is little doubt that many of the Japanese were ashamed of the excesses committed by their fellows and wished in some way to make amends. I accepted their gift in the spirit in which I am sure it was offered. I asked to meet my fellow artist, but the transport had arrived and there was no time to produce him before all were aboard and away. I still have the paintings, and though the delicate tints are a little faded the memory of that occasion remains fresh in my mind.

One day while we were at the jail I received an urgent message from Battalion Headquarters: 'The King is dead'. Supposing this to refer to King George VI, I was greatly shocked and wondered what the consequences might be. However, it transpired that the message had referred to King Ananda of Siam, who had been found dead in his palace bedroom in suspicious circumstances. There was a general belief that he had been murdered – to this day I do not know the full story – and I was summoned to Headquarters to meet the Commanding Officer and the other company commanders to discuss the possible effects of the king's death upon the local population and the internal security implications there might be for our troops in Thailand. As it turned out, life went on as usual. The dead king was succeeded by his young brother, Phumibol (pronounced, I think Phumiphon). I recall only one curious memory. While being driven by jeep from Bangkwang to Battalion Headquarters we passed the gates of the royal palace. Outside stood a Thai sentry. He wore a World War I French steel helmet, leaned on a musket of doubtful age and origin, and was shod with one boot and one plimsoll. That seemed to say it all about a happy-go-lucky, corrupt and yet comfortable country.

There were diversions, too. In Bangkok there was a splendid sports stadium where, for twenty minutes each way and in about ninety-degrees of heat, we played rugby matches. These were mostly as a divisional team against various Thai sides. It might have been supposed that we, coming from the home of rugby football and being several stones heavier than our opponents, would have overrun the Thais. We did indeed win several matches, but against the Tha Prachan we could not prevail. Their coach, as we discovered, had been at Cambridge, where he had played at scrum-half for his college. Inspired by his tuition, Tha Prachan overran us; they were like terriers, much smaller than we were, but fast and elusive and, of course, much more accustomed to the heat in which our matches were played. It was all great fun, especially when, after the game was over, we lined up – players, referee and touch-judges – to receive from pretty Thai girls large garlands of fragrant, albeit prickly flowers around our sweating necks.

Meanwhile, there were still the Japanese. After the end of my company's tour of duty at Bangkwang Jail we had the task of escorting a shipload of 'black' Japs from Klongtoi Docks to Changi Prison, Singapore, to stand trial for alleged war crimes. I recall one voyage in a former United States Liberty ship, in which the company had charge of some three hundred Japanese of all ranks, including several generals and an admiral. We packed our prisoners into the cargo hold where they gave little trouble since most were seasick for the three days of the voyage. The Japanese, it seemed, were not on the whole good sailors. The men of my company stood guard, and indeed we posted a sentry on the bridge of the ship, for at the point of depar-ture I had discovered that we were blessed with a Japanese captain and crew who for all I knew of navigation could have sailed us straight to Yokohama. However, all went well and the high spot of our voyage occurred one bright morning about eight o'clock when, coming on to the bridge, I saw a huge Royal Navy aircraft carrier overtaking us on a parallel course. We ourselves were flying the red ensign. I ordered the sentry on the bridge to present arms and I myself saluted. The carrier was by this time level with us, about three hundred yards away. Suddenly it dipped its white ensign in returned salute and flung out a string of signal flags whose significance we could not at that moment understand. Through binoculars I could see officers saluting us from the carrier's deck. It was a case of 'dignity

and impudence' perhaps, but also an example of the courtesy of the seas, and for us a memorable experience. The carrier sailed past us and out of sight.

Arriving at Singapore, we discharged our longsuffering cargo and escorted them to Changi. For them the tables were turned, for they were returning to the place where at least some of them had had custody of British prisoners of war. At least the Japanese were not treated there as harshly as they had treated their own captives. It was at Singapore that I gained a curious insight into the conduct of the Japanese officers towards their own men. A Jap soldier, laden with full kit, stumbled and fell on the quayside as he alighted from our ship. I was standing close by and saw a Japanese officer come up to him and kick him repeatedly until he struggled to his feet. When all our charges were lined up to march to the waiting trucks they were inspected by their officers. One of the latter, before my very eyes, seeing a man with, apparently, a button missing or undone, struck him twice across the face. It was a revealing spectacle.

Among the prisoners who had come from Bangkwang were some fifteen Koreans who had served the Japanese as prison guards. They were big men, taller than the Japanese, who in fact regarded them as especially cold and ruthless. I recall one of their number, a huge man named Chin Fook Goi, whom everyone seemed to treat with a mixture of respect and loathing. He and his fellows were all charged with crimes against Allied prisoners and would shortly be called to account.

The Company had some time to wait in Singapore before returning to Bangkok. We were accommodated in Nee Soon Transit Camp meanwhile, and there was time for some relaxation. While we were there it happened that Peter Woodrow of 1 Queen's arrived to catch his boat home. It was fitting that he should be accorded a farewell spree. He and I and Ted King, my second-in-command, had a night on the town. I forget how many bars we visited, but I do recall that at some unearthly hour on the following morning I was with some difficulty awakened by Peter, as fresh as a daisy, bidding me goodbye for the docks. I wished him well and fell asleep again. Few of us possessed a stamina equal to Peter's.

While in Singapore I was able to take my sketchbook and make drawings at the trials of my erstwhile charges. If I had expected dramatic proceedings I was soon disabused. There was the tedious

business of translating everything out of English into Japanese and thence into Dutch or French and back again. Questions arose in one's mind: in all the beastliness of war and the revolting crimes with which many Japanese were charged, who was to blame – those who had given the orders, or those who had obediently carried them out? Moral questions such as this troubled others besides myself, as I discovered in conversation with officers of the Judge Advocate General's department at the time. Be that as it may, many Japanese were executed. I was in fact invited to attend a hanging at Changi Prison. I had never seen myself in the role of such artists as Goya or Gustave Dore, and fortunately my dilemma was resolved when I was ordered to return to Bangkok. The process of justice, however, rolled on.

My own time in the Far East was coming to an end. After a prolonged and cordial farewell celebration I was given, as my final duty, the command of an assorted party who were to travel by train from Bangkok to Singapore, most of them for the last time. There were some thirty of the Queen's, like me homeward bound; there was an equal number of Japanese prisoners for Changi; there were also some Indian soldiers. We entrained amid scenes of emotion and hilarity and departed southwards behind a locomotive whose source of power was derived from the contents of its two tenders – logs of wood. The journey down the narrow peninsula towards the Malay frontier was slow, over rickety wooden bridges and through jungle, and it was insufferably hot. This was by reason of the fact that we were obliged to ride in American-type steel freight wagons which, even when the train was in motion and we had the sliding doors open,

Studies made of accused Japanese personnel during war crimes trials in Singapore in 1946, by Robert Strand
(*Photograph courtesy of Robert Strand*)

224

were like ovens. It was with great relief that we reached the border, though not without first rejecting the overtures of Chinese traders who tried to persuade us to take sacks of rice, containing heaven knows what in the way of opium or heroin, to Singapore.

At the first station inside Malaya all was transformed. We changed trains and found ourselves boarding the Straits Mail, which was such a contrast from what we had hitherto endured that we could hardly believe our luck. I got our travel-weary Queen's men into a long, open saloon coach and they were able to relax. There was little delay before the train left, and I saw strutting down the platform two Britons clad in white shirts, white shorts and white stockings and wearing a type of pith helmet we had abandoned in India years before. They carried canes and had a proprietorial air about them. Drawing level with our coach, they boarded it, looked around and demanded, 'Who's in charge of these men?' I explained that I was. 'Then what the devil are you doing, allowing "other ranks" to sit in a first class carriage?' I was momentarily lost for words. I had not even noticed the classi-fication of our coach, but next to me was sitting RSM Simmons, late of the Royal Sussex and a splendid regular soldier. Rising to his feet he reminded the intruders who we were, gave them a terse account of how the war had been won and by whom, and made it clear that he did not welcome the presence of a couple of planters – for such they clearly were – who thought that they could put the clock back five years. They retreated down the platform vowing to report us, and that was the last we saw or heard of them. The episode, comic in retro-spect, seemed to me to explain a good deal about British colonial attitudes in that part of the world.

Once arrived in Singapore and having seen our groups go their separate ways, there was little for me to do but wait for the boat home. I did not have to wait long, and three or four weeks later the *Queen of Bermuda* docked at Liverpool. In a day or two I was a civilian once more. A chapter of my life had closed and, in the harshest winter that Britain had known for years, I resumed my interrupted art studies, obtained a modest government grant and took up resi-dence in a bed-sitter in South Kensington. My memories of good friends and comrades, of strange places and events, have remained dormant until now, when they have emerged with unexpected clarity, like a photograph rediscovered in a long-locked drawer.